A THEOLOGY OF
ARTISTIC SENSIBILITIES

A THEOLOGY OF ARTISTIC SENSIBILITIES

The Visual Arts and the Church

JOHN DILLENBERGER

CROSSROAD • NEW YORK

1986

The Crossroad Publishing Company
370 Lexington Avenue, New York, NY 10017

Printed in the United States of America

Library of Congress Cataloging in Publication Data

Dillenberger, John.
 A theology of artistic sensibilities.

 Includes bibliographical references and indexes.
 1. Christianity and the arts. I. Title.
BR115.A8D55 246 86-13584
ISBN 0-8245-0783-5

For their public and visible role
in encouraging quality in art and architecture

DAVID E. A. CARSON
JOHN W. COOK
DOMINIQUE DE MENIL
ROBERT W. LYNN
RICHARD MEIER
J. IRWIN MILLER
ANNALEE NEWMAN
JANE OWEN
RALPH PETERSON
ELOISE SPAETH
GARY YOUNG

Contents

PREFACE

MY INTEREST THROUGHOUT this volume has been a theological understanding of the visual and the basis upon which the visual arts may again be incorporated into Protestantism and reinvigorated in Roman Catholicism. Since many of the contemporary problems reflect historic influences from which we are neither instructed nor freed, I have paid attention to historic junctures as the hidden bedrock in our contemporary understanding. Believing that history is not without its lessons and is therefore an essential ingredient in theological reflection, I have explored those moments in Western history in which the relation between religion and the arts was in ferment. Sometimes such moments expressed conflict (as in the iconoclastic controversies), sometimes new departures (as in the Gothic or baroque developments). Artists such as Tintoretto or Titian or Breughel are not included here, as they would need to be if this were a history or if one were dealing with developments in style. There are, of course, two styles or forms that were created by Christians—the Eastern icon and Gothic architecture.

Covering this length of time in Western history makes one acutely aware of one's dependence on the detailed work of others, both in theology and in art history. If there are new discoveries in this volume, they are not archival or historical in any specific sense. Rather, they are interpretative discoveries, resulting from my years of work at the intersections of the two fields. Most of all, the volume represents my thoughts on the subject of religion and the visual arts, including steps that I think need to be taken in theological education.

Organizationally, the book falls into three sections. Part 1 delineates formative historical junctures in the relation between conceptions of faith and the visual arts. Here I have tried to describe and to characterize the nature and meaning of the perceptions both in the art and in the theological currents of the time. Because that history is not a vital part of the understanding of contemporary Christians, I have tried to counter a

historical amnesia. Since the visual does not play a vital role in contemporary church life, the result has been that its powerful and living place in the past has largely gone unnoticed. Only a negative view of that history lingers, particularly in Protestant circles. Since the intent of part 1 is imaginative historical construction, I have generally refrained from critical analysis. Part 2, however, moves into the twentieth century, where delineation and analysis are essential. Both the visual arts and the theological currents of this century may not be known well by most, but the amnesia of the earlier periods does not exist. Our century is in our bones. Therefore, the methodology of part 2 is to describe our century's shape and to examine it critically with an eye to the future. Part 3 is mainly constructive—that is, it is my attempt to provide a theological perspective that demands and includes the visual arts. Just as the three parts are distinct and yet interrelated, so the methodologies are distinct and yet related in the intent to provide a unity of historical memory, contemporary delineation and analysis, and a constructive intention. Since the volume forms a unity, ideally it should be read in the order in which it appears. But differing interests may lead some to enter the volume at any one of the three parts.

What follows obviously has autobiographical ingredients. Although I grew up in a setting of cultural deprivation, it was one in which sight, taste, and smell were prized, for they formed the ambience of community life. To this day I look at the sky as if to divine what it will bring; in a farming community, that act is not merely an interest in nature, but also in history, for life and death depended on it. The acceptance and cultivation of such sensibilities provided the base from which my interest in the arts developed as subsequently I was exposed to them. Hence, it never occurred to me that verbal statements, propositional or more suggestive, theological or philosophical, defined one's existence. Karl Barth, Reinhold Niebuhr, and Paul Tillich were the current theologians to whom I was introduced. It always seemed strange to me that Barth was so vigorously verbal and restrictive in theological work but so culturally interesting as a human being, and that Niebuhr knew the poets and critics of his time but that they played no role in his thought. Tillich alone seemed to me to involve the full range of humanity's sensibilities in his theology.

My marriage in 1962 to Jane Daggett Karlin, an art historian who both taught in theological schools and worked at the curatorial level in various museums, encouraged my interest in the visual arts. A fifteen-month sabbatical was spent at the National Museum of American Art, and summers were totally devoted to research and to viewing works of art. The products of these endeavors were the books *Benjamin West* (San Antonio, TX: Trinity University Press, 1977) and *The Visual Arts and Christianity in America* (Chico, CA: Scholars Press, 1984). A two-year research project issued in the

exhibition and catalogue, done jointly with Jane Dillenberger, entitled *Perceptions of the Spirit in Twentieth-Century American Art* (Indianapolis Museum of Art, 1977).

That work led me to two conclusions that have been operative ever since. First, the issue of the visual arts and the church has much to do with theological understandings and very little to do with theories of aesthetics. There are notable volumes on aesthetics, but they have played a minor role in determining history or in providing clues for understanding the historic and contemporary issues. Second, what the visual arts convey cannot be translated totally into other modalities. As a result of these conclusions, I began to think that nothing less than a split among our sensibilities was involved and that this split was one way of thinking of the theological idea of the fall. Here I was helped by Augustine, who saw the physical, the logical, and the ethical; or action, contemplation, and discrimination; or the moral, the natural, and the rational; or the senses, action, and mind as echoes of the Trinity. All were God's gift, but they could not, like Humpty Dumpty, simply be put back together.

My agenda is the need to reclaim all our sensibilities. Each human sensibility requires a discipline, a habit of attention, because each gives us something that the others do not. For example, word and sacrament focus the same reality but in a way that also makes the two distinct. I tried to work these insights out theologically in *Contours of Faith* (Nashville, TN and New York: Abingdon, 1969). Since that time, I have undertaken historical and contemporary probings of the affinities and differences between the visual and the verbal. The issue is not whether theology is verbal; of course it is. The issue is whether a verbal discourse will take into account other sensibilities. Such taking into account involves precision without undue definition, suggestiveness without transgressing boundaries, and delineations that elicit the response "Now I see."

Finally, a theological note should be added. Although I am interested in the church from both a theological and a historical perspective, I am not a denominational theologian. My theological interest has always been in trying to broaden horizons, of trying to understand contributions even in formulations no longer acceptable. Hence, I have been concerned with a widening arena of truth and perception, with a center that is open to its many expressions, some more adequate than others. Of course, I make judgments; indeed, I believe it is necessary to do so. But I find the nature of such judgments to be rooted more in a habit of discernment than in applications of theories of logic or epistemology.

Portions of previous works are included in the systematic formulations of this volume. The first part of chapter 6 is based on my introduction to the

exhibition catalogue *Perceptions of the Spirit in Twentieth-Century American Art*, an exhibition that Jane Dillenberger and I did jointly. Chapter 8 is dependent on an address given as a Scholars Press Associates Lecture at the Annual Meeting of the American Academy of Religion and the Society of Biblical Literature in Chicago, December 1984, and published in the *Journal of the American Academy of Religion* 53:4 (December 1985). Chapter 9 is a rewriting and an expansion of the article "The Diversity of Disciplines as a Theological Question: The Visual Arts as Paradigm," *Journal of the American Academy of Religion* 48:2 (June 1980). The section on the Church at Assy in chapter 7 is dependent on the article "Artists and Church Commissions: Rubin's The Church at Assy Revisited," in *Art, Creativity, and the Sacred*, edited by Diane Apostolos-Cappadona (New York: Crossroad, 1984).

Others have, of course, published in the area of Christianity and the visual arts. Those interested in the subject apart from the question of its place in the life of the church have long had works available by Albert Edward Bailey and Cynthia Maus. Bailey knew the difference between art of quality and what is sometimes called "kitsch," but the publications by Maus, still widely read and readily available until recently, mix quality with trash and sentimentality. Undoubtedly, the popularity of sentimental portraits of Jesus by Heinrich Hofmann and Warner Sallman, frequently seen in the offices of clergy who "know better" in other areas of their lives and in Sunday school rooms, stems in part from the integration of pictures and pious sentiments. These are works in popular piety in which neither historical, theological, nor churchly concerns are present.

More recent works in the area of Christianity and the arts are more helpful. Since the fall of 1985, when the draft of this volume was completed, Margaret R. Miles's *Image as Insight: Visual Understanding in Western Christianity and Secular Culture* (Boston: Beacon Press, 1985) has appeared. Her work is particularly powerful in its delineation of the role of the visual as part of the data of the history of the church and the distortion that occurs when research is limited to written texts. Her analysis of fourth-century Roman churches and of the Reformation and subsequent Roman Catholic reforms covers materials that I too have included, but our treatments are complementary rather than identical. Her chapter on the images of women in fourteenth-century Tuscan painting opens new avenues of understanding. A book also close to my interest is *Art and the Message of the Church* (Philadelphia: Westminster, 1961) by the late Walter L. Nathan, who, had he lived, would undoubtedly have written other works in this area. Jane Dillenberger's *Style and Content in Christian Art* ([1965] Reprint, New York: Crossroad, 1986) provides detailed and perceptive commentary on specific works of art, utilizing these as the basis for

conclusions of a more general nature. The Dominican Aidan P. Nichols, in *The Art of God Incarnate: Theology and Symbol from Genesis to the Twentieth Century* (Ramsey, NJ: Paulist Press, 1980), combines theological reflection with historical references. Samuel Laeuchli, in *Religion and Art in Conflict* (Philadelphia: Fortress, 1980), juxtaposes the pros and cons of religion and art at various junctures and draws reflections on the whole. I have learned much from him particularly about biblical strands and their interpretation and about Aquileia and Nicaea, but my interests have led me in different directions. Moreover, I do not believe that in the early period conflict was as pronounced as Laeuchli indicates.

The contemporary scene is covered by a number of books. John Newport's *Theology and Contemporary Art Forms* (Waco, TX: Word Books, 1971) has been reissued in paperback under the title *Christianity and Contemporary Art Forms* (Waco, TX: Word Books, 1979). The book includes the literary and the visual arts as well as a theological analysis. Horton Davies and Hugh Davies published *Sacred Art in a Secular Century* (Collegeville, MN: Liturgical Press, 1978), which has a survey of the contemporary scene. The title and contents are not dissimilar to the earlier work by Jane Dillenberger, *Secular Art with Sacred Themes* (Nashville, TN: Abingdon, 1969). An extensive treatment of painters and sculptors on the American scene is given in Jane Dillenberger and John Dillenberger, *Perceptions of the Spirit in Twentieth-Century American Art*.

In addition, there are reflective books on the relation between Christianity and the arts—Nicholas Wolterstorff's *Art in Action* (Grand Rapids, MI: Eerdmans, 1980), which is philosophical, with theological references, and Roger Hazelton's graceful book, *A Theological Approach to the Visual Arts* (Nashville, TN: Abingdon, 1967). Kevin Wall in *A Classical Philosophy of Art: The Nature of Art in the Light of Classical Principles* (Washington, DC: University Press of America, 1982) shows his roots as a painter and as a Dominican theologian. Hans Küng, whose work I ordinarily admire, has published a brief volume entitled *Art and the Question of Meaning* (New York: Crossroad, 1981), which I did not admire, for it seems to be no more than a lament about the state of modern art. Always sound and suggestive is the work of John W. Dixon, Jr. His *Art and the Theological Imagination* (New York: Seabury, 1978), in particular, shows the strength of one who stands solidly in both fields. The essays in *Art, Creativity, and the Sacred*, edited by Diane Apostolos-Cappadona (New York: Crossroad, 1984), significantly open many avenues of exploration and are a barometer of this field of study. For a fine discussion of available texts on Christianity and the visual arts, the reader is referred to John Cook's bibliographic essay "Sources for the Study of Christianity and the Arts," in *Art, Creativity, and the Sacred.*

Since my interests center on the issue of the recovery of the visual arts for the life of the church as a matter of fundamental theological principle, I have followed my own hunches and so have not directly entered into conversation with the writers just mentioned. Their interests are complementary to my own concerns. Nevertheless, I have learned from them.

Finishing a preface makes one acutely aware of all who have helped along the way. I think of Cleve Gray, Patricia Bonicatti, Daniel Pater, Doug Adams, Margaret Miles, Kent Richards, Wilson Yates, and Conrad Cherry. They all will recognize how they helped me, and I gratefully thank them.

Robert W. Lynn played a major role in making this volume possible. Believing that theological education needs to face the issue of the visual arts, he personally—and officially in his role at the Lilly Endowment, Inc.—saw to it that I had funds to carry out the research for this project. Moreover, the Lilly Endowment, Inc., through a grant to the Candler School of Theology, Emory University, made possible a Consultation on the Arts and Theological Education in December 1985, in which the current manuscript received attention. I want to express my appreciation to Werner Linz and Frank Oveis of Crossroad and also to the designers, the printers, and those who market the book. Diane Apostolos-Cappadona has my special thanks for her creative role, which included suggestions that led to revisions and also help in checking concrete details and in determining the format of this volume. Jane Dillenberger's role is obvious to those who know her, but they can catch only a glimmer of her involvement in all facets of my life and work.

Since this volume is suggestive rather than exhaustive, I decided to limit the bibliographical references to those listed in the footnotes. All works of art mentioned in the text are listed in a section at the end of the volume, together with pertinent information, such as dates and location, when available.

I

FORMATIVE
HISTORICAL
JUNCTURES

1

THE FACT AND NATURE OF
ART IN THE EARLY CHURCH

FROM THE LATE nineteenth century into our own time, prominent scholars, from Adolf Harnack to Ernst Kitzinger, have assumed that scripture and the early fathers were opposed to the visual arts and that the arts hardly existed until the time of Constantine. In recent years, that outlook has had to be abandoned. Study of church history, archaeological and artistic discoveries over a period of decades, and the work of recent scholars such as Joseph Gutmann and Sister Charles Murray have provided evidence contrary to these assumptions. The result is that we now see continuities between the early church and the post-Constantinian period rather than the sharp divisions that were previously assumed. We were accustomed to seeing neat distinctions between a church that was supposedly relatively pure, simple, clear, and spiritual in the early centuries and the church that followed, which showed corruptions of power, the opulence of art and architecture, and a deadening security through the Constantinian promotion of Christianity. Of course, there is a difference between the forms of a church that is underground and a church that openly has governmental support. The fact that more art and architecture survive from the latter than from the former led to emphasizing the difference to a greater extent than is justifiable.

According to the present views, variety, diversity, and continuity characterized the church, both before and after Constantine. It has become increasingly difficult to talk of a pure church that became corrupt in a later period or a Constantinian fall of the church. Rather, we now see a variety of viewpoints in scripture and among the early church fathers. Moreover, since the Gospels and Epistles reflect churches that were already in existence, the distinction between the alleged clarity and simplicity of scripture and a beginning of corruption in the churches no longer seems justified. Indeed, the question is whether those who look to the biblical documents

3

in and of themselves as the clue to the true church can escape the condition-
ing of history in understanding the documents. There is no viable alterna-
tive to that of a continued probing of the biblical material with our
historically conditioned eyes. Such an approach will at least take both
source and development seriously as two components in the understanding
of the documents, even if priority is given to the first as the norm.

Scriptural Interpretations

In our Western, particularly Protestant, consciousness, Exodus 20:4–5 is the
pivotal text. "You shall not make yourself a graven image, or any likeness
of anything that is in heaven above, or that is in earth beneath, or that is
in the water under the earth; you shall not bow down to them or serve
them; for I the Lord your God am a jealous God." In one strand of biblical
scholarship, it is assumed that the original prohibition, "You shall not make
yourself a graven image," reflected the desert experience of the Jewish tribes
and that the additional elaborations—which more narrowly focus the
prohibition to bowing down to images or serving them—are undoubtedly
of later date. In the desert wandering, according to Joseph Gutmann, God's
presence was associated with the Ark.[1] By nature, this God, even when
present, was invisible, according to Exodus 24, 33, and Numbers 12. As
Gutmann says, "the purpose of the law forbidding images seems to have
been to assure loyalty to the invisible Yahweh and to keep the nomads from
creating idols or adopting the idols of the many sedentary cultures with
which they came in contact during their desert sojourn."[2] When the Israel-
ites entered into a settled existence, God no longer was associated with
travel, but with the land, with the monarchy, and with the temple. Writes
Gutmann: "Were the Second Commandment in its entirety to be taken
literally, the construction of Solomon's Temple, with its graven images, such
as the cherubim and the twelve oxen which supported the molten sea,
would obviously have been a direct violation and transgression. Yet no
censure was invoked by the biblical writers."[3] Conversations with scholars
whose work has not yet been published suggest that the development and
understanding of the decalogue traditions are more complicated, but the
basic picture here delineated, one in which prohibitions and affirmations
of images stand side by side, is affirmed.

[1] Joseph Gutmann, "The 'Second Comandment' and the Image in Judaism," in *No Graven
Images: Studies in Art and the Hebrew Bible*, ed. Joseph Gutmann (New York: Ktav, 1971)
2–3. See also Joseph Gutmann, ed., *The Image and the Word* (Missoula, MT: Scholars
Press, 1977).

[2] Ibid., 3.

[3] Ibid.

Beyond the ambiguous role of the second commandment lies the fact that the Hebrew Bible also has positive references to artists. In 1 Kings 7:14 it is noted that Solomon brought Hiram from Tyre, a man "full of wisdom, understanding, and skill, for making any work in bronze," and in Exodus 31:1–11, Bezalel, a desert artist, is said to have been filled "with the Spirit of God, with ability and intelligence, with knowledge and all craftsmanship, to devise artistic designs, to work in gold, silver, and bronze, in cutting stones for setting, and in carving wood, for work in every craft." Indeed, Bezalel, along with others, was to execute all the utensils, garments, etc. for the Holy Place.

Counterbalancing these ceremonial instructions are the subsequent Deuteronomic reforms under Josiah and the denunciation of idolatry by Amos and Hosea. But Gutmann also points out that Josiah apparently did not remove images from the time of Solomon and that his measures were primarily to strengthen the monarchy. The prophets "were moved, not so much by a revulsion against art or by a desire to enforce the Second Commandment, as by a pressing need to preserve the semi-nomadic way of life," even if for religious purposes.[4] What history we know suggests both an uneasiness with images and a positive attitude to use in the temple. The descriptions of the temple exhibit an artistic and suggestive language, clearly consonant with the images themselves.

Biblical materials are, therefore, ambiguous on the issue of images and art. Affirming that fact is not meant to sidetrack the issue of the second commandment; rather it is meant to place it in a less dominating context. Although there are references to the second commandment in debates on images both in the early church and in the medieval period, the decalogue itself did not then play the central role in the history of the church that it did after the Reformation. The new reforming consciousness led to the depiction of the two tablets of the law on the walls of churches, particularly in England. Wherever the second commandment was stressed as a weapon against images, there were also those who contended that the elaboration of the commandment in scripture made the prohibition extend only to the creation of images for the sake of worship, that is, to idols. This distinction was made already in the early church, and it became the major difference between Protestant and Roman Catholic approaches to the second commandment.

In assessing the early period of the church, one must always keep in mind that there was no ruling canon of New Testament scripture until the mid-third century. Until that period most churches had access to one or more

[4] Ibid., 7.

of the Gospels or Epistles, sometimes already arranged as emerging canons of scripture. Reference to scripture in the early period meant, of course, the Hebrew Bible. Furthermore, since both the Hebrew and the Christian sacred documents were hand-written parchments, access to scripture by the ordinary person was virtually excluded. A selective, oral tradition of scriptural texts formed the minds of believers, and the source of this oral tradition was the liturgy in which the people participated and the teaching that occurred in the church. For that reason, quotation and interpretation of scripture go hand in hand with quotation from the apostolic and church fathers, forming a fluid and concurrent tradition. It is thus understandable that quotations from the church fathers, along with scripture, play such a dominant role in subsequent controversies.

The Church Fathers and Art

Among both church historians and art historians, it has been widely assumed that the church fathers were opposed to the creation of images. A group of recent scholars, chief among whom is Sister Charles Murray, have examined carefully the texts of the fathers and their contexts, which goes beyond the usual collection of passages (*florilegium*) used in the early iconoclastic controversies. [5] The conclusion is that the situation was complex. Both positions were present in the early church, and some texts that were previously interpreted as prohibiting images do not in fact do so. One official action, the Synod of Elvira, held in southern Spain in about the year 300, clearly states that "there ought to be no pictures in a church lest what is worshipped and adored be depicted on walls." [6] Although the action of this local synod seems, on the surface, clearly to prohibit images of that which is worshiped, we know nothing of the context. We do know that this was still the period of house churches and that there were places in the empire where the church was subject to imperial raids or desecration by pagans, or where, as in southern Spain, Christians may have been engaged in black magic. The absence of paintings would thwart such practices in particular places; however, we know that house churches, such as the one at Dura-Europos, were painted. Without more information, it is impossible to draw definite conclusions about the Synod of Elvira.

[5] Sister Charles Murray, *Rebirth and Afterlife: A Study of the Transmutation of Some Pagan Imagery in Early Christian Funerary Art* (Oxford: BAR, 1981), and the condensed version, "Art and the Early Church," *Journal of Theological Studies* 28 (1977) 303–45. I have consulted the documents to which Murray refers, and the succeeding pages are largely based on her work.

[6] Murray, *Rebirth and Afterlife*, 20.

In Tertullian's work *On Idolatry*, in the *Syriac Didascalia*, in the *Egyptian Didascalia*, and in the Pseudo-Clementine *Church Order*, the issue is whether a Christian can be a painter, and the answer is negative if the painter produces idols. In Clement of Alexandria's *Stromateis*, the artist, it is said, would rob God by usurping the divine prerogative of creation (6.16). The issue curiously involves a discussion of the eighth commandment's prohibition of stealing, not the second, and the general context is a discussion of the transcendence of God with respect to all human activity. The point is that creativity is derived from God and that for humans to claim it is to rob God.

There are some passages from the early church on actual images. In *On Modesty* Tertullian speaks against the use of communion cups with the Good Shepherd on them (chap. 7). We know that Tertullian was vigorously opposed to the possibility of a second repentance and that he was therefore opposed to the Shepherd of Hermas. The question is whether the rigorist Tertullian was opposed to the shepherd symbol as an artistic symbol or as the symbol of a theology he opposed. In Clement's *Paedagogus*, the issue is what emblems are appropriate on signet rings worn by Christians, and the answer is ship, lyre, anchor, dove, or fish (3.11). Those who believe that Clement was opposed to art say that this was a concession to the populace; others understand this passage as a reflection of his positive artistic views. Indeed, a passage from his *Protrepticus* may be the basis for the Christian Orpheus in the Catacomb of St. Callixtus (chap. 1).

Three fourth-century figures also need reinterpretation. In the *Morals of the Catholic Church*, Augustine argues that the church is not to be judged by those who "forget what they have promised to God. I know that there are many worshippers of tombs and pictures. I know that there are many who drink to great excess over the dead, and who, in the feasts which they make for corpses, bury themselves over the buried, and give to their gluttony and drunkenness the name of religion" (chap. 34). Despite interpretations to the contrary, surely Murray is right in seeing this passage as a condemnation of a practice, not of images as such.[7] The same may be said of the historian Eusebius. He speaks positively of the representation of the Good Shepherd and Daniel with the Lions on a fountain created by Constantine in Constantinople and of Christ's passion on the ceiling of the imperial palace (*Life of Constantine* 3.49), and he mentions a statue thought at the time to represent Christ and the woman with the issue of blood (*Church History* 7.18). But Eusebius is generally thought to have been opposed to the representation of Christ; in his alleged letter to the

empress Constantia, he refuses to supply an image of Christ. Murray points out that the letter as we know it dates from the eighteenth century and that it was not found among what were considered to be the authentic works of Eusebius in the fourth century. Parts of it are found in one of the *flori-legium* of the iconoclastic controversy, but it appears to be spurious. More-over, a statement in this document to the effect that no representation of Christ existed in the fourth century is hard to believe, for Eusebius would "scarcely have been unaware of the five-foot high, hundred and twenty pounds weight, silver figure of Christ with the Apostles and angels which adorned the 'fastigium' of the Basilica Constantiniana, the Lateran." [8] Even if the letter were authentic, its point seems to be only that an icon is not a portrait providing the actual features of Christ. Speaking of the cathedral in Tyre, Eusebius goes so far as to suggest that in the interior "the evidence of our eyes makes instruction through the ears unnecessary," a strong state-ment from one who allegedly was against the visual (*Church History*, book 10).

Epiphanius of Salamis has also been placed among those opposed to imagery, both pagan and Christian. The basis of the claim is undoubtedly the Latin translation by Jerome of Epiphanius's apology for not yet having sent a curtain for the church at Anablata to replace the curtain he had pulled down. The original Greek text, according to Murray, makes it clear that the destroyed curtain had an idol figure in the form of a man—not at all a Christian figure, as is assumed in Jerome's Latin translation. Further-more, only in the Latin text is the second commandment mentioned. The anger on the part of the church seems to be only that a costly curtain had not been replaced, and Epiphanius seems to be concerned with the creation of idols, not images. This particular Latin translation is all the more puzzling, for Jerome and his friends regularly walked through the cata-combs with their painted walls as a form of cherished Sunday recreation. [9]

Art in the Pre-Constantinian Church

The literature of the church fathers does not seem to exclude images, and images in fact existed in the early period of the church. The earliest known survivals of Christian art are to be found in the catacombs, a system of underground passageways that survived from an early period; in sarcophagi from various locations—from catacombs, private cemeteries, and other sources; in the frontier town of Dura-Europos, a town buried in sand from

[8] Ibid., 28.
[9] Ibid., 31–33.

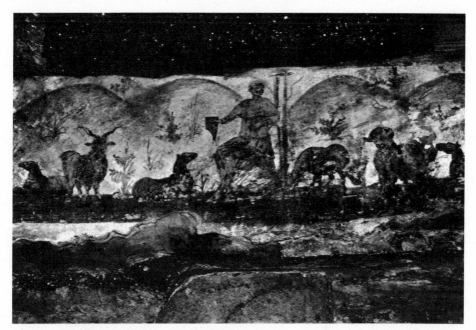

1. *Christ/Orpheus*, mid-3rd century

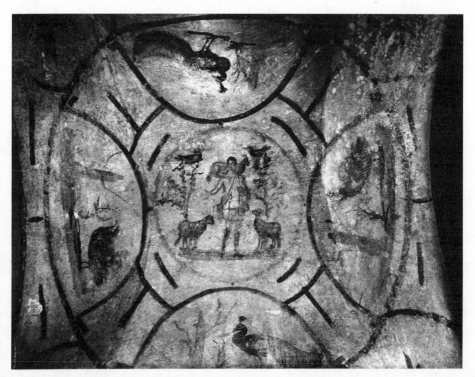

2. *Good Shepherd*, 3rd century

the third century until our own; and possibly in the remains of house churches in Rome. The exact origin of images and symbols, indeed of art, in the Christian movement is not known, though they obviously come from some Jewish and Greek sources. But there is certainly no reason to assume, as has often been the case, that the Christian movement was originally aniconic. One would suppose that the figure of Christ would appear in the art of the early Christians, and indeed it does. But the forms are surprising, for neither the cross nor the crucifixion appears in the early extant works. Instead one finds Christ represented in the figure of Orpheus, as in the mid-third-century Orpheus in the Catacomb of Domitilla (plate 1), and as the Good Shepherd. Both figures were current in the Hellenistic art of the time. Orpheus, with Phrygian cap and lyre taming the beasts, is a deliverance figure and is so delineated by Clement. Indeed, Clement's *Protrepticus* may well be the source for the transformation of this non-Christian form into the figure of Christ. The figure appears six times in the Roman catacombs, the oldest in St. Callixtus, from the beginning of the third century.

Although the transformation of the Orpheus figure has no scriptural base, that of the Good Shepherd obviously does (as in Psalms 23, 78, 80, 100, and in Isaiah, Jeremiah, Ezekiel, John, Matthew, Luke, Acts, 1 Peter, and Hebrews). Moreover, we know that the Twenty-third Psalm, with its shepherd imagery, was prominent in some of the ancient liturgies and was elaborated in Clement (*Paedagogus*, chap. 7). The figure is to be found in the catacombs, as in the ceiling of the cubiculum of the Velati in the Catacomb of Priscilla (plate 2), where it is surrounded by specific Christian symbols; in the Dura-Europos baptistry, along with Christian symbols; standing alone in a statuette from Asia Minor, which is now in the Cleveland Museum of Art (plate 3); in sarcophagi, as that from the Via Salaria, now in the Museo Pio Cristiano (plate 4), where the accompanying symbols are ambiguous. All of these are thought to date before the year 300.

In some instances, the use of the Good Shepherd image is directly associated with other Christian symbols, which confirms a Christian use or transformation. In other cases, it is ambiguous, as in the sarcophagus from the Via Salaria with Good Shepherd (plate 4). Here the shepherd carries a ram on his shoulders, and he looks at an orant. The bearded, barefoot man seated on the left is dressed as a philosopher. A discussion is apparently going on. The three major figures—shepherd, orant, and philosopher—belong both to the pagan classical world and, with a transformed meaning, to the Christian world.

Since the Orpheus and Shepherd iconographies spring from non-Christian sources, some interpreters see these figures as evidence of the Hellenization of Christianity. That Clement's writings, so anchored in the

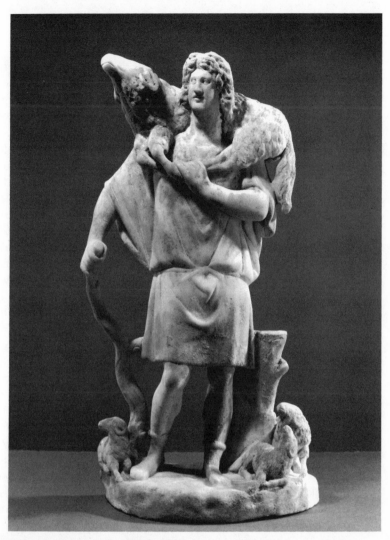

3. *Good Shepherd*, ca. 269–275

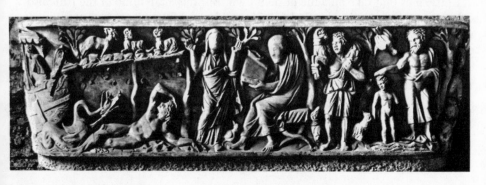

4. *Sarcophagus*, 3rd century

Hellenistic world, may be the source for the symbols and their transformation into a Christian form only confirms such interpreters in their position. A more adequate interpretation, however, seems to be that the Christian transformation of these symbols was successful because there was no other source for the visual than the late antique culture of the time. Artists and artisans do not start from scratch; they inherit a tradition which is transformed, so that the style becomes something new, and that occurs only with time. Western art and Byzantine art are built on the Greek tradition, however different they may appear to the untutored eye. The Orpheus and Good Shepherd images evoked belief in deliverance through Christ and the possibility of faith for non-Christians. Both images belonged to the symbol system of the time. When the culture was more dramatically formed by the victory of Christianity, the Orpheus iconography disappeared and the Good Shepherd symbol diminished in use. These symbols probably lost their original power because a more direct appropriation of the Christ figure took their place in an explicitly Christian culture developed after the time of Constantine.

The image of the Good Shepherd is emblematic—in the sense of evoking associations rather than depicting them—and it frequently is found with specific Christian symbols of deliverance. We know of instances in Rome that date from just after the mid-third century in which the Good Shepherd is particularly associated with Jonah. A sarcophagus in Santa Maria Antiqua (plate 5) portrays a seated figure reading, an orant, the Good Shepherd, Jonah, and a baptismal scene. Jonah is historically associated with both deliverance and baptism, as well as with the death and resurrection of Christ (Matthew 12:39–40). A sarcophagus in the Museo Pio Cristiano also has several Jonah scenes, an angler, a herdsman, Moses Striking the Rock, Noah's Ark, and the Raising of Lazarus (plate 6). In the small tomb of the Julii (known as tomb M) in the excavations of the necropolis under St. Peter's, the Good Shepherd is associated with Jonah, with an angler or a fisherman, with the vine, and with Christ as a Helios or Sun God. In these instances the Good Shepherd is associated with Christian themes that take on a life of their own. But the small tomb of the Julii also introduces another symbol for Christ, derived from the cult of the Invincible Sun. This figure is only partly preserved on the ceiling, but it is described from an earlier period as follows:

An octagonal panel in the center of a field of intertwined grapevines on a gold background contains the figure of Christ-Helios standing in a chariot pulled by four white horses (two of which are destroyed). This beardless figure has a rayed nimbus, wears a tunic and a cloak that billows behind him, and holds

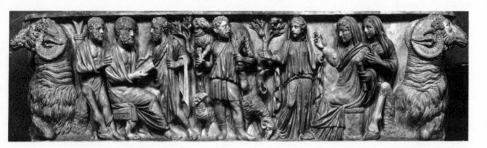

5. *Sarcophagus*, mid-3rd century

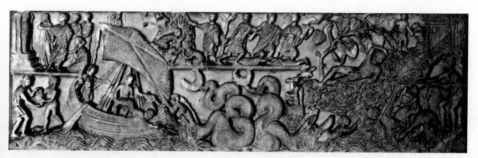

6. *Sarcophagus*, mid-3rd century

an orb in his left hand. His right hand, which is destroyed, was probably extended with palm open.[10]

Christ as Helios may be associated with ascension motifs, and a passage from Clement of Alexandria, called to my attention by Daniel Pater, shows that the image may well have been incorporated in Christian terms, as when the sun of righteousness "rides over the universe."

> For just as "if the sun were not, the world would have been in perpetual night, for all the other heavenly bodies could do"; so unless we had come to know the Word, and had been enlightened by His rays, we should have been in no way different from birds who are being crammed with food, fattening in darkness and reared for death. Let us admit the light, that we may admit God. Let us admit the light, and become disciples of the Lord. . . . Hail, O Light. Upon us who lay buried in darkness and shut up in the shadow of death a light shone forth from heaven, purer than the sun and sweeter than the life of earth. That light is life eternal, and whatsoever things partake of it, live. But night shrinks back from the light, and setting through fear, gives place to the day of the Lord. The universe has become sleepless light and the setting has turned into a rising. This is what was meant by "the new creation." For he who rides over the universe, "the sun of righteousness," visits mankind impartially, imitating His Father, who "causes His sun to rise upon all men," and sprinkles them all with the dew of truth. He it was who changed the setting into a rising, and crucified death into life; who having snatched man out of the jaws of destruction raised him to the sky, transplanting corruption to the soil of incorruption, and transformed earth into heaven. (Clement of Alexandria *Exhortationa to the Greeks*, chap. 11)

The sun symbolism is clear. Thus, to Christ as Orpheus and as the Good Shepherd may be added Christ in the language of the Sun God. All are instances of the transformation of previous symbols into a Christian context before the Constantinian period.

Three types of symbols may be said to be characteristic of this early period. First, there are heraldic symbols, or badges of identification, such as the chi-rho, the anchor, the fish, and so on. Second, there are figures such as Christ as Orpheus or as the Good Shepherd or as the Sun God, which show an identifiable function from antiquity in a new context. Finally, there are the specifically Christian subjects, with which the symbol of the Good Shepherd was increasingly associated. These subjects are to be found in the catacombs and sarcophagi, dating from the early third century.[11] We

[10] Kurt Weitzman, ed., *Age of Spirituality: Late Antique and Early Christian Art, Third to Seventh Century* (New York: Metropolitan Museum of Art; Princeton, NJ: Princeton University Press, 1979) 522. For additional representations, see 518–21.

[11] For an inventory of catacomb paintings in Rome, see Aldo Nestori, *Repertorio Topografico delle Pitture delle Catacombe Romane* (Rome: Pontificio Instituto de Archeologia

have already mentioned Moses Striking the Rock, Jonah, and the Raising of Lazarus as frequently encountered subjects. To this list may be added paintings of Daniel in the Lions' Den, the Sacrifice of Isaac, Three Men in the Fiery Furnace, Moses on Sinai, Job Forsaken by His Friends, the Visit of the Magi, the Wedding of Cana, healing miracles such as the Healing of the Paralytic, the Woman with an Issue of Blood, the Demoniac, the Blind Man, the Multiplication of the Loaves, and Christ and the Woman at the Well, the latter found already in the Catacomb of Praetextatus in the early third century (plate 7). In the catacombs, too, may be found a few eucharistic banquet scenes related, undoubtedly, to the occasional services in the catacombs on the anniversary of the death, interpreted as the birthday, of a significant saint.

This art of the paleo-Christian West does not feature crucifixion or resurrection or judgment; it focuses on deliverance through healing, on rescue from threatening natural and historical events, on sacramental signs. The typological prefiguration of Christ, which is later prominent, is evident only in sacramental figures such as Jonah and Moses. But a clue to the source for many of the subjects comes from various collections of materials that are meant to summarize the essentials of faith, prominent among which were prayers for the dead—indeed, the type of service that was held in the catacombs.[12] Such prayers "enumerate the precedents for divine intervention for one of the faithful, and express the desire that God may exercise the same benignity toward the person who is now dead: God, save him, as you saved Daniel, Noah, etc."[13] The liturgy and the paintings formed a whole.

Liturgical practice—or, in a Christian context, the liturgical form of a Gospel, such as the Gospel of John—may also be a clue to both the synagogue and Christian baptistry paintings in Dura-Europos. Dura-Europos, a Roman frontier fortress on the Euphrates River, was buried at the time of a Parthian attack and was not unearthed until excavations in the 1930s. Interpretations of the extensive synagogue paintings, which date from about 230, are varied and contradictory. These paintings refute all claims that Judaism did not have a tradition of art. An analysis by Joseph Gutmann shows that the wall paintings reflect "the history, vicissitudes and miracles of the ark" in terms of "an actual rabbinic liturgical hymn sung during worship." Continues Gutmann: "In the procession around the synagogue, the final resting place of the Torah ark was of course not the Temple

Christiana, 1975); and for the sarcophagi, see Friedrich Wilhelm Deickmann, *Repertorium der christlich-antiken Sarkophage* (2 vols.; Wiesbaden: F. Steiner, 1967).

[12] Weitzman, *Age of Spirituality*, 397.

[13] Andre Grabar, *Christian Iconography: A Study of Its Origins* (Princeton, NJ: Princeton University Press, 1968) 10.

of Solomon, but the synagogal Torah niche, the true repository of the syna-
gogal ark. The Biblical scenes serve here as pious anchors to secure the
continued function of the ark and its salvationary power within a new
context." [14] This form of Judaism, suggests Gutmann, substituted prayer for
sacrifice, believed in personal salvation, and used scripture as proof texts
rather than in a literal, historical way. Hence, although it remembered its
past, it celebrated God's continued presence religiously and liturgically,
rather than historically.

Apparently only the baptistry of the house church at Dura-Europos had
a full-fledged painting scheme, though at first sight the subjects seem too
disparate to form a unity. They include the Good Shepherd carrying a
sheep over his shoulder with numbers of sheep about. Below the Good
Shepherd is a scene with Adam and Eve and the serpent(s), though the
latter is considered an addition to the original paintings. There are scenes
of the Healing of the Paralytic (plate 8), Walking on the Water, the Woman
at the Well, David and Goliath, and, with considerable space devoted to
them, the Women at the Tomb. Carl Kraeling, who saw no single scheme
in the synagogue at Dura-Europos, is convincing in his pulling together of
most of the paintings in the baptistry, again by calling attention to bap-
tismal processions and practices. Kraeling writes:

> In the scene of the Woman at the Well the candidate is being taught to
> understand that as the Samaritan Woman who went out to draw water from
> Jacob's Well received the gift of "living water," so he does in connection with
> the water of baptism receive the "speaking and living water" of the divine
> revelation. In the scene of David and Goliath the candidate is being taught
> that as David was by virtue of his unction at the hands of Samuel enabled
> to overcome the might of Goliath, so he through the holy oil of baptism
> receives the divine power that guards him from and makes him superior to
> all evil Satanic powers. In the same way, in the scenes of the Women at the
> Tomb the candidate is being taught that as the women who went to Christ's
> Tomb to perform the pious act of anointing his body received from the three
> angelic visitors the assurance and the announcement of Christ's victory over
> Death, so he in and with the rite of baptism receives assurance of and has the
> experience of his own triumph over Death and participation in eternal life.[15]

It was noted previously that the Good Shepherd is associated with baptism,
but the reason for the inclusion of the Healing of the Paralytic and Walking
on the Water is not immediately self-evident. They belong to the mighty

[14] Gutmann, "Programmatic Painting in the Dura Synagogue," in *The Dura-Europos Syn-
agogue: A Re-evaluation (1932–1972)*, ed. Joseph Gutmann (Missoula, MT: Scholars Press,
1973) 149.
[15] Kraeling, with a contribution by C. Bradford Welles, *The Christian Building* (New
Haven, CT: Dura-Europos Publications, 1967) 196–97.

7. *Christ and the Samaritan Woman*, early 3rd century

8. *The Healing of the Paralytic*, ca. 230

works of God, but, as Kraeling points out, there is a passage in Origen's
Commentary on John that links the miracles and baptism as two parallel
activities of God, which thereby shows that there may have been traditions
linking the two (6.33). When interpreted in the light of the previous mate-
rials, additional sarcophagi and remnants of house churches in Rome repre-
sent two more pieces of evidence for art in the early church. The large
number of sarcophagi collected in the Museo Pio Cristiano, sarcophagi at
Arles, France, and the Adelphi sarcophagus in the National Museum of
Syracuse in Sicily disclose a tradition that surely did not emerge overnight.
The dating of many of the sarcophagi is not precise, but a good number
appear to come from the first third or half of the fourth century, that is,
when the Constantinian era was under way. We know that a few of them
antedate the Constantinian era. An examination of some twenty-five sar-
cophagi in the Museo Pio Cristiano discloses that particular scenes are
repeated in various combinations, chief of which are Christ and Peter
cycles, the latter obviously related to Peter's role in Rome. Listed in order
of frequency of appearance are, in addition to Christ and Peter, the Raising
of Lazarus, Abraham about to sacrifice Isaac, the nude Daniel between two
lions, the paralytic carrying his bed, Adam and Eve (usually thrust from
Paradise), the three wise men presenting gifts to the infant Christ seated on
the Virgin's lap, Christ's entry into Jerusalem, a woman orant, the vision
of Ezekiel, Jonah (as a separate figure rather than in a cycle of Jonah
episodes), and Moses Striking the Rock. Again, the figures are close to those
of the catacombs.

Although the house church found at Dura-Europos has no parallel,
traces of house churches in Rome provide collateral support to the notion
that such buildings contained works of art.[16] Churches were built on the
rubble of previous buildings, and in some instances previous houses had
been combined to provide a larger structure. Subsequently, the walls were
incorporated into or became the support for existing basilicas. Today we
may see such remains at the Church of San Martino ai Monti, and we surely
see them at SS. Giovanni e Paolo on the Caelian hill not far from the
Colosseum. Our conceptions of house churches are largely conditioned by
our notions of scale. Undoubtedly, many house churches were small, but
the houses upon which some basilicas were built belonged to relatively
wealthy individuals, some related to those in power. Therefore, we would
expect large houses among the titular churches, named after the owner or

[16] There are written references to churches in the East, many of which undoubtedly were
house churches. See Pierre Du Bourguet, *Early Christian Art* (New York: Reynal, 1971) 36.
See also Graydon F. Snyder, *Ante Pacem: Archaeological Evidence of Church Life before
Constantine* (Macon, GA: Mercer University Press, 1985).

donor of a building. Furthermore, at SS. Giovanni e Paolo traces of paintings remain, including an orant in a Christian context. Some of the pagan paintings here date from the second century, but the orant is undoubtedly later. Indeed, some scholars have argued that San Martino ai Monti and SS. Giovanni e Paolo date from the Constantinian era. The date of San Martino ai Monti is surely debatable but is probably late; SS. Giovanni e Paolo is surely early.[17] In any event, they do reflect a tradition that is now largely lost. It would be a mistake to rest a case for the visual arts in the early church on sarcophagi and remains of house churches that may date from the early Constantinian period, but when they are related to the other evidence and when one understands that artistic traditions do not emerge overnight, one sees that their role is not irrelevant.

It should be clear from the preceding that biblical materials, the writings of the church fathers, liturgical traditions, and sculpture and painting were interconnected in the period before the establishment of the church in 313. Since the period before the Constantinian era was one in which the church was in danger because its life was too public, it is interesting that so much has survived. Nevertheless, does enough survive to make it possible to make safe generalizations? Tentatively, one can say that the absence of representations of crucifixion and resurrection does fit the earlier stance of the church, one in which God's rescuing people from the powers of evil and destruction through miraculous acts is central. It is not that cross and resurrection were irrelevant; instead, what was accomplished by God came to the forefront among those who lived in the empire. Moreover, the paintings selected from scriptural and extracanonical sources seem to reflect liturgical manuals and practices. That this continued to be the case in still extant churches created after Constantine may provide a link between a church originally underground and a church increasingly accepted and given privilege in the empire.

It is not that the first centuries of the church were opposed to the visual but that the earliest works that survive reflect a situation in which religious art seems to have been taken for granted. There were no debates about the appropriateness of catacomb paintings, and the large scale of the synagogue paintings and the Christian baptistry scheme at Dura-Europos disclose no feeble effort but a major program. Stylistically, the catacomb paintings reflect a further departure from a Greek style already in decline, and the

[17] See A. Prandi, *The Basilica of Saints John and Paul on the Caelian Hill* (Rome, 1958). The explorations were carried out under the promotion of Francis Cardinal Spellman, cardinal titular of the basilica, with the assistance of the Honorable Joseph P. Kennedy. The saints for whom the church was named were probably martyrs of the fourth century rather than the apostles.

Dura-Europos paintings are like cartoons, with no known precedents. With the new encouragement that Christianity received from Constantine, it was natural that the number and quality of works would increase and that more of them would survive.

Art in the Post-Constantinian Church

Whereas the Christ figure had appeared earlier as the Good Shepherd, the Christian philosopher,[18] or a figure in a healing scene, in the post-Constantinian church Christ appears in scenes depicting his life. Illustrative of this type of subject matter is a sarcophagus from about 330 in the Museo Pio Cristiano, in which various events of Christ's life are depicted (plate 9). In the center is Christ healing the blind man, to the right the multiplication of loaves and fishes, then the entry into Jerusalem showing a youthful, beardless Christ wearing the garments of a philosopher, sitting on an ass, with his right hand raised in blessing and his left hand holding a scroll. Palms are being spread in front of the ass, and above that scene, in accordance with the biblical account, is a man in a tree, watching the events. On the left side is a depiction of the vision of Ezekiel and the dry bones and scenes from the life of Peter. Indeed, Peter is frequently represented along with the life of Christ, and is associated, along with Paul, with Rome.

Reflecting the self-conscious centrality of churchly Rome is the *traditio legis*, Christ giving the new law, that is, the Gospel with its authority, to Peter, while honoring Paul as the chief of the apostles. This subject was originally executed for St. Peter's, and, although that particular work is no longer extant, the subject does exist in various versions. The Metropolitan Museum of Art has a tomb relief with the giving of the law, apparently done in Rome between 375 and 400 (plate 10). The face of the central Christ figure is missing; the right arm is raised in the direction of Peter; and Paul looks toward the Christ figure from the other side. The bottom of a gold glass bowl that derives from Rome around the end of the fourth or the beginning of the fifth century, which is now in the Toledo Museum of Art, depicts the giving of the law.[19] Here the postures of the figures have the traditional format, but Christ, standing on a rock in Paradise, has short hair and is bearded. The theme is extant, perhaps as originally at St. Peter's, in the mosaic in the north apse of Santa Costanza in Rome.

There are also paintings and sculptures that feature episodes from the life of Christ. In the Museo Pio Cristiano is a frieze sarcophagus that dates from

[18] For two examples, see Weitzman, *Age of Spirituality*, 412, 415.
[19] For a description and a photographic reproduction, see Weitzman, *Age of Spirituality*, 559–60.

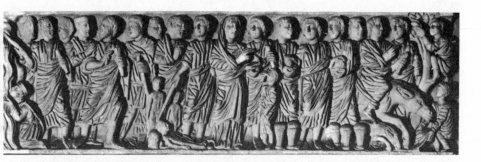

9. *Sarcophagus including Entry into Jerusalem*, ca. 330

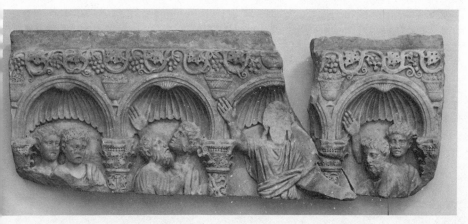

10. *Roman Tomb Relief with Traditio Legis*, late 4th century

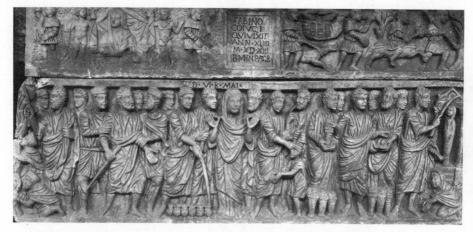

11. *Sarcophagus*, ca. 315–325

12. *Sarcophagus of Junius Bassus*, ca. 359

about 315–325 in Rome, with cycles of both Christ and Peter events. The Christ cycle, with Christ youthful and beardless, centers on the miracles of the New Testament (plate 11). Perhaps best known is the Sarcophagus of Junius Bassus in the Treasury of St. Peter's, dating from before 359 (plate 12). Here Christ, young and beardless, with a scroll in his left hand, is sitting on a throne over the bearded classical sky-god Caelus with the cloth of heaven, holding a scroll in his left hand.[20] The scenes from the Old Testament relate to the New. Prominence is given to Adam and Eve, Job, the Sacrifice of Isaac, and most of the scenes noted previously in discussing catacomb subjects. The New Testament events are largely passion events, leading up to but not including the crucifixion.

The cycle of Christ events was most extensively portrayed in paintings in churches. We know that Pope Leo the Great in the mid-fifth century believed that cycles of paintings should be on the walls of churches as a means of instructing converts and believers. Indeed, he was "responsible for having the nave walls of the three great fourth-century churches painted with Biblical cycles: one at St. Peter's; another at S. Paolo Fuori le Mura, where the collapse of part of the fourth-century nave in 441 led to its rebuilding and redecoration; a third, presumably, in Constantine's Lateran Basilica. All are lost and only the first two, repainted in the Middle Ages, are reflected in late copies."[21] In Santa Maria Maggiore, erected by the previous pope, Sixtus III, some forty-two panels executed before 440 representing Old Testament episodes and scenes from the infancy of Christ, are still to be seen on the triumphal arch (plate 13).

In Santa Sabina, the walls and apse were covered with mosaics, but these have disappeared. The cyprus doors, dating from about 432–440, are well preserved, though the panels were rearranged. There are major scenes from the Old Testament, including Elijah, Habakkuk, and Daniel. Christ is bearded, and most of the scenes have to do with the passion and its resolution. Here also appear the Crucifixion (plate 14), the Ascension, and Christ flanked by alpha and omega in accord with Revelation 12:12–13. Although the cross appeared occasionally prior to this period (for example, on a sarcophagus lid with Joseph scenes and the Adoration of the Magi from about 360, located in a public area just beneath St. Peter's [plate 15], or in five different sarcophagi in the Museo Pio Cristiano), we know of no crucifixion scenes from that early a date. The sign of the cross is not yet the

[20] In early Christian art two types of Christ are seen: one bearded, mature, and with shoulder-length hair; the other youthful, unbearded, and with short hair. The tradition of the unbearded Christ continues in Italian art, as is seen in Leonardo's Christ of the Last Supper and Michelangelo's Christ of the Last Judgment.

[21] Richard Krautheimer, *Rome: Profile of a City, 312–1308* (Princeton, NJ: Princeton University Press, 1980) 51.

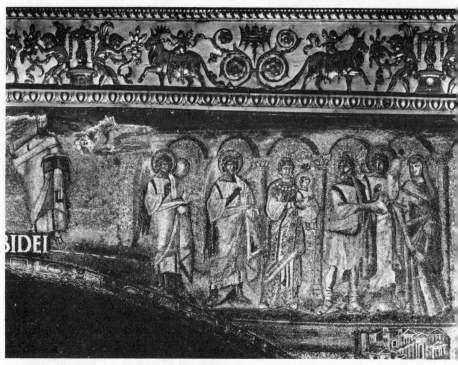

13. *Infancy Scene of Life of Christ*, 5th century

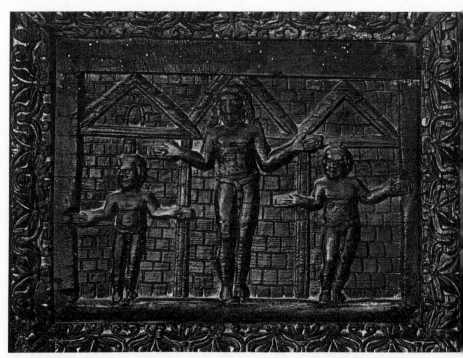

14. *The Crucifixion*, ca. 432–440

crucifixion. The crucifixion is depicted on the doors of Santa Sabina and on an ivory casket of four carved plaques in which the passion is featured, dating from about 420–430 in Rome and now in the British Museum, but such representations are rare. Only from the sixth century on do crucifixion scenes appear with some regularity.

A liturgical object with scenes in which Christ is central, though the subject of the scenes is debated, is *The Chalice of Antioch* (plate 16), possibly executed in Syria or environs before 550 and now in The Cloisters Collection of The Metropolitan Museum. It is surprising that Christ is represented in two versions, one without beard and one with, as if both Western and Eastern propensities were present. Christ with an eagle and a lamb is usually interpreted as the risen Christ, and, if this allusion is correct, it may well be one of the earliest depictions of the resurrection. Recently, however, there have been some challenges to the antiquity of the chalice itself.

A further development shows the Christ figure standing alone. Two such early representations are interesting, even though we know of no others like them. One is a statuette of Christ (plate 17), probably from the eastern Mediterranean from 370–380 and now in the Museo Nazionale Romano, Rome. Beardless, seated, wearing the tunic of the philosopher, hair falling to the shoulders, open scroll in left hand, the right hand apparently making a speaking gesture, this Christ figure represents the teacher of the true philosophy, so extensively elaborated by some of the church fathers. The philosopher Christ here develops into the Christ in majesty. The second instance, from approximately the same date, is a panel with a bust of Christ, now in the Museum at Ostia Antica (plate 18). Here the Christ figure with nimbus has long hair and heavy beard. It is the type that becomes Christ the Pantocrator, so prominent in Eastern churches. In the West, its equivalent is Christ enthroned, as in the triumphal arches of Santa Maria Maggiore and Santa Pudenziana. On the triumphal arch of Santa Maria Maggiore, Christ appears in the form of a young emperor, seated rather insecurely on a wide throne, with nimbus and small cross, attended by four chamberlains in the forms of angels (plate 19). Emile Mâle has shown—conclusively, I think—that the youth of Christ is related to the Council of Ephesus in 451, in which Nestorius was condemned. The emphasis falls not on Mary as the Mother of God but on Christ, who from the beginning had the role of God, which affirms that he was not adopted later for such purposes.[22] In the Santa Pudenziana apse mosaic, before 417, Christ sits securely and serenely on a throne, visibly the center of all (plate 20). On both sides of Christ are the apostles, wearing the togas of Roman senators. Behind the apostles are two female figures, one representing the church of the Gentiles and the

[22] Emile Mâle, *The Early Churches of Rome* (London: Ernest Benn, 1960) 63ff.

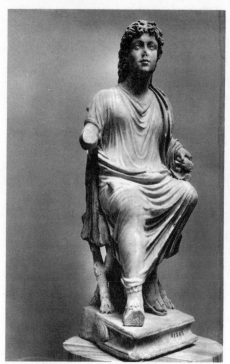

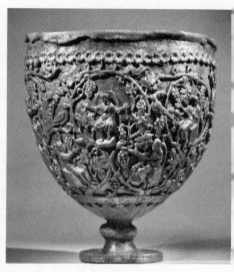

16. *Chalice of Antioch*, ca. 550

17. *Statuette of Christ*, ca. 370–380

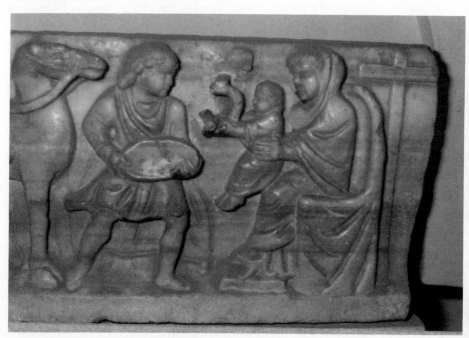

15. *Sarcophagus with Cross*, ca. 360

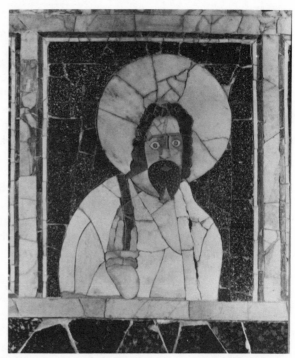

18. *Panel with Bust of Christ,* late 4th century

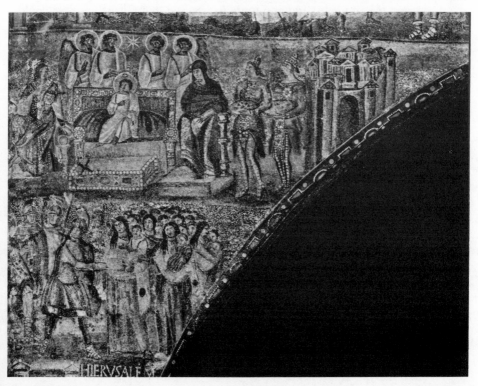

19. *Christ,* 5th century

other the circumcision. Above Christ's head is a huge cross surrounded by the symbols of the evangelists, and between the two zones are palatial buildings, representing probably both church and state.

In the apse mosaic of SS. Cosma e Damiano (plate 21), near the entrance to the Roman forum and dating from about 530, the reigning Christ also appears as judge, standing on the clouds, which reflects in particular the passage from Matthew 24:30, "And then . . . they shall see the Son of Man coming in the clouds of heaven with power and great glory." St. Peter and St. Paul present the titular saints of the church, St. Cosma and St. Damian, to Christ; below is the mystical lamb (now hidden by the baldacchino) beside twelve sheep representing the twelve apostles. Historically, this apse mosaic became the model for subsequent churches, most notably in the apse of Santa Prassede in the ninth century.

The changes in the depiction of the Christ figure reflect the changing fortunes of the church from its obscure beginnings to its central role in society. The previous images of the Good Shepherd disappear, though the concept does not. On the other hand, images of Christ in many forms become a part of biblical cycles generally. The central role of the church in forming and increasingly ruling society is reflected in the image of Christ enthroned, reigning in and over the world. The transition from the shepherd whose role was to protect those in trouble to the reigning Christ symbolized the emancipating and more secure role that Christians now could enjoy. Only later did this formative new concept create problems—indeed, even oppressive consequences.

In churches of both the East and the West, iconographic programs of the fifth and sixth centuries included several ingredients, namely, biblical cycles, liturgical elements, and the reigning Christ. Given the destruction and transformation of so much in the churches of Rome, one inevitably turns to a church with an Eastern spirit, San Vitale in Ravenna,[23] whose exquisite mosaics derive from a brief period of historic glory, for a picture of how such ingredients are combined in one coherent vision. Two features, however, distinguish it from churches in the West. First, in Byzantine art the biblical cycles are woven into both sacramental and imperial patterns, whereas in the West biblical cycles represent a different social context, though they frequently too have a liturgical base. Second, in the East the emperor has a special role as the only lay person who is permitted to function in the liturgical acts, though his role is as a representative of the people.

San Vitale, dedicated in 548, is liturgically sacramental, the mosaics

[23] There are many volumes on the Ravenna mosaics, but one of the best is still Otto G. von Simson, *Sacred Fortress: Byzantine Art and Statecraft in the Making* (Chicago: University of Chicago Press, 1948).

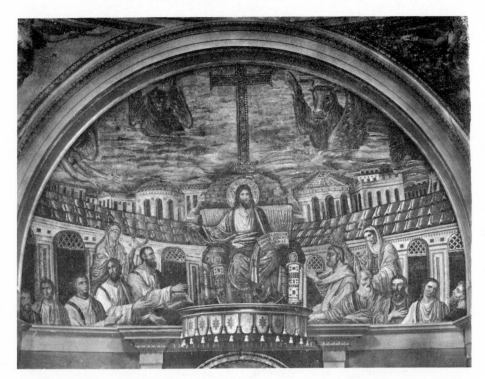

20. *Christ,* before 417

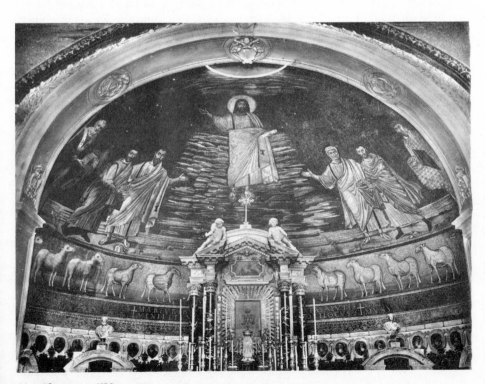

21. *Christ,* ca. 530

representing what transpires in the sacramental rites—chiefly the offering of the people and Christ's offering of himself for the people. At the center of the dome is the Lamb of God, symbol in both East and West of the eucharistic offering. Over the pillars under the dome which support the galleries and on a plane of sight that moves toward the altar are two mosaics of special eucharistic import. The mosaic on the left as one faces the altar shows Sarah and Abraham with the three angels appearing to him in the Valley of Mamre (Genesis 18). The three angels are behind a table, reminiscent of early altars, and, on the table, the three cakes Sarah has prepared have the sign of the cross on them. To the right of the table, a towering Abraham is about to sacrifice the diminutive Isaac, with a lamb looking back at both (plate 22). On the right wall as one faces the main altar, Abel and Melchizedek stand on opposite sides of an altar, Abel offering a lamb and Melchizedek bread and wine. On the altar are a chalice and two loaves of bread, and above the altar is the hand of God, symbolizing both God's presence and God's acceptance of the offerings (plate 23). The various symbols that accompany the figures leave no doubt of the typological meanings.

In the apse mosaic, the reigning Christ, sitting on a globe with the Book of Life in his left hand and offering a wreath with his right, receives the saint of the church and the donor, both of whom are presented to Christ by an angel. The double motif of giving and receiving is again present. On the two chancel sides are, of course, San Vitale's most famous mosaics, the one on the left representing Justinian and his entourage with the archbishop Maximianus (plate 24), and on the right Theodora with her entourage. In both instances, the scene is an offertory one in which Justinian holds the vessel in which the paten is present, and Theodora the vessel for the wine. Theologically the offertory is a sacrifice, a gift that presents one before God, who in turn is given to us through the bread and wine. Indeed, the offertory was a central part of the liturgy.[24] In the East, the emperor—and, at San Vitale, the empress too—represented the people, whereas in the West an offertory procession of the laity was part of the service until the Middle Ages.

San Vitale represents the full merger of church and state. Justinian is depicted as presenting gifts before God just as had Abraham, Abel, and Melchizedek; at the same time, Melchizedek and other biblical figures are shown in both priestly and imperial regalia. The latter form is the only one that Justinian knew, namely, the emperor's role as representative of both people and God. That societal form is far from the sensibilities of Western

[24] At the Consultation on the Arts and Theological Education at Emory University in December 1985, Arnold Klukas told me that the mosaic scheme at San Vitale represents an exact rendering of the liturgy. One hopes that his manuscript on this topic will soon be published.

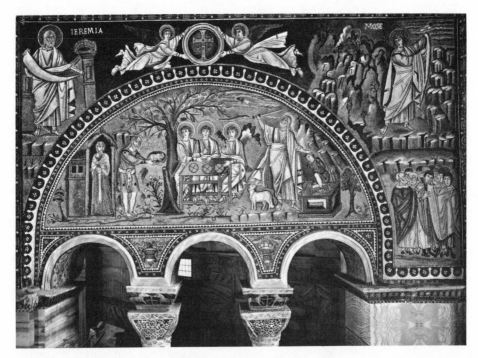

22. *Abraham and the Angels,* and *The Sacrifice of Isaac,* 548

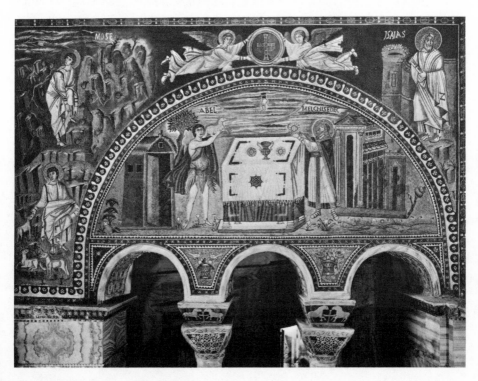

23. *Abel and Melchizedek,* 548

democratic traditions, but it shows an achievement in which the heavenly and earthly are intertwined. In the East, that intertwining coalesced the concerns of church and state. In the West, the tension between the two is not overcome, even as society's role is largely shaped by the church, including its own imperial mode. The formative power of the church is expressed through its own independent life, even when the papacy wields imperial power. Both East and West represent a Christianity that could and did form society. Those who are inclined to look back overemphasize both the achievements and the shortcomings of these societies. Christianity looks, and probably is, purer when it is not the dominating factor in a culture or is not on the defensive. Whether or not that makes a better world is a different question. Moreover, despite efforts we may undertake, society essentially presents to us the alternatives with which we have to grapple.

The frontal, reigning posture of both the emperor and the Christ figure, particularly in the East, signifies God's presence in the world. By analogy it was believed that the center of the Christian faith was expressed in the representation of that presence and in the holiness of persons and objects associated with them. Christian faith was the imitation of Christ, representing the holy, the invisible God made manifest in the world. Emperor, priest, and lay persons were made one in one quest. Those who devoted all their energies to the quest created a new class of individuals, desert monks who were freed of all but the minimal requirements for staying alive. The apparent attractiveness of such physical holiness led numbers of government and church officials to become monks. This monastic development, the emergence of the holy man, is part of a Christianity that believes that God's transformative presence is actual, even physical. God is present in the things of this world—through the sacraments, through holy persons, through things associated with the holy ones. Two developments associated with this outlook influenced the role of the arts, namely, the emergence of the icon and the role of the relics of the saints.

In the Eastern Orthodox Church it was assumed that an icon makes present that which it images. An icon allows for the possibility of the presence of Christ or the saint to the believer. This is not to say that the image is identical with the sacred reality, but that the sacred reality of Christ or the saint is present through the icon. In this sense, an image is like a sacrament. The icons are viewed spiritually, not aesthetically. A frontal style with a search for transparency characterizes these images of the saints. Thus, the style is appropriate to their function, namely, to make present without idolatry. Veneration—not worship, in which the iconic object and the reality are confused—is alone appropriate to the icon. But nothing less than veneration is appropriate, for God's holy presence and power are present through holy persons and that which represents them. Sight and

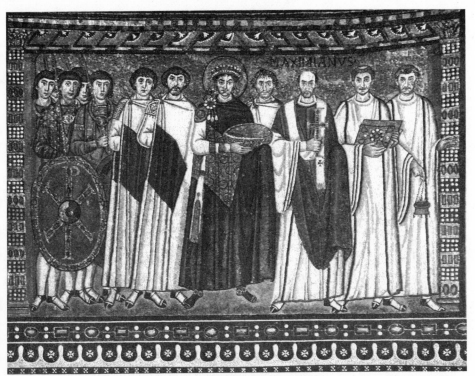

24. *Justinian, Julianus Argentarius, and Maximianus, 548*

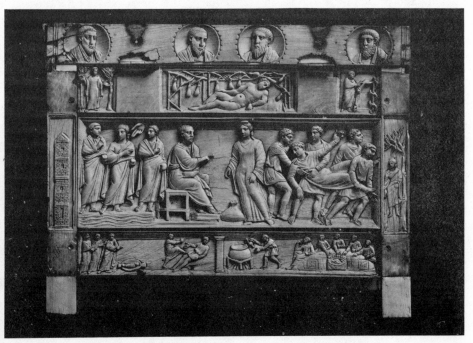

25. *Reliquary Casket, ca. 360–370*

touch—the kissing of the icon—are the modes of veneration and appropriation. Because of the holiness inherent in the saints and martyrs, their remains and the objects connected with them were felt to be worthy of honor and veneration and were believed to be full of deliverance and healing power. Here too sight and touch became important. The result was that the skeletal remains of the saints, martyrs, and apostles, including the fragments believed to be from the original cross of Christ, were prized. Churches vied for the full and partial remains. Reliquaries of exquisite design became the deposit boxes for bones, etc. of favorite saints. Such caskets for relics (*lipsanotheca*) had scenes from both the Old and the New Testament on the exterior surfaces, as is evident in an ivory casket from about 360–370 in Brescia, Italy (plate 25).[25]

When Islam spread over much of the East, Eastern clerics and monks brought many relics with them to the West, where they became increasingly important. The northern countries of Europe had been Christianized, partly through missionary activities and partly as the result of invasions from the north. These countries were converted so quickly that the faith itself could not form their lives. Christianity had been a teaching religion, and its heroes had been bishop theologians such as Ambrose and Augustine. Now there were masses of individuals attracted to the faith who needed the teaching services of the church. Such was the situation Pope Gregory the Great faced, and this is the background for his vigorous program of teaching and preaching in the Latin vernacular to the uneducated of his time. Even his statement that paintings were the Bible of the illiterate needs to be understood in this setting, for paintings, together with his preaching, were utilized in the assimilation, if not the transformation, of vast numbers of new Christians. The new group of Christians, without knowledge of the more rational classical thought and forms that had helped mold previous Christians in the West, lived in an ambiance in which things seen and felt formed their lives. In that setting, the emphasis on relics, already present in the East, was intensified.

[25] See Wolfgang Fritz Volbach, *Early Christian Art* (New York: Harry N. Abrams, 1961) 328, for a full description and plates 88 and 89.

2

MEDIEVAL, RENAISSANCE,
AND LUTHERAN DEVELOPMENTS

THE EMERGING MEDIEVAL world simultaneously embraced sophisticated theological developments and the religious sensibilities that centered on the intercession of the saints and the power of religious objects associated with them. Just as the Eucharist was considered to be the embodiment of Christ, visible to the eye and perceptible to the taste, so the sculptures and paintings of saints were real embodiments through which and with which one prayed to God for assistance and deliverance. The relics associated with Christ and the saints were present to be seen, possibly even touched, and their healing power was assumed. Since the relics were distributed far and wide among the churches and since their power was sought, pilgrimages and pilgrimage churches resulted. Four pilgrimage routes in France converged in Spain in one road that led to the tomb of St. James at Santiago de Compostela in northeastern Spain. Things and places coalesced in the religious imagination, with the result that the popular imagination could easily be stirred to crusades bent on wresting the holy places and objects of the Holy Land from Islamic control. The preaching and proclamation of political movements centered on holy places and things, creating unquestioning and enthusiastic support. Simultaneously, this popular piety was channeled through monastic education and learning, through the erection of major churches as centers of community life and through cathedral schools, some of which became universities.

The visual arts of the medieval world reflect this diversity. On the one hand, popular piety focused more and more on the visual to the virtual neglect of verbal comprehension. Indeed, seeing was so compelling that it seemed possible to live a Christian life through pilgrimages and the observation of relics without regard to conduct or thought. This development meant that many individuals crossed the line that separated magic and

idolatry from symbols. On the other hand, theologies and educational institutions were developing at a rapid pace. Sometimes the two strands existed side by side, and sometimes they were intermingled.

The Carolingian View of Art

The few wall paintings and frescoes that existed in the major Carolingian churches of the time have disappeared. Only a few objects remain. We know that in Charlemagne's world the arts did not play a central role. Like Pope Gregory the Great, Charlemagne accepted the commemorative, teaching, and decorative functions of art, but he was opposed to the veneration of images. Paintings are worthwhile, he stated, but they do not have the value of books. With respect to the Eastern iconoclastic controversy, his court took a middle road.

Carolingian art was primarily didactic, dedicated to telling a story, and so it was free of potential magical associations. Art that merely illustrated a place in a manuscript was not prized, for the text was considered sufficient. It was felt that art works should provide a text of their own. Nor was beauty considered valid in its own right. Yet manuscripts and their illustrations, apparently in violation of the official viewpoint, were the principal materials that survived. Apart from the manuscripts, we do find some other materials in the Aachen cathedral. Here we see Charlemagne's marble throne, which dates from the early eleventh century: a golden altar frontal with reliefs, with the reigning Christ in the center, surrounded by scenes of the passion, including the crucifixion. The gilded front of the pulpit is also from the early eleventh century (plate 26). In the Treasury, not far from the cathedral entrance, is the Lothar gold cross, dating from about 990. On one side are the crucifixion with trinitarian symbolism, the hand of God, and the dove, all exquisitely designed; on the other side are a cameo of Augustus and uncut jewels covering the entire surface.

In many ways things, not images, were at the center of the Carolingian world. Images were not denied, but they were considered to be the "heresy of the Greeks." Patrick J. Geary, quoting from the *Libri Carolini*, writes: "They [the Greeks] place almost all the hope of their credulity in images, but it remains firm that we venerate the saints in their bodies or better in their relics, or even in their clothing, in the ancient tradition of the Fathers." Geary then adds his own comments: "The author of the *Libri* insists further that there could be no equality between relics and images, since relics alone would share in the resurrection at the end of the world. Images might be more or less faithful representations and more or less beautiful, but they could have only a didactic function. Any greater honor or veneration was

26. *Gilded Pulpit*, early 11th century

reserved for relics alone." [1] The implication here is that, although subsequent generations became suspicious of images, they did so largely because they saw them as objects similar to relics. Perhaps this is because seeing relics directly united the image and the reality. That is, the image was transformed into a relic; it was literalized. For example, in the consecration of churches, a relic was to be placed in the cornerstone of the building, along with consecrated bread. If a relic could not be found, the consecrated bread alone sufficed as a relic. The doctrine of transubstantiation reflects this approach, as does the elevation of the host. Geary adds that this use of relics actually was intended to be a wedge separating the masses from paganism and magic. Relics were intended to be seen as icons. Nevertheless, this theology of seeing made the visual arts difficult for the later medieval and Reformation periods to interpret and accept.

Bernard of Clairvaux, Abbot Suger, and Bonaventure

In the first half of the twelfth century, diverging views of the arts emerged respectively in Bernard of Clairvaux and Abbot Suger. Bernard justified war against the "infidels" and preached the Second Crusade; yet he wrote to Abbot William of St. Thierry lamenting the size and costliness of churches. Moreover, he was upset by the costliness of the "relics cased in gold," by the kissing of gaudily painted saints instead of honoring their sanctity, by the bizarre creation of monstrous creatures that tempted the faithful to read marble sculpture rather than books. He concluded that "the church is resplendent in her walls, beggarly in her poor; she clothes her stones in gold, and leaves her sons naked; the rich man's eye is fed at the expense of the indigent. The curious find their delight here, yet the needy find no relief." [2] Bernard of Clairvaux did not challenge art or the saints or the relics or the pilgrimages. He objected to excess, to an opulence that both blinded individuals to the reality beneath the forms and diverted resources away from the poor.

It was in the work and thought of Abbot Suger that opulence became a vehicle for honoring God in new forms. Suger was obsessed by jewels and precious stones: he sought them from the wealthy and asked clerics to donate stones, which he then incorporated into liturgical objects, for example, the

[1] Patrick J. Geary, "The Ninth-Century Relic Trade," in *Religion and the People, 800–1700*, ed. James Obelkevich (Chapel Hill: The University of North Carolina Press, 1979) 13.

[2] Quoted in Elizabeth Gilmore Holt, *A Documentary History of Art* (Garden City, NY: Doubleday, Anchor Books, 1957) 1:20.

famous large golden cross made for the church at St. Denis. Emile Mâle has written of the cross:

> It was intended to mark the holy place where St. Denis and his two companions had originally been buried. It could be seen from all parts of the church, for it was almost seven meters high. A large golden Christ, whose wounds were rubies, was fixed to the dazzling jewel-incrusted cross. A tall square pillar supported the cross, and this pillar itself was a marvel. On each face it was decorated with seventeen enamels in which the events in the life of Christ paralleled the scenes from the Old Testament which prefigured them; at the pedestal, the four evangelists wrote the story of the Passion, and at the top, four mysterious figures contemplated the death of the Saviour. Five, and sometimes seven, goldsmiths had worked for two years on this masterpiece.[3]

Suger had at least two reasons for his interest in precious stones. First, he believed that one honored God by artistic processes in which style and materials were both at their best. Before God one could not be too opulent. Second, the stones reflected light; like the light of God, they were both source and reality, needing nothing except themselves. Material things led to spiritual understanding.

Although Bernard of Clairvaux and Abbot Suger clearly parted ways on the issue of particular art objects, they seemed in accord in their conceptions of public as distinguished from monastic architecture. Bernard found Cluny too pretentious in both its art and its architecture—that is, "soaring heights and extravagant lengths and unnecessary width of the churches, . . . their expensive decorations and their novel images."[4] He believed in a chaste but ample architecture, full of light and relatively free of the visual arts. For him architecture took precedence over the other visual arts. He believed that monks, educated and dedicated as they were expected to be, did not need props, but only an appropriate place—though when one says appropriate place, one does not imply a mean one. At the same time, he believed that bishops, and the church at large as distinguished from monastic communities, faced issues of faith in which the visual arts were essential. Bernard wrote to Abbot William:

> It is not the same for monks and bishops. Bishops have a duty toward both wise and foolish. They have to make use of material ornamentation to rouse devotion in a carnal people, incapable of spiritual things. But we no longer

[3] Emile Mâle, *Religious Art in France. The Twelfth Century: A Study of the Origins of Medieval Iconography* (Princeton, NJ: Princeton University Press, 1978) 155.

[4] Bernard of Clairvaux, "An Apologia to Abbot William," in *The Works of Bernard of Clairvaux* (Shannon: Irish University Press, 1970) 1:63.

belong to such people. For the sake of Christ we have abandoned all the world holds valuable and attractive. All that is beautiful in sight and sound we have left behind, all that is pleasant to taste and touch. To win Christ we have reckoned bodily enjoyments as dung.[5]

Given that approach, it is understandable that Bernard and Suger, particularly in their later years, were close friends. St. Denis, although a monastic foundation, also had a public function, one with a close relation to the crown. It was expected that the visual would play a role, though Bernard's interest was primarily in the architectural sphere. On the subject of architecture, Bernard and Suger were probably in substantial agreement. For both of them light was at once substance and medium. All things reflected their source, the light that is God and God's emanation. All of creation mirrors God, but in different gradations. Neo-Platonist in source, such a conception had a long history, dating back to Augustine. But in Augustine, Neo-Platonic concepts were related to harmony and mathematics, that is, to proportion. For this reason Augustine was most interested in music and architecture; the visual arts exhibited a world of images he largely distrusted. Similarly, Bernard was interested in music and architecture, both areas in which harmony was present. In architecture, mathematical harmony and light coincided, particularly in the self-consciously created Gothic cathedrals.

The emphasis on light received a major boost through the writing of the Pseudo-Dionysius. Apart from what the documents say, they carry additional weight through a series of wrong identifications. For example, the local saint, St. Denis, is identified with the sixth-century monk who wrote the documents and who in turn was identified with Dionysius the Areopagite in the book of Acts. Impressed by light as the modality for knowing and experiencing God, with light as the source and form of God's presence, Suger set out to form an appropriate building. Elevating the building by the new technique of rib vaulting, Suger was able to add windows that brought in light by developing stained glass to fill the membranes between the supports. Solid walls were no longer necessary to support the vaulting. Thus the extensive window spaces brought light into the building and provided the setting for the stained glass windows wherein a new iconography was developed at Suger's church at St. Denis. Later examples, such as the Genealogy of Christ window at Chartres (plate 27), derive from the iconography at St. Denis. Suger also transformed the portal entrances by creating a more ample space for the tympanum and by bringing competent artisans from southern France to do the carving.

[5] Ibid, 64.

27. *Geneology of Christ* or *Tree of Jesse*, 13th century

Although relatively little remains of what Suger directly created and intended for St. Denis—since the restoration was poorly done—his thought and work are evident throughout the cathedrals built in the area known as the Île de France, for example, Notre Dame in Paris. Few, if any, individuals have so changed the course of both architecture and art as Suger. On the inside, the Gothic cathedral, with its accent on light, was considered a type of the kingdom to come, a token of heaven on earth. The ambulatory and chapels, made possible by the new rib vaulting system, created an ambience more adequately incorporating the various saints dear to a particular place. The tympanum became the focal exterior expression of God's reign in Christ, expressed through portrayals of judgment, ascension, resurrection, or other central motifs of Christ's work.

In both the tympanum and the stained glass, great pains were taken to associate Old and New Testament figures and events with each other. Biblical, liturgical, and occasionally typological allusions were part of the history of the church, but only as a result of Suger's careful studies and iconographical programs did extensive typological correlations find their way into the new Gothic developments. Narrative had come fully into its own. The Gothic, although based on previous architectural models, was a new creation—indeed, the first time a particular Christian viewpoint had so thoroughly influenced the emergence of a unique style. Space, light, and narrative were combined in new ways.

Although windows and sculpture were congenial to this new architecture, painting was not. The wall paintings that once had covered many of the interiors of Romanesque and Byzantine churches were replaced by narratives and dogmatic imagery in stained glass. The result, as Otto von Simson has pointed out, was that the walls that remained were relatively light, as if themselves porous.[6] Whereas the Romanesque and modified Romanesque churches were examples of the focusing of light on particular points, the Gothic achievement was the suffusion of light throughout the building.

Despite the objection of some at the time, stained glass became dominant in churches from the Gothic period on. It was a medium that most Protestants could accept. The scenes on the glass were educational in the midst of their attractiveness, serving positive purposes relatively free from veneration, worship, or idolatry. Light came through the windows—from a source other than the object itself. Seeing and reality could not be identified, as in the case of relics. Such art could teach without being dangerous.

Suger left his mark both by what he thought and by what he did. A

[6] Otto von Simson, *The Gothic Cathedral* (New York: Harper Torchbooks, 1956, 1962) 3ff.

theological synthesis of the various views of the visual arts, or of images, is to be found in the thirteenth-century Bonaventure. He stated that the visual arts give us an open scripture, one open and visible to all, accessible to those who are uneducated and cannot read. Images, accompanied by preaching and teaching, could serve as a substitute for scripture for those who could not read. Bonaventure also declared that images "were introduced because of the sluggishness of our affections, so that men who are not aroused to devotion when they hear with the ear about those things which Christ has done for us will at the least be inspired when they see the same things in figures and pictures, present, as it were, to their bodily eyes. For our emotion is aroused more by what is seen than by what is heard." He also held that images "were introduced on account of the transitory nature of memory, because those things which are only heard fall into oblivion more easily than those things which are seen" (*Sententiarum* 3.12).[7] These suggestions, however, tell us more about the perceptions of the time than about the power of the visual throughout history. Our situation stands in marked contrast, for the educated ignorant can now read scripture but not the paintings or stained glass windows; revivals of faith and devotion have come from words not pictures; and more individuals remember what they have heard than what they have seen—unless it be nightmarish in quality. Around us, of course, is a seeing, popular culture, from television to public extravaganzas. Another turn of the cultural wheel may be taking place, but it seems to be scarcely one that restores depth of perception.

Although Bonaventure's claims brought together a long history of thought on the visual arts, it must be emphasized that they presuppose a clear defense of images as worthy of adoration, not because one can simply identify the image and its prototype but because the divine reality is manifest in the image. Such thinking is similar to the Eastern conception of the icon. It is also a way of thinking that sees God in and through material images, which in fact does not see a spiritual world apart from its embodiment. It is fully incarnational.

Bonaventure directly influenced the subjects of the St. Francis cycle in the upper church at Assisi. A Franciscan himself, Bonaventure was commissioned by the Chapter of Narbonne to write the official account of the life

[7] Quoted in Charles Garside, Jr., *Zwingli and the Arts* (New Haven, CT: Yale University Press, 1966) 91. Margaret R. Miles quotes a similar text from John of Genoa's *Catholicon*, a standard dictionary of the period (*Image as Insight: Visual Understanding in Western Christianity and Secular Culture* [Boston: Beacon, 1985] 66). See also the work of Bishop Durandus of Mende, whom Emile Mâle features in his *Religious Art in France. The Thirteenth Century: A Study of Medieval Iconography and Its Sources* (Bollingen Series 90.2; Princeton, NJ: Princeton University Press, 1984).

of St. Francis, and all other accounts were to be destroyed. In this life of St. Francis, the *Legenda Maior*, the emphasis is less on poverty, simplicity, and doubts about papal positions than on St. Francis as the earthly, true image of Christ. The stigmata is the final sign of the oneness that exists between them. It follows that both the life and the paintings are not to be interpreted in the narrative sense but rather as episodes of significance, that is, a life theologically viewed. So understood, the twenty-eight scenes from the life of St. Francis directly reflect Bonaventure's work, and appropriate texts from the work are shown beneath the painting, though they are now only partially visible (plate 28).

Renaissance Art: Michelangelo, Raphael, and Grünewald

Two additional developments demand attention: Flemish art of the fifteenth century and the High Renaissance art in the beginning of the sixteenth century. Although they need to be understood in their own time, they have also been interpreted as harbingers of the modern secular world. Flemish painting, as in Jan van Eyck (plate 29), is full of liturgical references, and most of it was executed for chapels in buildings or altars in churches. Nature and cityscapes, both frequently seen through the windows of buildings, form part of the context, but they have no significance in themselves, as they do in later painting traditions. Rather, they are subsidiary to the main liturgical and theological meaning, usually related to the Mass and other liturgical acts associated with the altar. In this sense, they are thoroughly medieval, even though as moderns we may see only a human scene in nature or in a city, without recognizing the plethora of liturgical symbols. It is perhaps our secular seeing rather than the paintings themselves that characterizes them as secular. For the Flemish artists, the natural and the supernatural were so intertwined that nature had no meaning in itself. Nature was the natural habitat of the supernatural. Individuals did not flee the natural; the supernatural was present, transforming the natural.

In Renaissance art, the natural is writ large, but not without a religious understanding. The recovery of the antique world of Greece through literature and archaeological remains was intoxicating. But that vital humanity, a past on which they drew for their own conceptions, was a humanity that understood itself as participating in and mirroring the creativity of God. The Renaissance was a world in which individuals discovered new powers and vitalities, a world in which they felt affinity at one and the same time with the vitalities around them and with God as their creative ground. In art, this manifested itself in a new accent on the delineation of the human figure in all of its inherent beauty and in the discovery of perspective, a way

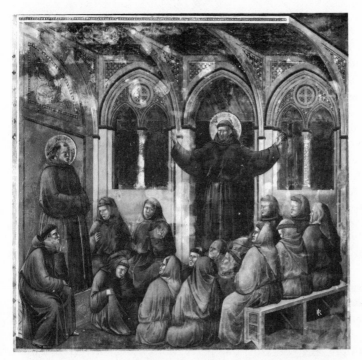

28. Attributed to Giotto di Bondone, *St. Francis Appearing to St. Anthony*, late 1280s

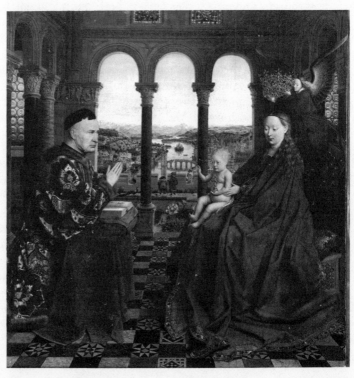

29. Jan van Eyck, *Madonna of Chancellor Rolin*, 1433–1434

in which nature and humanity were coherently related to each other. Beauty was the form that carried the recognizable beyond itself into an imitation of God's primordial creation. In this sense, humans were thinking beings who delineated God's thoughts and creativity and who partici- pated—derivatively, to be sure—in the acts and activities of God. It is hard for us who stand on the other side of the discoveries that made modern art possible to recognize the intoxicating passion that resulted from the recovery of the art of the world of classical antiquity as a paradigm for human existence.

Renaissance art, south and north of the Alps, shared certain affinities but also diverged in form and spirit. Both regions emphasized the human figure in its own right and in relation to other humans. It was assumed that humans alone could carry a painting without recourse to drama or setting; their presence was sufficient. The figures themselves carried the message without recourse to props. In that sense, the power of the painted image came into its own. It is no wonder that such a breaking forth of the artistic process bordered on hubris, for painters and sculptors had not felt such independent power before in Christendom. Artists were now shaping rather than simply reflecting Christian perceptions. Here emerged creative power, for good or ill.

Although both the human figure and nature were represented with a new accuracy and on a larger scale in both south and north, a profound differ- ence existed between the two regions. One need only think of Leonardo da Vinci, Michelangelo Buonarroti, and Raphael Sanzio on the one side, and of Lucas Cranach, Albrecht Dürer, and Mathias Grünewald on the other. The Renaissance spirit, that is, a passion for excellence in execution and for a powerful expression of theme and message existed in both groups; but a difference in spirituality also resulted in artistic differences, even though artists in both south and north worked with Christian convictions. The world of antiquity triggered many of their new artistic perceptions, but the artists were consciously in the Christian orbit.

The difference between south and north has to do with style rather than with subject matter. The Virgin Mary and the Christ child are prominent in both south and north. In considering them, however, we need to avoid the later sentimental viewing of the Madonna and Child, made possible by the fact that Renaissance style, freed from its former Christian setting, could be piously and secularly viewed without a full-orbed Christian understand- ing. In the Renaissance, the Virgin and Child together stand for the incar- nation, for God having become flesh.[8] In this sense, the Renaissance

[8] For a strong case on behalf of such views, see Leo Steinberg, *The Sexuality of Christ in Renaissance Art and in Modern Oblivion* (New York: Pantheon, 1983).

perspective was closer to that of the Eastern Orthodox Church than to the sacrificial or satisfaction theories of medieval Europe. Unlike the Eastern Orthodox development, in which icons protected the mystery, Renaissance art stressed the humanity, the incarnation. But in the forms, sometimes with the help of a Platonist understanding, one could see how another world was present in the visible world. Michelangelo's sculptural figures were light and ethereal, moving and breathing in a way in which trans-worldly powers coincided with the human depictions. In the *Madonna Taddei* (plate 30), the calm bodily presence bespoke another presence, re-inforced by a plethora of accompanying symbols.

Also from the south of the Alps, Raphael created madonnas in which there was a new sense of harmony, order, peace, and ease among the figures, for example, *The Alba Madonna* (plate 31). All of this was expressed by the total delineations and interrelations of the figures, not by countenance alone. Order, beauty, and repose were one and the same, a reflective paradigm of what God had done. The dynamics of the painter were fulfilled when the harmony of the painting erased the dynamism that had created it. The power of the painting or sculpture lay in the order and calm that suggested activity through fiat and deliberateness rather than through obvious concerted effort. Michelangelo's God gets results without effort or strain. On the ceiling of the Sistine Chapel, the focus is not on God, for all of God's presence, but on the acts that predate both law and gospel. There they are in front of us, like frames that define our existence, making us ready for law and gospel.

In Michelangelo and Raphael, paintings and sculpture define our existence. The power of the world of antiquity rediscovered and transformed is in the service of the Roman Catholic faith. The theological world is set before us in its essentials, framings for us to see and participate in, without anxiety or distress. In that theological world the actual world mirrors the divine, and God deals with people and their infirmities as ripples that cannot adversely affect wind or sea, God having acted in behalf of the people.

When one enters the world north of the Alps, the figures and scenes also carry their own message without the need of narrative or props, but the spirit is different. When one compares the *Madonna Taddei* by Michelangelo (plate 30) and *The Alba Madonna* by Raphael (plate 31) with Grünewald's *Virgin and Child with Angels* from *The Isenheim Altarpiece* (plate 32), the contrast is clear. The composed figures by Michelangelo and Raphael, with their vitality expressed in an inner power, contrast markedly with the Grünewald creation, in which an ordinary mother and child express a playful, involved relation with each other. The rosary and torn cloth alone carry the direct religious connotations. Here the harmony is in the composition as a whole, not in the figures. In Grünewald's *Crucifixion*

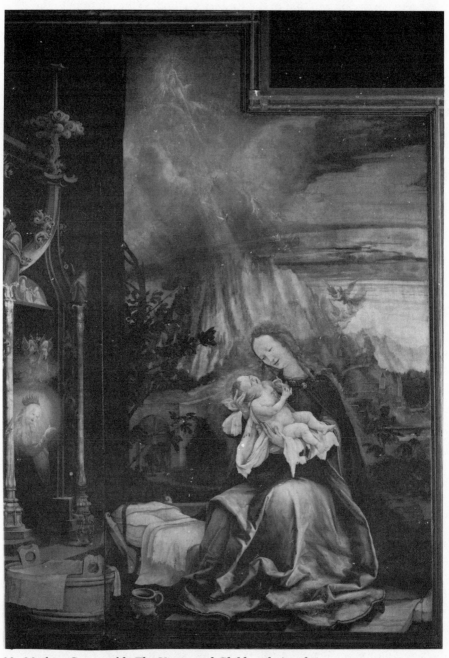

32. Mathias Grünewald, *The Virgin and Child with Angels,*
The Isenheim Altarpiece, 1515–1516

30. Michelangelo Buonarroti, *Taddei Tondo*, ca. 1505

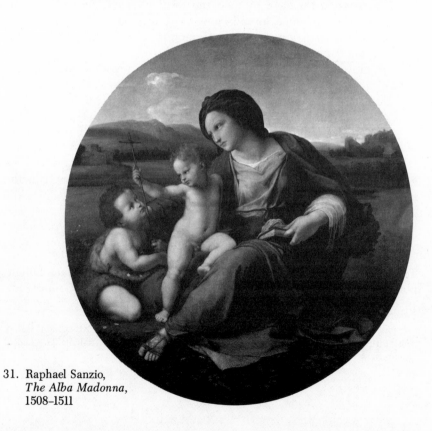

31. Raphael Sanzio,
The Alba Madonna,
1508–1511

from *The Isenheim Altarpiece* (plate 33), the figures and their placement too reflect the Renaissance discoveries, including the harmony of the whole. Whereas the *Virgin and Child with Angels* discloses the natural relations of love and trust, the *Crucifixion* discloses the brutality of existence. In Grünewald's *Crucifixion*, the figures and their placement reflect the Renaissance discoveries. There is harmony of composition, but the figures themselves are quite non-harmonious. Even when one takes into account that some of the figures seem to have the terrible diseases that were present in the hospital for which it was painted, an inescapable residue of participating in forces and alien powers is present in the figures. An active dread pervades their countenances, and the afflictions are more than terrible physical ones. They are psychic to the core.

Michelangelo and Grünewald were contemporaries and they were both Roman Catholic—though we do not know if Grünewald was influenced by Catholic sectarianism or incipient Protestantism. But the contrast between them is stark, which reflects a marked difference between the regions to the south and to the north of the Alps. Michelangelo's *Pietà* groups disclose the sorrow of the Virgin in noble, classical acceptance, as if all that had happened was fated and one could do nothing about the dead Christ on her lap. In contrast, in the *Pietà* groups of the north, intense suffering is present. Michelangelo's madonnas are all-knowing, accepting, and composed. In Grünewald's *Crucifixion* extremes of emotion and psychic and physical suffering are depicted.

In portrayals of the Virgin and Child, a classic grandeur pervades the paintings of the south, whereas one finds a playfulness in the north, as if the doings of mother and child were like all mothers and children. Only the subject and the historic clues tell us that it is *the* Virgin and Child. Here, too, the human emotions take over. In northern art, we have the delineation of a full range of human emotions from inordinate pain to sheer human joy. In the south, in the art of Michelangelo, both the *Pietà* groups and the Madonna and Child are portrayed as if both events were fused in the natural order of things.

Dürer, Cranach, and the Lutheran Development

This difference between south and north of the Alps, which Jane Dillenberger has described in her account of Michelangelo and Grünewald,[9]

 [9] Jane Dillenberger, "Michelangelo versus Grünewald: A Study of Northern and Italian Sensibilities at the Time of the Reformation." (address delivered at Graduate Theological Union, Berkeley, California, February 25, 1981).

appears more fundamental to the northern perception of reality than the split then emerging with Roman Catholicism. Artists knowledgeable and interested in the Reformation reflect a northern spirit that transcends their religious allegiance, as is evident among northern artists who worked for both Roman Catholic and Protestant patrons. Northern Renaissance artists were affected by the new emphasis on the human figure and the landscape, particularly scale and size. But the delineations are different from the art of southern Europe. *Adam and Eve* by Dürer (plate 34), or even by Hans Holbein the Younger, disclose figures without classical proportions; rather, they seem to be ashamed of their nudity and ill at ease in their nakedness, which obscures the meaning of the fall.

In Lutheranism, in which the visual arts were not removed from the domain of the church as they were in other Protestant bodies, one sees the effect of a Reformation consciousness. First, the teaching function of the church, particularly its interest in the Bible, is evident in the extensive use of woodcuts. This medium illustrates biblical stories and does not stray from the verbal content. Second, the impact of Luther seems to have led to an increasing interest in depicting passion scenes, the Lord's Supper (obviously in contrast to the Mass), the woman taken in adultery (though this too had been executed throughout the history of the church), and Jesus and the little children (related to the question of baptism, here opposed not to Roman Catholics but to Anabaptists). Perhaps most distinctive are the paintings that convey both the heritage of the law and the gospel, the former portraying our condition and driving us to the latter, to the free gift of God's grace. Carl C. Christensen has documented these themes and in particular has pointed out the theme of law and gospel in the work of Cranach the elder.[10] We know of the interest of the Cranachs and Dürer in Luther and the Reformation. Craig Harbison has even correlated the painting career of Dürer with Luther's own statements, ranging from a fairly negative attitude toward the visual to a positive though restrained one.[11]

It is one thing to see certain subjects coming into prominence or even to correlate painting careers with Reformation events; it is another to raise the question of whether artists in their style and content conveyed a Reformation understanding, as, for example, Michelangelo conveyed a Roman Catholic one. If one believes that northern artists more than southern artists did express their convictions through psychic depictions, one would expect a Protestant perspective to be more prevalent in the north than in fact seems

[10] Carl C. Christensen, *Art and the Reformation in Germany* (Athens, OH: Ohio University Press; Detroit, MI: Wayne State University Press, 1979).

[11] Craig Harbison, "Dürer and the Reformation: The Problem of Re-dating of the St. Philip Engraving," *The Art Bulletin* 58 (September 1976) 368–73.

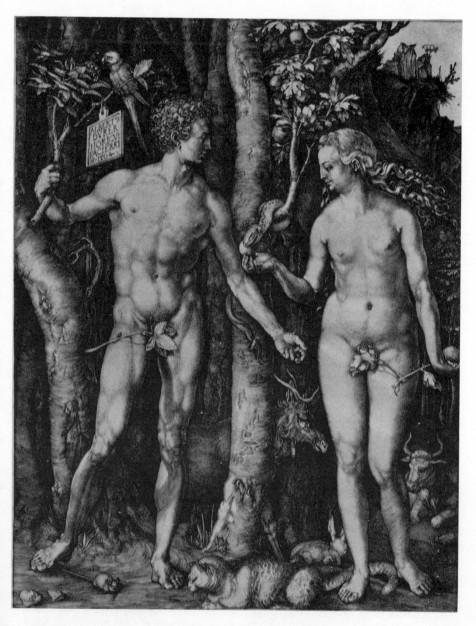

34. Albrecht Dürer, *Adam and Eve*, 1504

to be the case. When one examines a work by Dürer such as *Knight, Death and the Devil* (plate 35), one discovers that it does show a psychic state. But the confident knight, looking neither to the right nor to the left, rides through the terrain as if there were no powers to assault him. This is more in the spirit of Renaissance humanism as found in Erasmus than in the spirit of Luther. The knight Luther would have done battle with the forces, confident that with God's help the demons would be both recognized and destroyed.

It is obvious that the Reformation made a difference in the art created for those Protestant churches that continued to accept the arts. But it is surprising how little the difference was. Protestant Nurenberg in its Lutheran form, as far as the arts were concerned, was essentially medieval. What emerged was a departure from the extremes in medieval art, the undue emphasis on relics, and the dubious role of the adoration of the saints. But that reforming thrust was far removed from the religious understanding of Luther and other reformers. The interest of Cranach and Dürer in Luther does not mean that they really came to understand the central theological shift that created the Protestant church. Reforming in the sense in which they understood Luther was not yet the Reformation.

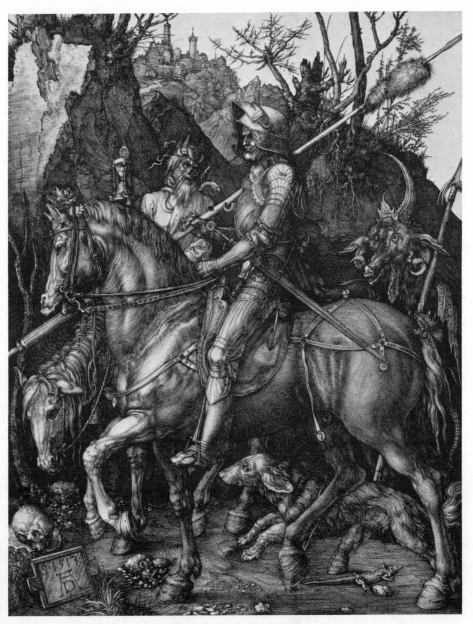

35. Albrecht Dürer, *Knight, Death and the Devil*, 1513

3

ICONOCLASTIC MOVEMENTS— VARIATIONS ON A THEME

THE ICONOCLASTIC IMPULSE seems to lie just beneath the surface of civilizations in which cultural creations have reached a significant level. Moreover, the impulse appears to be based on two interrelated but separable perceptions. First, the impulse toward iconoclasm arises when art objects are conspicuous enough to challenge other values, when they appear to get in the way of competing claims. In the Eastern iconoclastic controversies of the eighth and ninth centuries, icons were associated with popular religious movements, particularly monasticism, in contrast to the claims of emperors and occasionally bishops. In the medieval Lollard tradition, art objects seemed to express the opulence of the church. In the Continental Reformed developments, the accent on a particular form of spiritual religion precluded the role of objects in worship. In the French Revolution, art objects seemed to exemplify the very religion one rejected.

Common to and underlying the differing shapes is a second factor, namely, that the art objects are singled out as having extraordinary power. Although they are frequently referred to as being but things made of cloth or stone, the art objects are actually dealt with in a quite different way. The impulse to destroy testifies to a power much stronger than the sticks and stones one could ignore. Art, which turns sticks and stones into new creations, testifies to a power that is at the center of the issue. For one thing, art is visible, a power that is not hidden behind other facades. In addition, the fact of idolatry testifies not only to a primitive and untutored seeing of objects but also to the mystery of why idolatry is possible. That mystery belongs to art and is also the basis for a positive understanding of the visual. Iconoclasm testifies to the negative side of the power of art. As in life generally, the positive aspects of that which can become a negative power seldom stir drastic actions among individuals or groups. In iconoclasm, we

face the issue of whether a negative expression can be overcome only by eradication, whether idolatry can be met only by removing the objects so interpreted. Perhaps more critically, the issue arises whether the suppression of objects leading to idolatry does not lead to the breaking out of other destructive powers. It may be that the fight against idolatry can be managed only by a more correct reading of the role of images, of their inevitable presence, and therefore by a more disciplined consideration of the positive role they play.

Eastern Iconoclasm

There are similarities among the historic iconoclastic movements, but there are also major differences. In the Eastern controversy, images were accepted among all parties. The issues were which images were appropriate and how they were interpreted. All agreed that, in the light of the Incarnation, God had entered the world and that, consequently, God was known in and through things and humans. The eucharistic sacrament was an image of God, the bread and wine representing the invisible God in visible terms, just as Christ himself had done. Holy persons, too, imaged God. But were there other legitimate representations, representations that could be made by human hands. For some, only the Christ figure could be represented; for others, the Virgin Mary and the saints qualified. If God was present through the grace in which the imitation of Christ was carried out, every individual was, in principle, an image—an image of Adam restored. In some, such as the saints, the image had reached a zenith, a special status, one through which all people might be helped.

The role of the saints was challenged by a few individuals in the East. Predominantly, however, the issue was not the role of the saints but the images of the saints, Christ, and the Virgin Mother (plate 36). The invisible God, as invisible, could not be pictured, though God's presence was sometimes indicated by a hand. The invisible God made visible in Christ must be imaged, for God in the Incarnation had taken human form, had come to humanity through human agency. Already in the late seventh century, the Council of Trullo stated that "in order to expose to the sight of all, at least with the help of painting, that which is perfect, we decree that henceforth Christ our God must be presented *in His human form*, and not in the form of the ancient lamb."[1] John of Damascus, a Palestinian monk removed from the center of the controversy, wrote: "I boldly draw an image of the

[1] John Meyendorff, *Byzantine Theology: Historical Trends and Doctrinal Themes* (New York: Fordham University Press, 1979) 45.

invisible God, not as invisible, but as having become visible for our sakes by partaking of flesh and blood. I do not draw an image of the immortal Godhead, but I paint the image of God who became visible in the flesh. . . ." [2] Then he goes on to describe what that includes: "Depict His wonderful condescension, His birth from the Virgin, His baptism in the Jordan, His transfiguration on Tabor, His sufferings which have freed us from passion, His death, His miracles which are signs of His divine nature, since through divine power He worked them in the flesh. Show His saving cross, the tomb, the resurrection, the ascension into the heavens. Use every kind of drawing, word, or color. Fear not; have no anxiety; discern between the different kinds of worship." [3]

Two things deserve mention in the light of this passage. First, the depictions in imagery are like the biblical stories. It is for this reason that John of Damascus too mentions that "what the book is to the literate, the image is to the illiterate." [4] A parallelism between the two is assumed. Therefore, both are commended. [5] It is doubtful that the early distinction between the literate and the illiterate should be interpreted as giving superiority to the literate; that appears to be a later assumption. Second, John of Damascus assumes that there need be no anxiety about the visual so long as the appropriate distinctions are made with respect to the nature of worship. Adoration is different from honoring that which is of greater excellence. Worship is adoration; honoring belongs to the image. Elsewhere he distinguishes between absolute worship, appropriate to God alone, and relative worship, appropriate to holy places, holy objects, images, and—sociologically or politically speaking—those who have authority over us. [6]

In accord with the language of the time, we can speak of the difference and identity between the image and the archetype. Because of the difference, we do not worship the image, but because of the image, we adore the reality expressed through it. Because of the identity, we know we have to do with God's presence through a mediating reality. The image and God's reality are conjoined, but they are not identical.

The iconoclasts did not accept such distinctions, and for them the proof of their viewpoint was evident in the idolatry they saw around them. Since

[2] St. John of Damascus, *On the Divine Images* (Crestwood, NY: St. Vladimir's Seminary Press, 1980) p. 16.

[3] Ibid., 18–19.

[4] Ibid., 25.

[5] Patrick Henry, "What was the Iconoclastic Controversy About?" *Church History* 45 (March, 1976) 16–31, esp. 24. For this issue and the Eastern controversy, see Jaroslav Pelikan, *The Christian Tradition: A History of the Development of Doctrine*, vol. 2, *The Spirit of Eastern Christendom* (Chicago and London: University of Chicago Press, 1974) chap. 3.

[6] *On the Divine Images*, pp. 82ff.

36. *Our Lady of Vladimir*, 12th century

idolatry and images were identical in their minds, the iconoclasts cited texts from scripture that forbade idolatry and interpreted all images in that sense. Moreover, they collected passages from the early church fathers that they believed clearly forbade the making and use of images. Such collections, called *florilegia*, were cited out of context as proof texts, a method characteristic of earlier periods. Little of these collections and arguments remains, except what is reported by the victors, who destroyed the writings of the iconoclasts, and icons created before and during the controversy were, in turn, destroyed by the iconoclasts.

Those who defended images likewise argued from scripture and the church fathers. More fundamentally, they claimed that the whole Christian tradition was on their side, that images had existed all along, that there were no injunctions against them, that their practices reflected a history antedating recorded memory. It is interesting that, until recently, art historians have sided with the iconoclasts, maintaining both that the early church was opposed to art and that early Christian art did not exist. More recent scholarship gives support to the notion of a living tradition in which images may have been present and to an interpretation of scripture and the church fathers that images were not summarily excluded.

All the major theological differences between the iconoclasts and those who believed in images belong to a theological world in which liturgical practices and eucharistic affirmations were central, a world in which God's grace made people holy. Moreover, most believed that things also were made holy. The question was whether this religious spectrum was open to being imaged. In that sense, fierce as the debates and political machinations were, the disputes were carried on within a common sacramental context. In this they differ dramatically from the disputes of later Western history. In addition, the debates, although theological in nature, were also conditioned by political contexts. The iconoclastic emperors came from lands such as Syria, where Monophysite theology was prominent and contact with Islam was inevitable. It was not that Islam directly influenced Christianity in an iconoclastic direction, but that in the struggle with Islam some Christians contended for a purified Christianity, freed of icons, which by nature were offensive to the followers of Muhammad. Moreover, the emperors were in conflict with the monastic community, which accorded to images a place of prominence and which had the support of the populace at large. Iconoclasm was clearly in part a weapon in the struggle for control.

While the struggle went on in the East, the Western church, centered in Rome, supported the role of the visual images and the saints in the creation of a series of ninth-century churches. Indeed, it utilized Eastern workmen

who had fled to the West. Pope Paschal I was responsible for three churches in Rome that reflect the Byzantine spirit, Santa Prassede, Santa Maria in Domnica, and Santa Cecilia in Trastevere. The apse mosaic of SS. Cosma e Damiano, as noted previously, was the source for the apse mosaic of Santa Prassede. Visually, the latter is the Byzantine transformation of a mosaic that in its original form is distinctly Roman. Even more Byzantine is the exquisite St. Zeno chapel in Santa Prassede.

The final victory of the iconodules in 843 and the separate unfolding of Eastern Orthodox church life, reflecting the political developments of East and West, led to a tradition in which the arts became essential to church life in the full development of icons. Although icons are art objects, the Eastern Orthodox tradition views them as essential to the life of the church. Aesthetic characteristics are not central, though there are certain features that make icons what they are. Frontal and partially stylized figures suggest the mysterious presence of the prototype. Questions of faith are central to the making of icons in a way that is not characteristic of the West.

Icons are a part of the liturgical tradition, so they cannot be used merely as an aide or be shunted aside. They are central to the worship experience. For the Eastern Orthodox Church, scripture and images are two ways in which the faith is carried and expressed. Icons, therefore, are not illustrations of scripture. Like Scripture, they are living deposits of the tradition. Liturgy is where the icon and scripture meet: the visual and the verbal are two fundamental realities, neither of which can be elevated over the other. That view of the visual makes the Eastern Orthodox development unique.

Iconoclasm and the Reformers of the North

Although the iconoclastic impulse, wherever it occurs, has the same characteristics, the settings in which it breaks out may be extremely different. Culturally and theologically, the iconoclastic controversy of the Eastern Orthodox Church has little in common with that of the Reformation period. The distinction is grounded, first, in the differences between East and West and, second, in the form of biblical Christianity associated with the Reformation.

In the Reformation itself, one must distinguish among the Lutheran, the Reformed, and the English developments, and then one must distinguish these from the type of attack exhibited in the Sack of Rome in 1527. But common to the reforming movements within Roman Catholicism and to the Reformation itself was a strong aversion to relics and to the intercession of the saints and veneration of them, particularly as depicted in paintings

and sculpture. The collection of alleged relics associated with Christ, the Virgin, and the saints, all stressing their healing power, had resulted in Christians' making pilgrimages to the churches whose relics provided particular powers. It followed that churches and political powers made every effort to secure relics. Modern people are aware of these developments, but it is hard for us to comprehend how central the relics became for the life of Christians. When the use of relics was combined with the veneration of the saints, Christian life was mediated by visible embodiments. Even when relics and saints were accepted in terms of honor and veneration, freed of the all-too-prevalent magical powers, accent on them shifted attention to mediating entities rather than to the mediator, Jesus Christ. Many theologians of the medieval period spoke out against the proliferation of statues of the saints, which required altars and Masses as part of their mediating role. There was thus a proliferation of chapels, and artists and artisans were kept busy supplying the required objects. Bernard of Clairvaux, himself later declared a saint, was dismayed at the sight of Ste. Foi at Conques (plate 37). Bernard found her crude; yet even today one is astounded by the mysterious character of this small seated figure, covered with precious stones.[7] Christianity had become very visible in its major symbols, as in the elevation of the host during the Mass for all to see. What troubled reforming spirits had a very visible character, so it is not surprising that abuses triggered destructive acts.

In the previous discussion of Renaissance artists of the north, the Lutheran openness to the visual arts was noted. Clearly, the Lutheran openness is based on Luther's views of the arts. Luther was plunged into the issue by the reforming activity of Andreas Karlstadt and his associates in Wittenberg during the former's hidden protective stay in the Wartburg castle. Luther considered the issue to be so critical that he left the protection of the castle to return to Wittenberg, where he delivered eight sermons against the destructive form of the reforming activities, a part of which had to do with the removal of images. Nonetheless, at this time Luther was hardly more sympathetic to images than was Karlstadt. Indeed, he wished that images might be abolished, but he believed that that should happen on the basis of the Word's rendering them ineffective, not by physical removal or destruction. The theological point behind this view is all-important for Luther. Abuses must be met as abuses, not as occasions for removing that which gives offense. Everything is open to abuse and therefore to idolatry. But we should not decide to eliminate that which gives

[7] For a discussion of the opposition of theologians to such developments, see William R. Jones, "Art and Christian Piety: Iconoclasm in Medieval Europe," in *The Image and the Word*, ed. Joseph Gutmann (Missoula, MT: Scholars Press, 1977) 87ff.

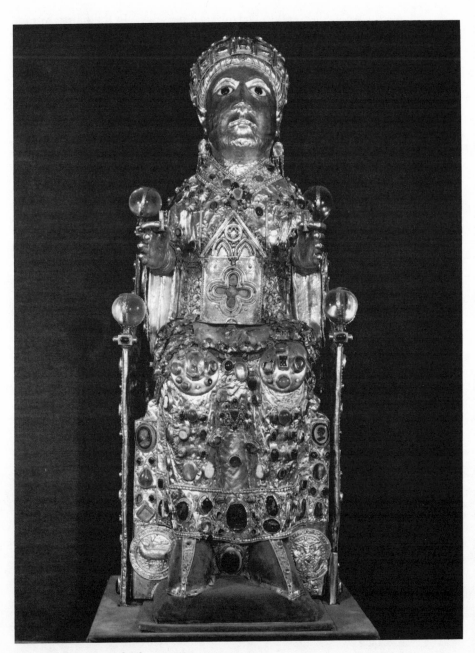

37. *Ste. Foi*, 5th and 9th centuries

offense, or we would need to destroy even ourselves. In the fourth sermon Luther declares:

> God has commanded us in Deut. 4 not to lift up our eyes to the sun, etc., that we may not worship them, for they are created to serve all nations. But there are many people who worship the sun and stars. Therefore we propose to rush in and pull the sun and stars from the skies. No, we had better let it be. Again, wine and women bring many a man to misery and make a fool of him; so we kill all the women and pour out all the wine. Again, gold and silver cause much evil, so we condemn them. Indeed, if we want to drive away our worst enemy, the one who does us the most harm, we shall have to kill ourselves, for we have no greater enemy than our own heart.[8]

From this passage it is obvious that Luther focuses not on the elimination of that which causes trouble but on the fundamental issue of our orientation to the totality of life. Idolatry is possible in everything we touch. A proper emphasis on the fundamentals of faith keeps our life intact. We do not eliminate the troublesome; we transform it. In some instances, faith will also result in the withering away of that which is of no help. At times it seems as if Luther believes that the arts could and perhaps should disappear in the vibrancy of faith. At other times, and particularly subsequent to the sermons, he takes a more positive view. Already in the fourth sermon, he points out that in scripture itself the views of images are contradictory, that they are both condemned and approved.[9] In *Against the Heavenly Prophets in the Matter of Images and Sacraments* of 1525, written primarily against Andreas Karlstadt, Luther gives us an extensive analysis of the biblical passages on images.[10] Luther is clear that "according to the law of Moses no other images are forbidden than an image of God which one worships."[11] What Luther detects in Karlstadt is another law, a law as binding as the papacy on the other side. Images are external matters, about which one should exercise freedom. When the Word of God is present, Luther can declare, "God grant that they may be destroyed, become dilapidated, or that they remain. It is all the same and makes no difference, just as when the poison has been removed from a snake."[12] Hence, "images for memorial and witness, such as crucifixes and images of saints, are to be tolerated."[13]

[8] Luther's Works (Philadelphia: Muhlenberg Press, 1969) 51:85.
[9] Ibid., 51:84.
[10] Ibid., 40:84ff.
[11] Ibid., 40:85.
[12] Ibid., 40:91.
[13] Ibid., 40:91.

Luther derives the role of art directly from the scriptures themselves by pointing out that they are full of images, that to read scripture as Karlstadt does is incorrect.

> Now there are a great many pictures in those books, both of God, the angels, men and animals, especially in the Revelation of John and in Moses and Joshua. . . . Pictures contained in these books we would paint on walls for the sake of remembrance and better understanding, since they do no more harm on walls than in books. It is to be sure better to paint pictures on walls of how God created the world, how Noah built the ark and whatever other good stories there may be, than to paint shameless worldly things. Yes, would to God that I could persuade the rich and the mighty that they would permit the whole Bible to be painted on houses, on the inside and outside, so that all can see it.[14]

Luther insisted on the primacy of reading and hearing scriptures, but, even as he stressed the human heart as the locus of faith, he was also aware that one inevitably forms mental images. He writes:

> For whether I will or not, when I hear of Christ, an image of a man hanging on a cross takes form in my heart, just as the reflection of my face naturally appears in the water when I look into it. If it is not a sin but good to have the image of Christ in my heart, why should it be a sin to have it in my eyes? This is especially true since the heart is more important than the eyes, and should be less stained by sin because it is the true abode and dwelling place of God.[15]

Although Luther does not share the negative views of the other reformers on the visual arts, it is clear that the arts do not have a central role in Luther's thought. For Luther, the living Word was the preached, heard word, dependent on scripture. But the written scripture in itself has a character not unlike the visual arts. In both, realities are mediated in a vital way. For Luther, there is an order: the living Word and the scriptural words from which the living Word emerges, followed by other realities such as the visual and the liturgical. Freedom in the Word makes many things matters of indifference, and their use or non-use is a matter of freedom, not a command to be or not to be.

In Luther and in the Lutheran development, liturgical and artistic usages of the past are to be maintained where they enhance and do not hinder Christian faith and freedom. The saints and statues of saints are not the basic issue; when properly understood, they may be prized not as intercessors but as examples and models of faith. Luther wrote:

14 Ibid., 40:99.
15 Ibid., 40:99–100.

Next to the Holy Scripture there certainly is no more useful book of Christendom than that of the lives of the saints, especially when unadulterated and authentic. For in these stories one is greatly pleased to find how they sincerely believed God's Word, confessed it with their lips, praised it by their living, and honored and confirmed it by their suffering and dying. All this immeasurably comforts and strengthens those weak in the faith and increases the courage and confidence of those already strong far more than the teaching of Scripture alone, without any examples and stories of the saints.[16]

A similar passage is found in the Augsburg Confession (article 21), written by Melanchthon. Both Luther and Melanchthon honored the saints but rejected invoking the saints to seek their help.

Luther, the Reformers in what became the Reformed tradition, and the Anabaptists agreed on many individual points, but their differences reveal a different spirit, which Luther recognized in his dealings with Zwingli on the sacrament of the Lord's Supper. In Luther's vision, proclamation, sacrament, liturgy and the visual formed a unity, one in which faith, although based on hearing of the Word, nevertheless expressed itself through acts and tangible things.

A similar unity is expressed in Zwingli, Martin Bucer, Johannes Oeclampadius, Heinrich Bullinger, and to some extent, John Calvin. Among them, Christianity is primarily a spiritual religion: God is known through spiritual means. Earthly, tactile, visible modalities are inappropriate. The Lord's Supper is now a memorial or spiritual symbol, and the arts do not belong in the church.

Ulrich Zwingli, the architect of the Reformation in Zurich, was the product of the humanist development and of a concern at the time for the apostolic period of the church, both of which are exemplified in Erasmus. The humanist perspective found the world of ideas and of spirit more congenial than the mystery of sacramental developments, in which the corporeal world was considered a medium of transworldly realities. Developments in church history were judged wholly by their conformity to what is explicitly sanctioned in scripture. Reading of scripture meant for Zwingli that God was to be worshiped in spiritual terms, that prayer and worship were identical, that liturgies and ceremonies substituted "babblings" for the spirit, that images were inevitably idols.

This is essentially the Erasmian position, though it needs immediately to be added that Zwingli differed from it in two fundamentals. First, he was more evangelically oriented than Erasmus. Second, he was willing to draw

[16] Weimarer Ausgabe 38:313, quoted from Carl C. Christensen, *Art and the Reformation in Germany* (Athens, OH: Ohio University Press; Detroit, MI: Wayne State University Press, 1979) 57.

the consequences of his position, attempting to form a society in terms of his evangelical vision no matter what the consequences. Erasmus, in contrast, wanted reform without revolution; indeed, he could not stand the thought of the latter.

Zwingli's views of images were anticipated by Andreas Karlstadt and Ludwig Haetzer. Karlstadt, whom Luther had attacked in his return from the Wartburg to Wittenberg, had written a pamphlet against images in January 1522, though he may not himself have been responsible for the destruction of images in Wittenberg. Given his general and abstract view that art was immoral and the lack of organization in his writing, Karlstadt's biblical views did not appear prominently in his pamphlet. That was rectified by the pamphlet of Ludwig Haetzer in September 1523, a document that influenced Zwingli and the Zurich scene. In this eighteen-page document, the first twelve pages consist of thirty-three biblical passages on images, all drawn from the Old Testament. The last six pages consist of answers to the four main arguments for the validity of images: (1) that citations from the Old Testament are no longer valid; (2) that images are not honored or prayed to but that the saints alone are honored; (3) that they are books for the laity; and (4) that they induce individuals to reverence and improvements. With respect to the first argument, Haetzer insisted that the moral and reverential aspects of the Old Testament stand intact, as in the Ten Commandments. Then he proceeded to quote New Testament passages against images, with considerable attention to Paul. The argument that the saints, not the images are honored, meant nothing to Haetzer, since the saints no longer had a religious role; nothing stands between God and the human soul. In treating both this argument and the third one, Haetzer repeated the prohibition of images from the Old Testament commandments. Pope Gregory the Great may have thought of images as books for lay persons; God does not. That images help people to be more reverent Haetzer rejected outright. Christ alone draws people to him, and he is responsible for their dispositions.

Many of these arguments were developed also by Zwingli, though his concern for faith was even more rigorously guided by what he considered to be the dictates of scripture. Like Luther, Zwingli set himself against false gods, against the strange gods of the human heart, against the temptation to make something God which is less than God. The exercise of power, belief in one's own goodness, the role of others in salvation—indeed, a myriad of possibilities—tempt the human heart to trust creations of the Creator rather than the Creator. But unlike Luther, Zwingli saw a direct next step in such machinations of the human mind, namely, its translation into visual embodiments. The strange gods of the human heart are translated into idols. The yearnings of the human heart, the strange gods that

possess us, precede and are the basis of images as idols, and both need to be eradicated from our existence. That for Zwingli is the double meaning of the prohibition in Exodus. Faith involves a spirituality grounded in God beyond the cleavings of the human heart, internally and externally expressed.

Himself a musician and one who confessed an interest in the visual arts, Zwingli was opposed to both in the church.[17] Eventually music in the Zurich churches was abolished along with images, though Zwingli believed that music could belong to one's private existence. Although Zwingli was a musician, he knew little about the arts and was sufficiently nearsighted as to have a problem in seeing art. At the time of his arrival in Zurich, the city had just undergone a time of artistic production, provincial though it was. The many altars had been supplied with liturgical objects, and wall paintings and sculptures had been created. The relatively small Zurich Minster had no less than seventeen altars. Consequently, Charles Garside, Jr., states—and one might add that he is correct if Zwingli could see clearly—that when "Zwingli walked through the Great Minster in December 1518, seeing for the first time the saints' images, the Gethsemane group, the Easter Grave, the reliquaries, the eternal lights, all these combined to form for him a visual epitome of the 'corporeal things' and 'corporeal ceremonies' against which he had come to preach."[18]

After four years of preaching against images, Zwingli could point to little progress. The images were still in place, although popular feeling—as a result of the leadership of Zwingli and colleagues throughout Zurich—was strongly against the images. Zwingli, unlike the members of the emerging Anabaptist movements, believed that action could be taken only through the city council. It was only after several public debates and the outbreak of sporadic destruction of images, that the city council, advised by Zwingli, took concerted action to rid the city of all images in the churches. Previously donors had been permitted to take back what they had given, altar wings had been closed, and the draping of figures had been stopped. But in the period from 20 June to 2 July 1524 images were methodically removed from the churches.

> Every standing statue was removed from its niche or base and, together with the base, taken out of the church. It was then either broken up by the masons, if made of stone or plaster, or burned, if made of wood. Every painting was

[17] Doug Adams has informed me that Phyllis Taylor has made a case that Zwingli opposed music in the church because it was so poor that the musician in him could not tolerate what he heard.

[18] Charles Garside, Jr., *Zwingli and the Arts* (New Haven, CT: Yale University Press, 1966) 93.

taken down from the altars and burned outside. All murals were chipped away or scraped off the walls. The altars were stripped of all images and vessels, all votive lamps were taken down and melted outside, and all cruci-fixes were removed. Even the carved choir stalls were taken up and burned. Then the walls were whitewashed so that no traces whatsoever of the old decorations and appointments might be seen. That done, the whole group went on to another church and repeated the process.[19]

Obviously such activities totally transformed the interior and sometimes the exterior spaces of the churches. Two conflicting views of the result are well expressed by the devout Roman Catholic Hans Stockbar and Zwingli himself. Stockbar, who had been to the Holy Land and to Santiago de Compostela, entered the Zurich Minster and reported that "there was nothing at all inside and it was hideous"; Zwingli declared "in Zurich we have churches which are positively luminous; the walls are beautifully white." [20]

Zwingli's stress on God as invisible and incomprehensible and his convic-tion that God cannot and dare not be imaged were written into the Second Helvetic Confession, drafted by his successor, Heinrich Bullinger. In the white spaces of Zurich the sermons, prayers, and quiet dignity—the still-ness Zwingli prized so much—were characteristic of the services. Music and the visual had disappeared; the verbal carried the faithful in and out of the churches. The art that remained in private houses was for edification, not for religious meaning.

Paintings and sculptures were removed from the Reformed churches generally. In Strasbourg, the pattern was similar to that in Zurich. Martin Bucer, the most prominent preacher in Strasbourg, had views similar to those of Zwingli, but his influence on the city council was less central. In Strasbourg, the council also was stirred to action by lay destruction of some of the objects when the ameliorative acts of the council—such as closing altar wings, not draping sculpture during holy week, removing cultic objects such as a weeping virgin—were considered too little too late. Most of all, however, the council was led to action by its association with Zurich, Bern, and Basel in the Christian Civic Alliance.

In Basel, Oecolampadius preached against images, but he too insisted that their removal must be authorized by those in authority. Here, however, the populace did not wait for an overly cautious city council. They invaded the Minster, then the other churches, and destroyed everything in sight. Basel, according to one writer, looked like a battle field, and the council had only the alternative of cleaning up and completing the reformation of

[19] Ibid., 159.
[20] Ibid., 160.

the churches—that is, getting rid of images and every last vestige of the Mass.[21] They saw to it that the walls were whitewashed and that the leftover remnants were collected—ostensibly to be given to the poor for firewood—but fighting over the remains led the authorities to burn everything that was left. The destruction was so extensive that Erasmus complained that neither the costliness of objects nor their artistic worth made any difference to the iconoclasts. Oecolampadius consoled himself that it had all been done quickly and without cost of life—in contrast, for example, to events in the city of Magdeburg.

Given the continued presence of Roman Catholic power, the Netherlands and France present special and instructive aspects of iconoclastic activites. The Netherlands represents a complex of social and political strife that makes the breaking of images less a central part of the total landscape. Calvinist preachers were involved in creating the religious justification for the destruction of images, but essentially they insisted on their removal by legitimate authorities. Yet they also rejoiced when others removed images, particularly if they could see positive results and if violence had been averted, as indeed it had been in the Netherlands.

In France, a Protestant movement largely directed from Geneva was attempting a reformation, but the largely Roman Catholic populace and government proved too much for the Huguenot tradition, which was brought to a virtual end in the massacre of St. Bartholomew's Day. Natalie Zemon Davis has studied both the Roman Catholic and the Protestant side of the violent controversies in France, trying to fathom the motivations of both sides.[22] Social factors were involved, but Davis does not believe that there was a particular strand of society from which violence and the destruction of liturgical objects stemmed. Central to her thesis is that the motivation on both sides came from a clearly felt need to guarantee religious truth and to free religious society from pollution by elements that corrupt that truth. Thus, the actions of destruction were not wanton but were directed to a particular objective—to guaranteeing the peace and integrity of a religious society. It was believed that ridding the community of offending objects would make the true faith possible. Protestants destroyed images and Roman Catholics destroyed pews—a Protestant object—and pulpits. Frequently the destruction was accompanied by deliberately outrageous acts, such as urinating in the communion chalice, to show how common and nonreligious liturgical objects were.

Although Davis's study is instructive, her suggestion that conflict belongs

[21] Carl C. Christensen, *Art and the Reformation*, 101.

[22] Natalie Zemon Davis, "The Rites of Violence: Religious Riot in Sixteenth-Century France," *Past and Present* 59 (1973) 51–91.

to all life and that violence directed toward goals is normal makes one uneasy.[23] The line between the normal and the fanatical act is a thin one. It is further blurred when groups decide that authorities are acting too slowly or need assistance, as both Protestants and Roman Catholics contended in the French struggle. It is perhaps in this context that Calvin represented a position between acquiescence and taking things in one's own hands. Resistance to constituted authority is legitimate when authorities do not act as authorities should, but resistance is permitted only through other authorities at a lower level.

Calvin himself was a second-generation reformer, and he shared the general Reformed rejection of images, as is evident in his biblical commentaries and in the *Institutes*. He, too, interprets scripture in a way that excludes images, and further contends that most of the early history of the church was against images. Gregory's view is rejected as having nothing to do with scripture. In a passage in the *Institutes* Calvin clearly states that although art may have a function, even when it presents no problems it is of no help.

> And yet I am not gripped by the superstition of thinking absolutely no images permissible. But because sculpture and painting are gifts of God, I seek a pure and legitimate use of each, lest those things which the Lord has conferred upon us for his glory and our good be not only polluted by perverse misuse but also turned to our destruction. We believe it wrong that God should be represented by a visible appearance, because he himself has forbidden it [Exodus 20:4] and it cannot be done without some defacing of his glory. . . . Therefore it remains that only those things are to be sculptured or painted which the eyes are capable of seeing: let not God's majesty, which is far above the perception of the eyes, be debased through unseemly representations. Within this class some are histories and events, some are images and forms of bodies without any depiction of past events. The former have some use in teaching or admonition; as for the latter, I do not see what they can afford other than pleasure. (*Institutes* 1.11.12)

Calvin believes that most church art belongs in the area of pleasure, that it serves human cravings. His final conclusion is that "even if the use of images contained nothing evil, it still had no value for teaching" (*Institutes* 1.11.12)

The rejection of images in the Reformed tradition is clear and consistent. It is part of the rejection of a Roman Catholic sacramental view of the faith. The sacramental substance is rejected; abuses are not the issue.

Still, there is a mystery concerning why the issue of images should be so central to the rejection of the medieval Christian world. Part of the answer

[23] Ibid., 90.

may be that clergy controlled the liturgy and the preaching, and therefore lay people could not enter that arena. But images were there to be seen, objects on which the lay people could get their hands. Although one can get hold of objects, one cannot get hold of the spirit. If one does, the spirit has become a thing. The spirit can get hold of one, making one a believer. It is perhaps ironic that spiritual believers should spend so much energy getting rid of objects of a material kind. On this matter the Anabaptist tradition was more consistent. It decided to organize its life independent of traditional clergy, structures, and authority. Its creation of churches apart from the traditional churches freed Anabaptists from the problems of more societally formed churches.

One additional theological argument may help us to explain, if not to understand, the fierceness of the argument against images. Karlstadt had expressed it clearly when he suggested that an image was a worse offense than adultery, since it offended against the first commandment. There was a tradition, expressed even by Calvin, that sins against the first table of the law were worse than those against the second table. Luther, too, had said that even the second table needed to be understood in terms of the first, that is, our relation to God. The logic of the argument is clear; the substance is less convincing.

Iconoclasm in England

There are some similarities between the Continental iconoclastic movements and the English scene, but the differences are pronounced.[24] In England the confiscation and destruction of art objects in churches and monastic communities were initially the result of the action of the crown in the person of Henry VIII. Roman Catholic to the core and himself interested in art objects, Henry shrewdly marshaled the support of the populace in his fight with Rome by playing on the anti-image propensities of a public that had been influenced for centuries by the Lollard movement. Although this medieval movement had been officially suppressed, its ideas at many levels were still to be found in the public at large. The Lollard movement was similar to public and sectarian movements on the Continent in the medieval period, but its influence continued more significantly in

[24] For a fuller elaboration of the English scene, see John Dillenberger, *The Visual Arts and Christianity in America* (Chico, CA: Scholars Press, 1984) chap. 1. The footnotes in that volume make reference to other bibliographical material. One might also add, as Doug Adams has suggested, that Henry VIII was uncomfortable with much of the art in which prelates were in heaven and kings in hell.

England than did similar movements on the Continent. Perhaps that was in part because of the fact that the Lollard negative view of images had both theological and social reasons, which were joined. The English objection, on theological grounds, centered more on the opulence and corruption attendant on the use of wealth in such forms than on the question of images in themselves. The split between a lay population and a landed aristocracy and gentry was a fact of English life that Henry exploited for his own purposes.

Thus, the movement against images in England rested first in the hands of the crown, a fact that continued through the reign of Queen Elizabeth. Although there were Puritans who stood against images and who were responsible for the destruction of art objects, the main destruction occurred under Henry. Between the crown and the Puritan negativity, the visual arts of painting and sculpture virtually dropped out of English lives, except for the collections of the nobility and the crown itself, to which the average person had no access. Only in portraits did a tradition continue, but then only for individuals who could be said to be of note in society. The disappearance of the visual arts from private as well as public life stands in marked contrast to the situation on the Continent, where visual objects, although banished from the churches, were considered acceptable in private life. In the one instance in England in which the visual continued—in illustrations—the intent was negative. For example, the illustrations in Foxe's *Book of Martyrs* were used as a powerful weapon in the suppression of Roman Catholicism in England. The disappearance of painting and sculpture from English life was not the result of an English aversion to the good life. The English had a regard for good clothing, wine, porcelain, and other objects that served a direct function in living. It was not until the eighteenth century that the visual arts reappeared in English life generally, as distinct from the lives of the crown and the nobility.

Throughout the discussion on iconoclasm of the late medieval period, it has been apparent that a diverse series of popular movements stood against opulence in the church and insisted on forming simpler Christian communities. Since they found themselves standing against the overwhelming power of either empire or church authority or both, they were generally suppressed. But it was the lingering memories of and sympathies toward such groups that became the basis for the unleashing of popular iconoclastic movements in the Reformation period. Thus, there is a medieval root to Reformation iconoclasm, which was reinforced by new Reformation ideas. Although more evident in England, it was also characteristic of the Continent.

The Sack of Rome

The Sack of Rome in 1527, an event and date prominent in art history but seldom mentioned in church history, reflects the confluence of medieval Roman Catholic and Reformation traditions. There were movements in Italy itself against the papacy for its apparently inordinate accent on the arts and on antiquity and for the use of its power and resources in its own behalf. Again, the visual arts were associated with religious and political factors that made them the pawns of such powers. Rome was the seat of a system of religious rites, such as relics and the particular use of indulgences, that elevated the problem of the visual into the midst of the conflicting religious views. When Luther was in Rome in 1508, he apparently saw the art of the time only in context of the church's use of art through relics and indulgences.

Politically, the Sack of Rome belongs to the struggles of the time. The armies of Charles V, together with Lutheran mercenaries, entered Rome and held the pope captive, while destroying works of art and manuscripts. The result was that material we would like to have, such as information on phases of the career of Michelangelo, simply no longer exists.

When reference is made to the Sack of Rome, it is usually said that it was the result of the Protestant invasion of Italy. The intent here is not to exonerate the Protestant Lutherans but to indicate that the situation was more complex than that. The Sack was conducted by a Roman Catholic emperor and his mercenaries, the mercenaries obviously relishing their destructive propensities. That the Sack of Rome has entered the consciousness of the West as a Protestant act stems perhaps largely from Thomas More's account of the horrors perpetrated by "those uplandish Lutherans." [25]

[25] André Chastel, *The Sack of Rome* (Princeton, NJ: Princeton University Press, 1983) 37.

4

The Baroque—Roman Catholic and Protestant

THE SEVENTEENTH CENTURY was at once the narrowing of worlds and the broadening of worlds. Religiously speaking, the Counter-Reformation stood for a reformed, chaste, theologically defined Roman Catholicism, and the emergent Protestantism for a series of distinct bodies, each clearly and religiously defined in opposition as much to one another as to Roman Catholicism. Theological differentiation was everywhere, and each group was convinced of the truth of its claims.

Contours of the Baroque

Yet this world of absolutisms was also the harbinger of new powers, of worlds coming into being by the extension of frequent travel to the far reaches of the globe and by the new science and its transformation of a fixed world into a vast, flexible universe. The result was a new awareness of the world around and of its new, larger context. Religious absolutism and the philosophy associated with the new science frequently stood against each other. Competing truth claims were everywhere. Yet it was the essence of the baroque spirit, more than any other movement of the time, to combine these apparently diverging tendencies into one vision of reality. The baroque combined particular religious understanding with the new awareness of the world's energies and vitalities. This is true whether one is considering the Counter-Reformation Catholics Peter Paul Rubens and Gian Lorenzo Bernini or the lone and lonely Protestant figure, Rembrandt van Rijn.

Baroque art in its religious forms discloses a transworldly religious understanding through the energies and vitalities of the worlds of nature and humanity. There is no escape from this world toward another, nor a sober or somber looking at this world in the light of another; rather, this world

75

itself is depicted in its active transfiguration. When that spirit expresses itself in variegated and extensive elaborations in architecture or in painting, one is in the arena of what is known as the baroque. But the baroque is not a special style; it includes all the styles that convey this new Christian understanding of the vitalities and concreteness of the world and of humanity.

In Roman Catholicism the baroque is the art of the Counter-Reformation. Recognizing that paintings and sculpture had received excessive attention in themselves rather than as symbols that conveyed dimensions beyond themselves, the Council of Trent both affirmed the traditional Roman Catholic views of images and called for a chaste art. It affirmed the role of the saints, of relics, and of images, thereby embracing precisely what the Protestants had rejected. It called on the bishops to "instruct the faithful diligently concerning the intercession and invocation of saints; the honor [paid] to relics; and the legitimate use of images: teaching them, that the saints, who reign together with Christ, offer up their own prayers to God for men; that it is good and useful suppliantly to invoke them, and to have recourse to their prayers, aid, [and] help for obtaining benefits from God, through his Son, Jesus Christ our Redeemer and Saviour." [1]

Specifically on the question of images, Trent affirmed the historic view that veneration and honor are appropriate, not worship, "because the honor which is shown them is referred to the prototypes which those images represent; in such wise that by the images which we kiss, and before which we uncover the head, and prostrate ourselves, we adore Christ, and we venerate the saints, whose similitude they bear." [2] At the same time, the council called for the abolition of abuses, such as the ascription of divinity, by the unlettered or uneducated, to works of art that portray facts and narratives of scripture, as if divinity "could be seen by the eyes of the body, or be portrayed by colors or figures." [3]

Perhaps of more concern to artists was that restrictions were placed on the nature of art, restrictions that in turn were to be enforced by the bishops. "In the invocation of saints, the veneration of relics, and the sacred use of images, every superstition shall be removed, all filthy lucre be abolished; finally, all lasciviousness be avoided; in such wise that figures shall not be painted or adorned with a beauty exciting to lust; nor the celebration of the saints and the visitation of relics be by any perverted into revelings

[1] The Canons and Decrees of the Council of Trent, twenty-fifth session, quoted from Philip Schaff, *The Creeds of Christendom* (New York: Harper & Brothers, 1877, 1905, 1919) 2:200.

[2] Ibid., 2:202.

[3] Ibid., 2:203.

and drunkenness; as if festivals were celebrated to the honor of the saints by luxury and wantonness." [4] Bishops were to see to it that there was nothing disorderly, unbecoming, profane, indecorous, or confusedly arranged. No unusual image, no acceptance of new miracles, and no new relics were to have a place in a church without the approval of the bishop. Indeed, if any controversy were to arise on these matters, the Roman pontiff himself was to be consulted. [5] In short, in the light of abuses of the recent past, art was to be under the strict control of the church. Indeed, in 1573, the painter Paolo Veronese was called before the Holy Tribunal of the Inquisition for having inappropriately painted "buffoons, drunkards, Germans [heretics], dwarfs, and similar vulgarities" in a Last Supper for the refectory of SS. Giovanni e Paolo in Venice. [6] When the artist pleaded poetic license to fill in empty spaces in canvas with what the imagination thought appropriate to the scene, contending that Michelangelo was given license to use the nude in *The Last Judgment*, the answer was that the additions were not suitable and that Michelangelo was dealing with another subject. One need only recall, however, that Michelangelo's nudes in *The Last Judgment* were later draped on orders of the Vatican. In the case of Veronese, the judges gave him three months in which to change the painting or suffer unspecified penalties. Veronese did not change the painting but instead changed the title to *The Feast in the House of Levi*, thereby satisfying the accusers, for with that title his images were acceptable.

The spirit of the Counter-Reformation was extensively influenced by Spain, whose power in the Council of Trent was crucial and who controlled the Netherlands and part of Italy. Spain, uninfluenced by the Reformation currents but concerned for a religious ethos free of abuses, took the lead in promoting a Roman Catholicism that Protestantism had doctrinally attacked. So, for example, the Mass was the center of the life of the church. The role of the Virgin Mary was emphasized, and the Immaculate Conception and the Assumption were indications of her preeminence. The function of the saints as intermediaries and avenues of access to God was newly stressed—particularly as their expressions of faith were evident in mystic visions, martyrdom, or virtuous lives against all odds. This view of the faith of the church, based on the earliest traditions and guaranteed by the papacy, was aggressively defended and promoted by the newly founded order of the Society of Jesus. St. Ignatius, the spiritual father of the Jesuits, was Spanish. The Jesuits were defenders of the papacy *par excellence* and

[4] Ibid.

[5] Ibid., 2:204–5.

[6] Elizabeth Gilmore Holt, *A Documentary History of Art* (Garden City, NY: Doubleday, Anchor Books, 1958) 2:69.

were interested not so much in theological elaboration as in standing for the truth that had been received. Into that truth one was to be educated not only in terms of itself but also in the way in which such truth illumined and gave shape to all other truth.

The Jesuit vision was traditional and total, so the arts come under its purview. Essentially, its vision was that of the Counter-Reformation, though with a greater emphasis on the teaching role of the visual arts. The Jesuits promoted architecture and the arts, including the theater and dance. Such visible manifestations of faith could be grand, that is, there for all to see. But the arts had no standing in themselves, for art as beautiful and sensuous image was rejected. The passion of art had to be an acceptable religious passion. The Jesuits, therefore, were interested in the visual arts but also suspicious of and sometimes opposed to particular visual expressions. Their interest was in the use of art, not in its promotion.

The Roman Catholic baroque was an artistic tradition in which the accepted subjects were portrayed through a style that developed out of the new emphasis on the world around us, in which an expanding world was also a world being observed and carefully scrutinized. The inherited classical world, with its placing of harmonious artistic forms at center stage, was superseded by a world in which the artistic forms expressed not the harmonies of the whole but the explicit impact of a specific religious conviction. The art form was not an image of another world made manifest, but was itself a reality that disclosed the effective power of God's presence. The difference is exhibited in the contrast between Michelangelo's Renaissance *David* (plate 38) and Bernini's Baroque *David* (plate 39). In the former, the power is pent up in a classical form that towers over us; in Bernini, the psychic and physical power is exhibited in the visage itself. It is the difference between a reserved and an active power or energy, between contemplation and action.

This development, classically expressed in Rubens and Bernini, is anticipated in Michelangelo Merisi da Caravaggio, in whose art the actual figures aggressively confront us. His *Deposition* or *Entombment* (plate 40) depicts the transition from the cross to the grave, an event for meditation. The standing orant is meant to relate this event to the context of the painting (in the Chapel of the Pietà, Santa Maria in Vallicella, Rome, though today the painting is in the Vatican). Rubens, who himself portrayed saints and the Virgin for this church, also copied the *Entombment* but transposed the figure of the orant to the left of the painting, transforming her into a viewing figure and thereby helping us to gaze at the event without a liturgical setting.

The religious context of Caravaggio is similar to that of the Michelangelo of *The Last Judgment* and of his later *Pietà* groups. Michelangelo had come

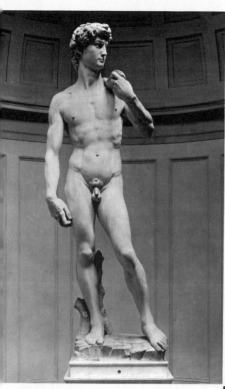

8. Michelangelo Buonarroti,
 David, 1501–1504

39. Gian Lorenzo Bernini, *David*, 1623

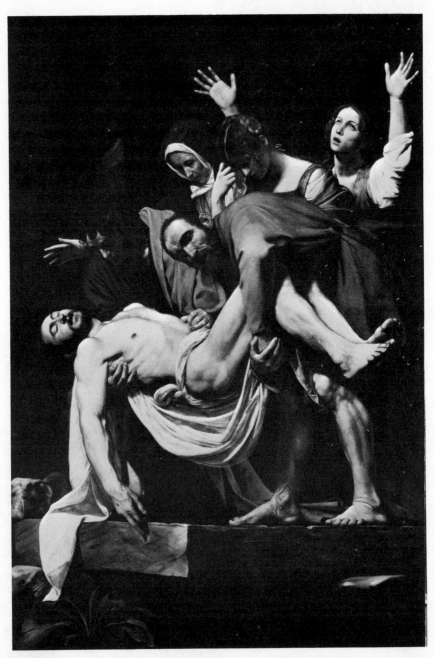

40. Michelangelo Merisi da Caravaggio, *The Deposition*, 1603–1604

under the influence of reforming elements in the church, namely, a group centered on his friend, Vittoria Colonna. Similarly, Caravaggio worked under the influence of Filippo Neri, founder of the Roman Oratory, a group that emphasized spiritual development, including prayers in the vernacular, discussions of faith and the church, and the singing of hymns, some of which were written by Palestrina. But although Michelangelo and Caravaggio both worked on reforming elements in the church, their respective styles differed greatly. Caravaggio placed his figures before us almost in effrontery, taking us to the limits of expression; indeed, Caravaggio seems to have pushed to the limits in both his life—he was frequently in trouble with the law for violent action—and his art.

Caravaggio did numerous commissions for churches. Some are still in place, but many were rejected upon completion. There is no doubt about his concern to express the beliefs of the church; his style, however, conveyed transcendence through stretching the ordinary and familiar in unusual directions. His *Conversion of St. Paul*, still to be found in the Cerasi Chapel, Santa Maria del Popolo, Rome, shows St. Paul lying on the ground, head toward us, while we see the looming horse from side and rear, with the other figures behind the horse as if more concerned about the animal than about St. Paul. In the *Crucifixion of St. Peter*, which is in the same chapel, two of the figures look away from us, while St. Peter raises his head toward us, nailed on a cross which in the action in the painting is being lowered or raised upside down. In both paintings it is as if the meaning were conveyed through an episodic depiction that is slightly out of kilter.

The two sides of the developing baroque are evident in Caravaggio's two versions of *The Supper at Emmaus*. In the earlier version, which is in the National Gallery, London (plate 41), a beardless Christ, with fleshy face and long hair, has his right hand stretched out toward us and over the meal—each dish having a eucharistic meaning—while his eyes rest on the meal itself. The figure to the left of Christ has both arms outstretched, and the figure on the opposite side of the table has his hands on the arms of the chair and is in the act of rising. The mutual recognition of the stranger has just occurred. In the later version, in the Pinacoteca di Brera, Milan (plate 42), the Christ figure is older and slightly bearded, and the outstretched arm is clearly in an act of blessing. The two figures corresponding to those in the earlier version are drawn into a psychic involvement. The two servants standing behind and to the side of the seated Christ also seem to recognize that something has just transpired. When one compares the two versions, it is apparent that the first intensifies the event in outward expression, one in which the physical acts confront us. In the second version the figures are more serene, and we are drawn into their psychic presence. The

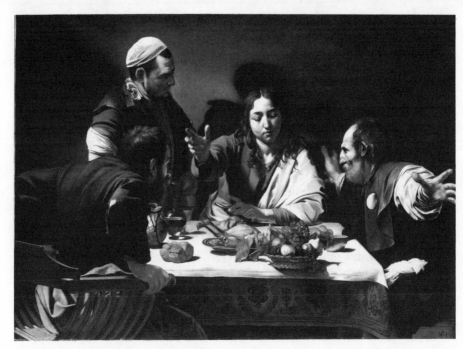

41. Michelangelo Merisi da Caravaggio, *The Supper at Emmaus*, ca. 1600–1601

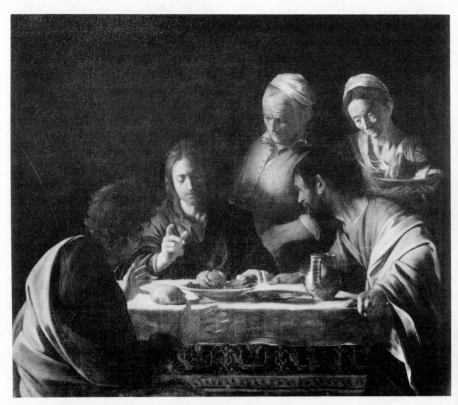

42. Michelangelo Merisi da Caravaggio, *The Supper at Emmaus*, 1606

first is closer to Rubens, the second to Rembrandt, whose *Supper at Emmaus* (plate 48) will be treated later.[7]

The range of Caravaggio's use of human emotion through ordinary humans raised to transcendent significance is visible in one place, namely, the three scenes of the St. Matthew cycle placed next to each other in the Contarelli Chapel of San Luigi dei Francesi. In *St. Matthew and the Angel*, over the altar, we find Matthew writing his Gospel, with an angel overhead. Matthew is portrayed as if his visage were caught between heaven and earth—obedient and calm but bewildered. On the left chapel wall is *The Calling of St. Matthew*. Here in the midst of the artist's contemporaries, one with head down, another reaching over the table, a boy looking out, all unaware of what is happening, Matthew is pointing his finger at himself, as if to say, Who? Me? On the right chapel wall is *The Martyrdom of St. Matthew*. Here the horror of the event is evident on every side, for executioner and witnesses alike, as Matthew lies prone and calm just before the inevitable decapitation.

The fully developed Roman Catholic baroque takes us into a different world of the church. Previous reforming activities within the church had been undertaken by individuals and groups, frequently in tension with the church hierarchy, but the full thrust of the Counter-Reformation occurred with the support of the hierarchy, particularly the Spanish prelates and the Jesuits. Moreover, this reformation, like the Protestant Reformation, meant the espousal of doctrines to be accepted, especially the doctrines that had been abandoned by the Protestants and even sidetracked by the reforming elements within the Roman Catholic Church.

Rubens and Bernini

It is not surprising that Spanish artists represented the Counter-Reformation, and El Greco, Diego Rodriguez de Silva Velazquez, and Francisco de Zurburan did just that. Since Rubens painted for and in every major country in western Europe at the time and Bernini left such an impact on Rome, we shall confine our attention to these two Roman Catholic baroque artists. Both were devout Catholics who regularly attended Mass, daily Mass having been promoted by the Counter-Reformation in contrast to its relative infrequency during the medieval period. While developing their own styles, Rubens and Bernini were willing to accept the subjects their patrons desired, namely, the subjects dear to the Counter-Reformation.

[7] See *The Age of Caravaggio* (exhibition catalogue; New York: The Metropolitan Museum of Art, 1985).

The first major religious commission executed by Rubens was for the Jesuit Church in Antwerp in 1620. The ceiling paintings of the church were burned in 1718, but, fortunately, descriptions of the church survive as do oil sketches and studies for the various paintings. Rubens's contract gave him the option of keeping the models in exchange for providing an altarpiece for a side chapel. His way of working on most projects included painting small oil sketches of the total composition, which provided a wide range of materials for specific projects. He used assistants, who did much of the surrounding and background painting, but Rubens still left his own impress. He let nothing go out of his studio that did not bear his stamp.

For the Jesuit Antwerp commission Rubens did two large altar paintings of the two major Jesuit figures and their miraculous deeds, *The Miracles of St. Ignatius Loyola* (plate 43) and *The Miracles of St. Francis Xavier*. Both paintings clearly focus on the respective saint, surrounded in an architectural setting by a collage-like assemblage of the miracles ascribed to that saint. Impressive as these paintings are, the main scheme of the church consists of thirty-nine ceiling paintings. The gallery ceilings consist of Old Testament events that prefigured New Testament ones in a rather standard medieval sense, and the ceilings of the aisles consist of over twenty paintings of saints, approximately half of which are women. The emphasis on both the Eucharist and the saints is evident in the selection of the subjects.

A second major religious cycle consists of the tapestries entitled *The Triumph of the Eucharist* for the convent Descalzes Reales in Madrid. In 1609, Rubens had been appointed court painter to the Infanta Isabella, governor of the Spanish Netherlands, and her husband, Archduke Albert. Having spent some time in her youth in the convent and having worn the habit of the order upon her husband's death, the Infanta was responsible for a commission that would provide permanent tapestries for the order, which previously had borrowed tapestries for the major processions of the Blessed Sacrament. Among the subjects for the tapestries, numbering between sixteen and twenty, are such Old Testament themes as Abraham and Melchizedek and Moses, and the Discovery of Manna, eucharistically interpreted. Addressing the theme directly are such subjects as *The Victory of the Sacrament over Pagan Sacrifices*, *The Victory of Eucharistic Truth over Heresy*, *The Adoration of the Sacrament*, and *The Adoration of the Sacrament by the Ecclesiastical Hierarchy*.

A single painting on the same theme, Rubens's *The Glorification of the Eucharist*, was done for the Carmelite Church in Antwerp in 1630.[8] *The Triumph of Christ over Sin and Death* (plate 44) is an oil sketch for this work. Describing this painting, Julius S. Held writes:

[8] Sketch in the Metropolitan Museum of Art.

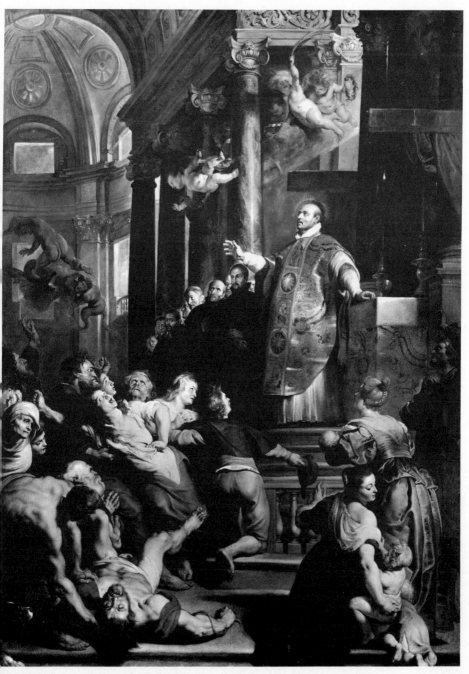

43. Peter Paul Rubens, *The Miracles of St. Ignatius of Loyola*, 1617–1618

Standing on a sphere encircled by a serpent whose head he crushes with his foot, Christ elevates the eucharistic chalice and host with his right hand and holds the labarum in his left. A skeleton underneath the sphere is death overcome by the life that is in Christ. God the Father and the Holy Ghost are above Christ in the central axis of the picture, and nine small angels holding eucharistic attributes . . . are distributed among the clouds. These objects are two candles, a cross, a bell, a ewer and towel, a missal, altar-cruets, and a censer; a scroll-like object held by a small angel in the upper right may be a stole. The two figures at the left are Old Testament personages with particularly close connections to the eucharist: the high priest Melchizedek who offered Abraham bread and wine . . . and Elijah, the pretended founder of the Carmelite order. . . . At the right are St. Paul, intimately connected with the eucharistic sacrifice because of I Cor. 10:16 . . . and I Cor. 11:28–35, and St. Cyril of Alexandria who in the Council of Ephesus had upheld the orthodox view of the eucharistic sacrifice.[9]

Held's entries of over 450 oil sketches testify to Rubens's prodigious output, and most of the sketches are of religious subjects: Old and New Testament figures and scenes, saints, and doctrines particularly germane to the Counter-Reformation, such as the Coronation and Assumption of the Virgin, and, of course, the Eucharist. Most of these works were commissions for churches, chapels, convents, or monasteries. Private commissions were frequently intended as gifts for particular religious establishments and, on occasion, for private chapels. Rubens's religious works were for the church.

Stylistically, the works for the church were similar to other subjects, though Rubens's exquisite portraits are unique. The religious works are always expressive of their themes, the human visage conveying the pain and joys of the event. The final paintings are larger in scale than is the case with most of the artists of the time, and the human figures frequently border on the corpulent, a fact of which we are conscious both because many today prize more slender figures and because the exposure of the human flesh makes this fact more pronounced to our eyes. Although Rubens was criticized by a few in his own time for the exposure of parts of the human anatomy, the fact that it was so readily accepted in his own time indicates that there was no reluctance to find in the flesh a medium that can disclose the spirit.

If Rubens is the master of the baroque in painting, Bernini can be said to be its master in sculpture and architecture. Among his secular works, one

[9] Julius S. Held, *The Oil Sketches of Peter Paul Rubens*, (Princeton, NJ: Princeton University Press, 1960) 1:529–30.

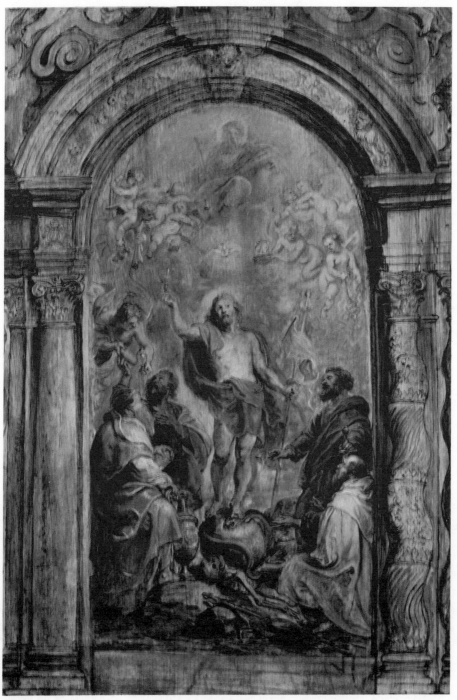

44. Peter Paul Rubens, *The Triumph of Christ over Sin and Death,*
 ca. 1615–1620

thinks of the *Fountain of the Four Rivers* in the Piazza Navona, the *Triton Fountain* in the Piazza Barberini, and the *Elephant Carrying Obelisk* in the Piazza della Minerva, all in Rome. The Colonnade of St. Peter's, which Bernini himself characterized as symbolizing the church taking us into her arms, and the interior and exterior of the Church of San Andrea del Quirinale are excellent examples of his architectural creations. Within St. Peter's, Bernini did the *Cathedra Pietri* in the apse, the *Tomb of Alexander VII*, the *Praying Angels* and *Ciborium* for the Blessed Sacrament Chapel, and, most well known, the immense baldacchino directly under the dome of St. Peter's. The baldacchino, with its combination of architectural and sculptural motifs, typifies the baroque in its combination of classical forms with immense vitality and graceful curves that seem undulating in their very nature.

Bernini was also the master of the human visage. In addition to the *David* (plate 39), one may note the sculpture of *Truth Revealed by Time*, which is now located in the Borghese Gallery, with its nude female body, the pudenda covered, and a face that almost seems to suggest that it knows too much. But the most expressive of all of Bernini's sculptures is his *Transverberation of St. Teresa* (plate 45) in the Cornaro Chapel in Santa Maria della Vittoria, Rome. It is based on a moment in the transport of the soul in a mystic vision. St. Teresa, who along with St. John of the Cross defines the spirit and nature of Spanish mysticism, has given us precise accounts of her spiritual pilgrimage. To understand her and the mystic vision, it is important for us to understand that the moment of transport, frequently called the dark night of the soul, which simultaneously is the moment of indescribable illumination, stands at the end of a process of practice and discipline. It is the event in which for a moment one is lifted, body and soul, into eternity; it is the birth of God in the soul, an indescribable ravishing of the human body. Such visions, over which one has no control, occur as an invasion of the self in psychic and bodily transfigurations to those who exercise a discipline designed to remove the pull of the world and elevate the soul toward God. Having followed such a practice, one knows how to wait.

Undoubtedly Bernini based his composition on a repeated vision that St. Teresa recorded.

> I would see beside me, on my left hand, an angel in bodily form. . . . He was not tall, but short, and very beautiful, his face so aflame that he appeared to be one of the highest types of angel who seem to be all afire. . . . In his hands I saw a long golden spear and at the end of the iron tip I seemed to see a point of fire. With this he seemed to pierce my heart several times so that it penetrated my entrails. When he drew it out, I thought he was drawing them out with it and he left me completely afire with a great love for God.

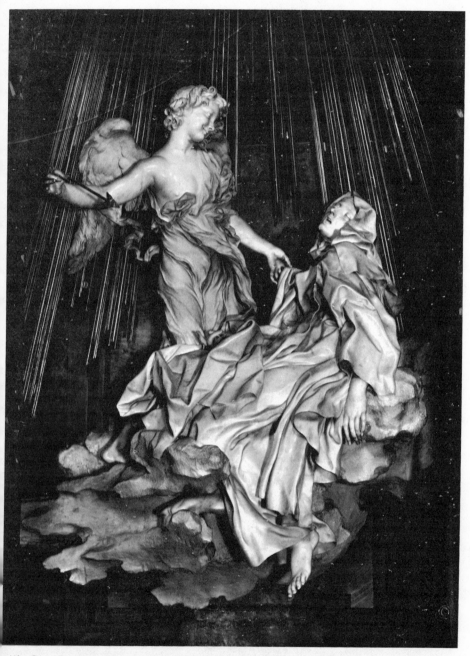

45. Gian Lorenzo Bernini, *Transverberation of St. Teresa*, 1647–1652

The pain was so sharp that it made me utter several moans; and so excessive was the sweetness caused me by this intense pain that one can never wish to lose it, nor will one's soul be content with anything less than God. It is not bodily pain, but spiritual, though the body has its share in it—indeed, a great share.[10]

The sculpture, deliberately placed just above eye level, includes the angel with spear and St. Teresa in ecstasy. It is not clear whether the spear is about to be used or has been used; indeed, the postures are symbolic, not literal, renderings of the event that causes Teresa's ecstasy. The angel's face has the expression appropriate to a happy messenger and executioner of an act, but St. Teresa's face shows protruding eyes half-closed in pain, her mouth open, as if moans of pain and pleasure occurred simultaneously, while her body is relatively relaxed. The sexual analogy, which William James characterized as an endless amatory flirtation with God, is explicit without embarrassment. God is the ravisher of the body, and God's presence transports and transfigures. Bernini's *St. Teresa* is the most intense expression of the Roman Catholic baroque in its physical portrayal of the effects of God's presence at a miraculous moment.

Protestants who stress the spiritual presence of God in nonphysical form and contemporary Roman Catholics who have lost this seventeenth-century ethos have difficulty in coming to terms with depictions such as Bernini's *St. Teresa*. Baroque art is a two-edged sword, for the source of its strength is also the possibility of its corruption. Yet the ironic fact is that the corruption came not in a physicality that bordered on an unacceptable sexuality but in the loss of the vitality and energy which had gone into baroque art. When the ethos disappeared in which the energy of God expressed itself in the vitalities of the human body, art expressed religious subjects not in ecstasy but in melodrama or sentimentality.

Rembrandt

With Rembrandt we enter into the baroque in a Protestant form, though without reference to the church. Except for the Lutherans, Protestants had banished the visual arts from the churches. The result was that the Protestant church was not a patron of the visual arts. Religious subjects were done by artists either out of an inner necessity, with the hope for a sale, or sometimes for a specific patron.

[10] Robert T. Petersson, *The Art of Ecstasy: Teresa, Bernini, and Crashaw* (New York: Atheneum, 1970) 40.

In only one instance do we know of a series of works by Rembrandt possibly intended for a liturgical setting, the series on the passion commissioned in the 1630s for Prince Frederick Henry, head of the Dutch state, probably for his chapel. In a letter to Constantin Huygens, who probably secured the commission for Rembrandt, Rembrandt writes: "I hope that you will be so kind as to tell His Excellency that I am diligently engaged in completing the three Passion pictures, which were ordered personally by His Excellency: an *Entombment*, a *Resurrection* and an *Ascension of Christ*, which will be pendant pictures to the *Elevation* and the *Descent from the Cross*." [11] Apparently Rembrandt's style changed in the protracted period in which he worked on these paintings, and, in apology for the delay, he gave the Prince another painting, *The Blinding of Samson*, a large painting unpleasant in the depiction of its subject.

The five paintings for the prince, which are now in Munich, belong to the early period of Rembrandt's painting career and reflect his indebtedness to the traditional baroque and his simultaneous unease with it and the classical conceptions of beauty and form. Certainly his *Samson and Delilah* (1628) and his *Sacrifice of Abraham* (1635) reflect the baroque in the dramatic action and energy seen in bodily shapes and tensions. His *Death of the Virgin* (1639) also indicates his then-willing association with the Roman Catholic life of Amsterdam. But his transformation of the subject is already evident in the depiction of the dying Virgin. While the other figures reflect a baroque posture, the Virgin, "instead of an idealised head with upturned eyes," has "the misery of extreme sickness. The Virgin—no doubt inspired by his wife, Saskia, who in course of four difficult confinements spent much of her time in bed—is too weak to raise her head, but one of the apostles does so, with his hand behind the pillow, and with the other hand wipes the sweat from her upper lip." [12]

Rembrandt's transformation of the baroque, partially evident in this etching, involved a transition from dramatic effects and actions displayed in bodily postures and contours to the depiction of God's presence in inner psychic states of composed, relatively inactive individuals. It is as if the action emanated from the countenance of one figure, as in the case of the Christ figure, or from countenance to countenance without dramatic action. Moreover, the depiction of humans has changed from the ideal figure to actual humans in their unique, ordinary selves.

Inasmuch as transworldly realities are still expressed through the human body, one can talk of the transformation of the baroque. Insofar as the style

[11] Elizabeth Gilmore Holt, *Documentary History*, 199–200.

[12] Kenneth Clark, *Rembrandt and the Italian Renaissance* (New York: New York University Press, 1960) 20.

has dramatically changed, it is a shift from what is popularly called the baroque style. Most of all, however, Rembrandt can be said fully to represent a style based on a Protestant faith. Cranach and Dürer, stylistically and theologically, were still so much in the Renaissance spirit that their art has few traces of the new religious sensibility.

Rembrandt's own religious history is clear only in its major outlines. Baptized in the Reformed faith, Rembrandt painted his mother, born a Roman Catholic, reading her breviary. Throughout his life there is evidence of his continued formal association with the Reformed church, though he was apparently not an active churchman. We know of his associations and friendships with Mennonites, who may have influenced some of his work, and of his sympathetic acquaintance with the Jewish community. Essentially, Rembrandt was nourished by his reading of the Bible, which was relatively free of the theological assumptions of the conservatives and the liberals of his time. His educational background would probably not have equipped him for theological subtlety. But he did combine an artistic gift with a keen sense for the center of the Protestant faith and how it affected human life.

Rembrandt was the master of both paintings and etchings. Since etchings could be sold more easily for the home and the public market, whereas a painting needed a patron, Rembrandt gave considerable time to his etchings. Further, etchings were particularly suited to the Protestant cause, for they made it possible to have works of art in private homes relatively inexpensively. Private meditation involving such art works was acceptable to Protestants, but their liturgical use in churches was not, partially because of the rejection of most of the Roman Catholic subjects and partially because public services were not liturgical in character.

The new style and content of Rembrandt's paintings and drawings are seen most clearly when one contrasts the same subjects depicted in the 1630s and then in the 1640s. The oil painting of *The Holy Family* of 1631 (plate 46) shows the Christ child having just fallen asleep on his mother's lap, her nursing breast still exposed, with Mary and Joseph looking intently at the child. In *The Holy Family with Angels* of 1645 (plate 47) Mary apparently interrupts her reading of scripture to look at the child in the crib, while Joseph is doing some carpentry work just behind both Mary and the child. In the upper scene, behind all three figures, are several angels. Whereas the earlier *Holy Family* shows the figures interacting with each other, in the later version each figure is self-contained, full of a radiance that is the basis of the suggested relations among the figures. The angels in the background seem traditional, perhaps because there had not been the same controversy concerning them as there had been about the saints.

Two additional paintings particularly exhibit the Protestant consciousness,

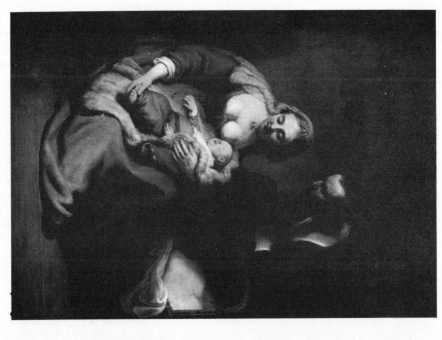

46. Rembrandt van Rijn, *The Holy Family*, 1631

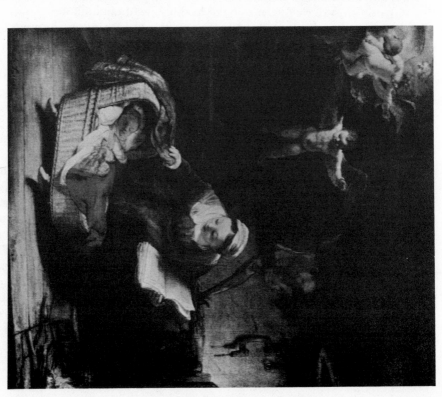

47. Rembrandt van Rijn, *The Holy Family with Angels*, 1645

The Supper at Emmaus and *The Return of the Prodigal Son.* In the light of the eucharistic interpretation of the Last Supper among Roman Catholics at the time of Rembrandt, as well as his own predilections, he turned to *The Supper at Emmaus* (plate 48), where Christ was recognized in a post-resurrection appearance in the breaking of bread. Christ sits behind the square table directly facing us, with the radiance of his face reflecting a slight halo. Although the figures are related to each other compositionally, the relation among the figures is not dramatic. It is a quiet scene in which countenance speaks to countenance. *The Return of the Prodigal Son* (plate 49), a subject particularly popular among Dutch Protestants and Protestants generally as expressing the essence of God's gracious news without reference to merit, shows the father accepting the son with a tenderness that does not blink at either the deed or the repentance. The event is simply there, as if father and son existed alone on a new plane. The tender face of the father discloses a graciousness that reaches out to those who see his towering body above the son. The son's face is buried in the father's chest, and the father's hands are over the son's shoulder.

Among the best known of the etchings is *Christ Healing the Sick* (plate 50), known as the hundred-guilder print because of the price it once brought at auction. Based on Matthew 19, the painting depicts the crowds around Christ during his mission of healing. Rembrandt alludes to rather than directly addresses the debate with the Pharisees over divorce, by depicting the Pharisees in conversation at the upper left of the painting. Central, distinct, yet related to the crowd is the figure of Christ with outstretched hands and a countenance that appears transcendent. Over against Peter, who is trying to keep petitioners away, Christ welcomes them—women with children to be healed and others brought in because they could not come under their own power. Even the rich young ruler is thoughtfully present. In short, Rembrandt has produced a kaleidoscopic summary of Christ's healing ministry in one etching.

Similarly the etching *Christ Preaching* (plate 51) is not a single episode of scripture but reflects a summary of the gospel, in which the Christ figure, whose role represents the forgiveness of sins, is also the proclaimer of that gospel. The crowd is not large, in contrast to paintings by other artists of the time, but many conditions of humanity are represented.

Among the later etchings of Rembrandt are *The Three Crosses* (plate 52), a composition which he repeatedly revised and which, through the reworking of the plate, became darker and darker as successive revisions were printed. The crosses are in the same position throughout, with that of Christ dominating the scene, but a major difference occurs between the first and the fourth state of the series. William H. Halewood writes of the first version:

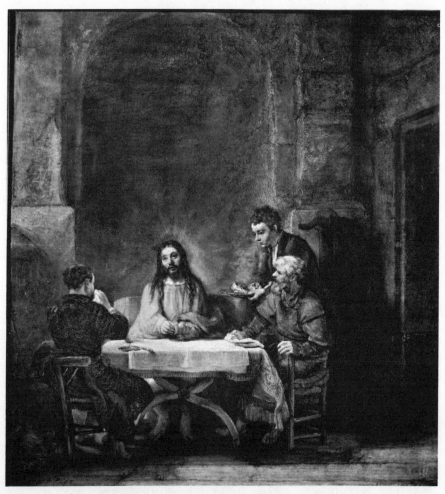

48. Rembrandt van Rijn, *The Supper at Emmaus*, 1648

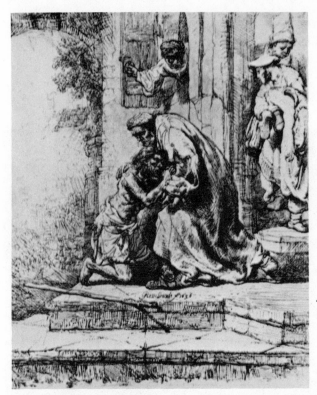

49. Rembrandt van Rijn, *The Return of the Prodigal Son*, 1636

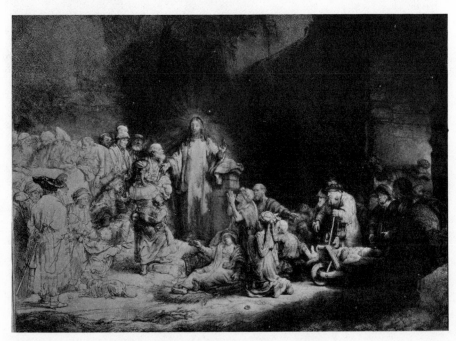

50. Rembrandt van Rijn, *Christ Healing the Sick*, ca. 1649

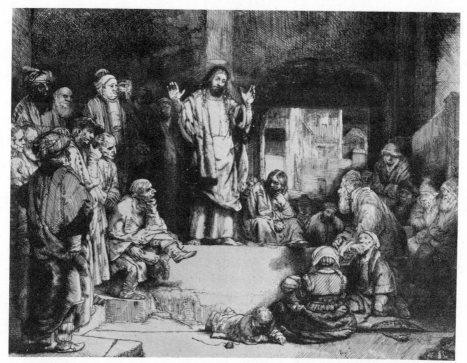

51. Rembrandt van Rijn, *Christ Preaching*, ca. 1652

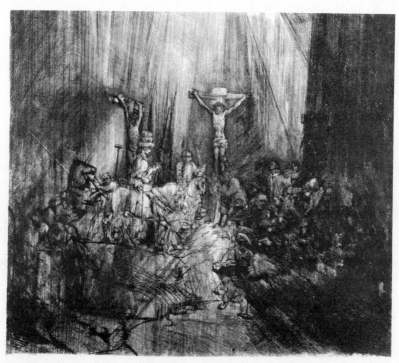

52. Rembrandt van Rijn, *Three Crosses*, ca. 1653

The scene . . . is crowded and miscellaneous and surrounded by the darkness which fell at the sixth hour. The three figures on their crosses loom above a busy crowd of soldiers, mourners, and "them that stood by." There are signs of hurried leaving. The two figures scuttling away in the foreground may be making haste because of the barking dog or because of the supernatural upheavals in the landscape. A group to the left moves away more sedately, turning its back on the central drama of the centurion recognizing God. Indeed, Rembrandt isolates the centurion both from his men, who go on about their soldiers' business, and also from the group of Christ's people, who are too intent upon their sorrow to notice Their grief is for the loss of their human friend—Christ as man—whereas the centurion, shocked into adoration, is seeing God.[13]

Then, as if to drive home the Reformation point still further, Halewood adds: "The wind of mercy, blowing only where it listeth, improbably picks from among the jeering executioners."[14] Of the fourth state in the series, Halewood first describes the scene as follows: "The Biblical tale, for one thing, is no longer told: the figures of the mourners have become indistinguishable, though the darkness contains huddled misery; other actors, such as the chief priests, scribes, and elders, are entirely missing; one of the crucified thieves has been absorbed in the darkness."[15] In short, no one seems to be focused on the cross; they concentrate instead on their own confusions. Halewood's conclusion regarding this fourth etching in the series is that "Rembrandt's rigidly self-enclosed horseman, turned the opposite way and ignoring the offer of reconciliation from the cross, seems a clear enough attempt to illustrate a predicament regarded by the Reformation as identical with the human condition. The characteristic and essentially human response of man is to reject his true good."[16] One can conclude, on the basis of Halewood's analysis, that the series discloses two aspects of Reformation consciousness: first, the mystery of the centurion's faith, and, second, the disregard of humanity for its own good, expressed in nonrecognition, a sign of its own sin and alienation.

Rembrandt's artistic style and Reformation consciousness form a whole; style and content are matched. But it was not a liturgical art or one created for a church setting. It was a meditative art, one that centered on the individual consciousness, on the states of soul in themselves and then on the relation or nonrelation to others. It could perform a preparatory function in relation to the liturgy. Its emphasis, in any case, was on the difference

[13] William H. Halewood, *Six Subjects of Reformation Art: A Preface to Rembrandt* (Toronto: University of Toronto Press, 1982) 128–29.

[14] Ibid., 129.

[15] Ibid., 131.

[16] Ibid., 133.

that grace makes in specific situations, a mirror of the gospel message. It had little to do with human community, except the community of sinners or humanity in its problems. Rembrandt was the painter of the grace of God, exhibited to the unworthy, the unimportant, those without merit, in such a way that only the grace of God mattered. Rembrandt was unique not only in his own right but also in that he had no successors. Protestantism had not and has not been expressed that well by other painters. Indeed, succeeding artists who were Protestants and Protestant groups who became open to the visual arts looked elsewhere rather than to the type of biblical consciousness that Rembrandt expressed.

Catholic and English Directions

Within Roman Catholicism the visual arts continued with a baroque emphasis well into the nineteenth century. In the eighteenth century rococo developments occurred in southern Germany and in parts of Italy, particularly in the work of Giovanni Battista Tiepolo in Venice. In this art, light and whiteness became dominant and the figures became more svelte. It was a playful art, joyful in its expression of the faith. Precisely that aspect puzzled Roman Catholics and Protestants alike whose characteristic mien was seriousness. Diverging conceptions of truth characterized the eighteenth century—both a reasoned seriousness and a joyful triumphalism.

Predominantly throughout Roman Catholic countries and constituencies a chaste form of the baroque held sway. However, an emerging interest in the neo-Gothic style, which became prominent in the latter eighteenth century, and then in the romantic style, which significantly entered the scene at the turn into the nineteenth century, also influenced art placed in the churches. This was particularly true in France, where the artistic tradition exhibited both the influence of the church and the increasingly anti-clerical opposition that stemmed from the French Revolution. In countries dominantly of the Protestant Reformed tradition, art continued to remain outside the church, though painters still drew on Christian subjects either for private commissions or because the traditions of art and the predilections of their own psyches so dictated.

In the English scene in the latter half of the eighteenth century a significant attempt was made to reintroduce painting into the Anglican tradition, which prior to the Tractarian movement of the mid-nineteenth century was essentially Protestant in its theology. That is, it was inimical to the visual arts. Stained-glass windows had been installed in Westminster Abbey and colleges at Oxford and Cambridge. However, when a window that was originally given by the magistrates of Dort to Henry VII for Westminster

was installed in St. Margaret's, Westminster, a lawsuit was brought against two of the wardens for reintroducing popery because the design included the images of Christ and the devil. At St. Paul's, London, a piece of sculpture had been offered to the church, and, although the officials were interested, the sculpture was rejected by Bishop Osbaldeston sometime before 1758, the year of the bishop's death. In 1773, when Thomas Newton was dean of St. Paul's, another attempt was made to reintroduce art, this time in paintings. It was known that paintings had been installed in cathedrals at Salisbury, Winchester, Rochester, and St. Stephen, Walbrook, London; in the last three instances, each had a religious painting by Benjamin West. Also, in support of the attempt reference was made to the Thornhill paintings of episodes from the life of St. Paul in St. Paul's Cathedral. But few paid attention to the paintings since they were so high in the dome and hard to see. However, a controversy had arisen when they were commissioned, a Roman Catholic artist being rejected even though he had been appointed to do the dome. England self-consciously thought of itself as a Protestant nation, a fact symbolized in the introduction of the Hanover line for the English crown.

Believing that the role of art in society depended on the patronage of the church, the Royal Academy proposed, largely through the initiative of Joshua Reynolds and Benjamin West, that certain of its members give a painting for installation in St. Paul's, thereby setting a new pattern. Dean Newton and the cathedral chapter were in favor, and George III offered his approval; but Bishop Richard Terrick of London and Frederick Cornwallis, the archbishop of Canterbury, disapproved. George III chose not to push the matter. Later, a proposal that a painting by Reynolds and a painting by West be hung discreetly in St. Paul's was also vetoed.

George III decided that he might be able to promote a pattern of art in the church by having Benjamin West do paintings for a private chapel at Windsor. Although the chapel was never completed, West, with the help of various Anglican bishops, created a dispensation scheme for the proposed Chapel of the History of Revealed Religion. During the years in which West executed the oil sketches and paintings for this project, his style changed from neo-classical to romantic. In fact, his *Death on a Pale Horse* (plate 53), exhibited in Paris in 1803, received wide attention as an early expression of the romanticism of the sublime.

The chapel paintings, divided approximately equally between Old and New Testament themes, would have created an encompassing pictorial environment. Finally, however, the long friendship of George III and West disintegrated into disagreements over political and stylistic issues, and the project was abandoned. The extant paintings were subsequently sold, a

53. Benjamin West, *Death on a Pale Horse*, 1817

fifth of them today residing in the chapel and museum at Bob Jones University in South Carolina.

During the twenty-year period in which West was working on paintings for the king's private chapel, he was actively involved in additional projects. Also for George III he did stained-glass designs and a *Last Supper* for St. George's Collegiate Chapel at Windsor. For the Foundling Hospital, an institution committed to providing a total cultural and religious environment for its children, West did a painting entitled *Christ Blessing the Little Children*, which can still be seen in the administration building of the hospital. For St. Paul's, Birmingham, West did three paintings focusing on *The Conversion of St. Paul*, though today the paintings are to be found in the Smith College Museum of Art, Northampton, Massachusetts. For the Church of St. Mary-le-Bone, London, West did a transparency of *The Annunciation* (which had already disappeared by the nineteenth century) and an oil painting, *The Nativity* or *Holy Family*, which today can be seen at the end of the left aisle of the church. For William Beckford, the eccentric literary and political figure, West did scenes from the book of Revelation for a chantry chapel, a work not completed. Only in the Chapel of St. Peter and St. Paul at the Royal Naval College, Greenwich, does one have the placing of West's paintings as one would have seen them in the last decade of the eighteenth and the early nineteenth century. Here West's large painting *St. Paul and the Viper* still dominates the apse wall, since the pulpit, originally three stories high, was removed from a central position in front of the painting. In addition, West did designs for other paintings and fittings in the chapel, though they were executed by others.

Although West's paintings for the Chapel of the History of Revealed Religion and for other church projects are not in their intended locations and his large religious paintings of the latter years (for example, *Death on a Pale Horse* [plate 53], and *Christ Rejected*, both at the Pennsylvania Academy) were intended for public religious spaces, West did give the impetus to the reintroduction of the visual arts in the English churches. That reintroduction did not happen extensively, however, until the mid-nineteenth century as a consequence of the Tractarian movement.[17]

[17] For the role of Benjamin West, see John Dillenberger, *Benjamin West: The Context of His Life's Work* (San Antonio: Trinity University Press, 1977).

5

THE NINETEENTH CENTURY AND ITS DIVERSE DIRECTIONS

THE TYPE OF ART represented by Benjamin West and the circle of the Royal Academy in London, or by the American artist Washington Allston, was rooted in the tradition of the church, even though the Protestant churches had no interest in that artistic heritage. The traditional subjects and their iconography were generally accepted, while new painting styles were sought and experimented with, such as in the transition from the neo-classical to the romantic and the sublime.

Roman Catholic Art in France: Eugène Delacroix and Edouard Manet

Even Eugène Delacroix, involved in a French Roman Catholicism tempered by the considerable anticlericalism in the decades leading to the midnineteenth century, worked with the traditional subjects and a romantic style, though he cast his subjects with a uniquely personal vision, uneasy with the inheritance. Baudelaire recorded in his journal of 15 February and 1 March 1847 that "he alone [Delacroix] in our unbelieving age, conceived religious pictures which were neither without meaning nor cold." Delacroix, aware of the grand and the terrible in Christian history, though he grew up in an atmosphere alien to religion, readily transformed a history he could not expunge into the way its events appeared to him. Surely that ambiguity is evident in his paintings in the churches of St. Paul-St. Louis and St. Sulpice in Paris, in *Christ Falling under the Cross*, in *Christ on the Cross*, or in *The Entombment* (plate 54).

That uneasiness with tradition and the inability to let it go are also evident in the work of Edouard Manet. His *Dead Christ*—or *Angels at the Tomb of Christ* (plate 55), as he called it when it was exhibited at the Salon

103

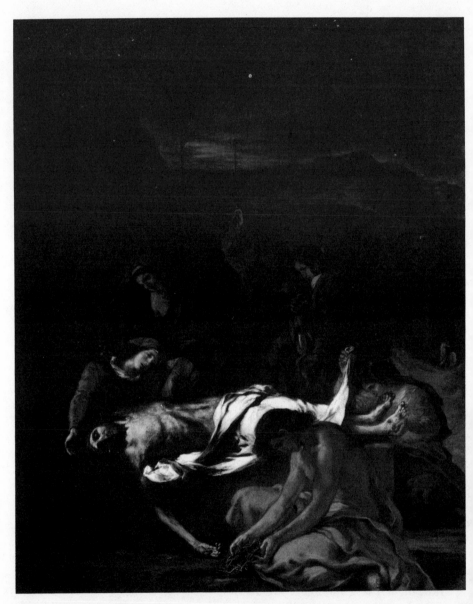

54. Eugène Delacroix, *The Entombment of Christ,* 1848

in 1864—and his *Christ Mocked* of a year later, frontally present the Christ figure to us. In the *Dead Christ* the Christ figure has all the characteristics of death—indeed is called a cadaver at the time—but still carries all the marks of human suffering. Similarly, in *Christ Mocked* (plate 56) the living pain is evident. Antonin Proust recorded that Manet had wanted to do a Crucifixion, stating: "The Crucifixion, what a symbol! One could search until the end of time and find nothing comparable. Minerva is fine, Venus is fine. But the heroic image, the image of love can never be worth as much as the image of sorrow. That is the root of human nature—in it is the poem."[1]

Both in the paintings and in this statement the traditional interpretations of Christianity are no longer present, but the suffering of Christ becomes a metaphoric or heraldic reality exemplifying human suffering. It is not that human sufferings are projected onto Christ; rather, Christ is the paradigm of suffering, the figure through whom we see our suffering. In one sense nothing could be more central to a Christian understanding; in another sense nothing could be farther removed. For suffering is defined only in terms of itself without its overriding redemptive meaning in Christian history. In Manet's own day the critics saw these paintings as ignoble, as a caricature of religious subjects.

Seeking New Directions:
Caspar David Friedrich

Delacroix and Manet represented two ways for artists to respond within the Roman Catholicism of France in the nineteenth century. The unease about both art and religion in Europe and in the United States in the nineteenth century took other forms as well. A group of artists who started a brotherhood in Rome, the Nazarenes, dedicated themselves to returning to the style of the early Renaissance. By and large these artists, trying to repristinate a past, did not affect the future, and of its members only Johann Friedrich Overbeck has a place in history.

Roman Catholic theology continued to be Scholastic in the definitional sense, as did much Protestant theology. Right belief was the test of faith. In a world of expanding knowledge, much of it associated with, though not necessarily requiring, secular presuppositions, theology had become defensive and declarative. Some who could accept neither the dogmatic theology of the traditions nor the new secular knowledge turned to a piety that substituted the experiential for epistemological categories, thus turning

[1] Anne Coffin Hanson, *Manet and the Modern Tradition* (New Haven, CT: Yale University Press, 1977) 107.

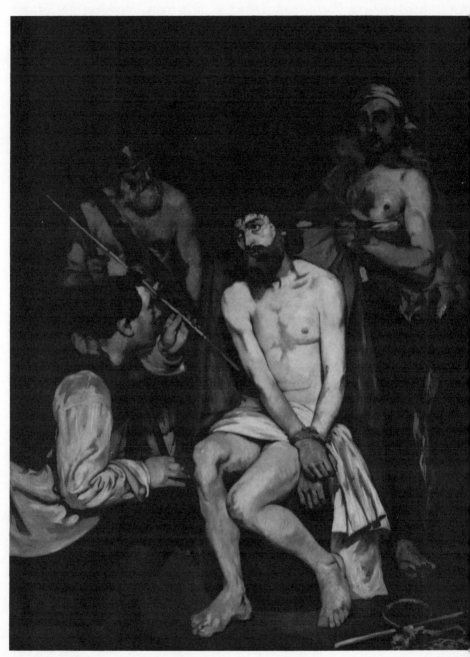

56. Edouard Manet, *Christ Mocked*, 1865

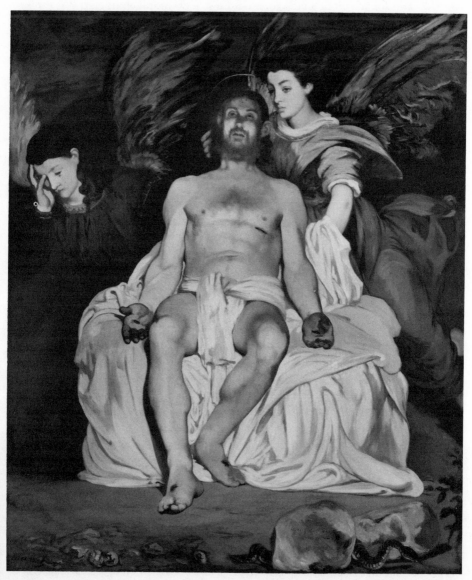

55. Edouard Manet, *Dead Christ*, or *Angels at the Tomb of Christ*, 1864

thought aside. The philosopher Imanuel Kant had limited knowledge to the confines of the Newtonian world in order to make room for faith, though the faith for which he made room had a strictly moral character. But if his making room for faith over against the orthodoxies of his time unduly limited the nature of faith, his denomination of the arts as an arena unto itself protected them from being adjunctive to other disciplines. (Eventually Kant's position fed the notion of art for art's sake, a slogan that can be attacked or defended, depending on the perspective from which one comes.) Kant saw that art, which in the past had freely shared in the assumptions of a culture, would lose its nature if it continued to do that; it needed its own niche or role, an independent role that it has experienced ever since.

There were also new directions in theology. Aware that theology as either ethics or knowledge had no future, Friedrich Schleiermacher defined religion as a third, new, *sui generis* category. Whether defined as sensing the infinite in the finite, intuiting the universe, the feeling of absolute dependence, or religious affections set forth in speech, Schleiermacher's religion sought ways to express the conviction that ultimacies are experienced in themselves without the traditional mediation of thought or act. Religion is something foundational to both thought and act.

Schleiermacher had given an independence to religion that Kant had given to art. It is therefore not by accident that Schleiermacher saw analogies between art and religion and was himself a member of a group of literary and visual artists, among whom the literary figure of Frederich von Schlegel alone is remembered, whereas the painters are mainly forgotten. On the other hand, Caspar David Friedrich has had a come-back in the last decade,[2] and it is known that Schleiermacher visited Friedrich in Dresden and was involved in getting Friedrich to exhibit in Berlin.[3] Although Schleiermacher may have been naïve in believing that if artists really knew what religion and Christianity were about they would join with him, it is true that he and they shared an aversion to life defined as knowledge, science, or duty. It was perhaps inevitable that nature, whether viewed while rambling through a park or sensed through its newly discovered infinities, provided fresh perspectives that nourished the human psyche.

The artist Caspar David Friedrich expressed the new direction. Whether

[2] During the summer of 1985, there were a number of Caspar David Friedrich exhibits in Europe, including in Munich and Zurich.

[3] See Peter Krieger, "Caspar David Friedrich, " in *Gemälde der deutschen Romantik aus der Nationalgalerie Berlin* (Kunsthaus Zürich; Berlin: Frolich & Kaufman, Berlin, 1985) 9, 10, 13.

57. Caspar David Friedrich, *Cross in the Mountains*, 1808

it is the *Monk by the Seashore* (1809), *Two Men by the Sea* (1817), or *The Sea with Sunrise* (1826), the mystery of nature, that which is beyond it but in and through it, captures our imagination. In the *Cross in the Mountains* (1808) (plate 57), we have a central rock, with fir trees growing on and around it, against a light-filled sky. On the rock is a cross with corpus, the kind that one sees at outdoor shrines. Here the traditional symbol remains, but it is overshadowed or, rather, outshone by the firmness of the rock, the presence of the green firs, and the undulating light. Friedrich himself stated that "the cross stands high on a rock, firm and unshakable like our faith in Christ. Fir trees surround it, lasting through the season, like our hopes in Him who was crucified."[4] In *Cross and the Cathedral in the Mountains* (1813), an outdoor cross and corpus are set behind a stream in the midst of rock boulders, behind which one sees symmetrical fir trees, and behind which in turn rises, as if floating, the facade of a Gothic cathedral. While the crucifix and cathedral hold center stage, the trees, rocks, and stream command our attention. Again, the natural and the Christian are ambiguously mixed. It is not unusual for artists at this time to include Gothic cathedrals, perhaps not so much for their own sake as because they mirror the heavenly, transworldly dimensions exhibited in the affinity between the heaven-aspiring trees and arches. In a painting free of traditional Christian symbolism but combining sea and ships, entitled *Stages of Life* (1818), there appears the "overall metaphor of a life cycle, symbolized by the progression from youth to maturity to old age in the five figures on the shore (of whom the children, in imitation of a ship, raise a flag on high) and echoed in the differing positions of five ships moving from the horizon to the eternal rest of the coast."[5] One is reminded of Thomas Cole's paintings in the 1840s—his four paintings of *The Voyage of Life* and his previous five, *The Course of Empire*—or of the popular American prints of the stages of the life of woman or man or both.

Although Cole subsequently portrayed a more definitely Christian orientation in his series *The Cross and the World*, made possible by his new interest in the Episcopal Church, Friedrich was among a group who were interested in an alternative religious understanding of the world to that of the Christianity they saw around them. Even the Roman Catholic Friedrich von Schlegel wrote to Novalis: "I am thinking of founding a new religion or at least of helping to preach it. Perhaps you are better qualified to make a new Christ—if so, he will find in me his St. Paul."[6]

 [4] Robert Rosenblum, *Modern Painting and the Northern Romantic Tradition: Friedrich to Rothko* (San Francisco: Harper and Row, 1975) 26, 220.
 [5] Ibid., 33.
 [6] Ibid., 41, 221.

Controversial Christian Works:
Paul Gauguin and James Ensor

While the interest in a new approach to religion continued among artists and theologians until well into the twentieth century, there were artists in the same period who expressed Christian subjects in fresh forms, forms not acceptable to the church. Unorthodox though he was and with the seriousness of a comedian, Gauguin did several suggestive religious subjects. In *The Vision after the Sermon (Jacob Wrestling with the Angel)* (plate 58), painted in 1888 during his unhappy time with Vincent van Gogh in the south of France, Gauguin shows the struggle between Jacob and the angel occurring in a red field, while a tree trunk divides the event from the Breton peasant women viewing the scene. On the level of the viewer, it is almost like a human struggle; on our level, seeing both the observers and the event, we may be aware of its transcendent character, particularly through the medium of the dramatic color.

Gauguin offered the painting to the local priest, for he felt that it would fit well into the rather primitive architecture of the church. The priest rejected the offer, perhaps most of all because he did not believe artists such as Gauguin could be serious. Gauguin's *Yellow Christ* (plate 59), painted from a statue in a church placed outdoors and surrounded by worshipers, exhibits a similar, tantalizing ambiguity; but the angular face of Christ is deeply expressive. The ambiguity is even more accented in one of his first paintings done in Tahiti, *Ia Orana Maria* (plate 60), the equivalent of "Ave Maria." In the painting, a native woman with her son on her shoulder, both with halo, are the objects of reverence by two women facing them from the side, while an angel in the background points to the Tahitian Madonna and Child. The painting, combining incommensurables such as the Tahitian settings and Western subjects, obviously fits neither world. Yet, while crossing the cultural differences, combined as it is with Gauguin's unique color palette, the painting is more nuanced than the artist's simple objective of selling an exotic painting in Paris would indicate.

Gauguin's masterful painting *Where do we come from — What are we — Where are we going?* (plate 61), done in Tahiti near the end of his life and just before his unsuccessful suicide attempt, represents an alternative religious message to that of the Christian subjects he had painted. Gauguin describes the painting as follows:

> The two upper corners are chrome yellow, with an inscription on the left and my name on the right, like a fresco which is spoiled with age, and which is appliquéd upon a golden wall. To the right at the lower end, a sleeping child and three crouching women. Two figures dressed in purple confide their thoughts to one another. An enormous crouching figure, out of all proportion,

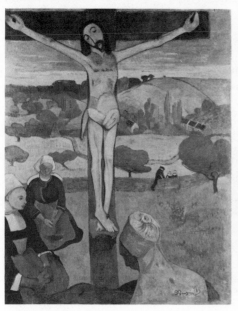

59. Paul Gauguin,
 The Yellow Christ, 1889

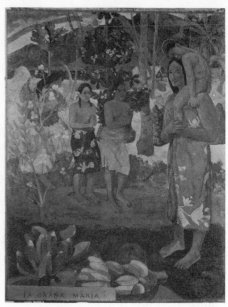

60. Paul Gauguin, *Ia Orana Maria*, 1892

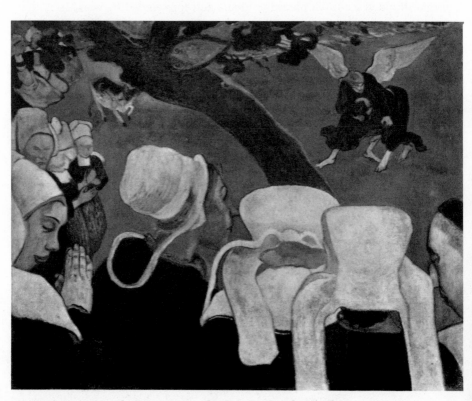

58. Paul Gauguin, *The Vision After the Sermon (Jacob Wrestling
 with the Angel)*, 1888

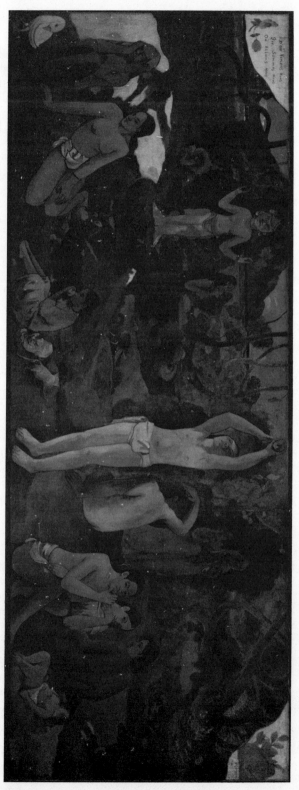

61. Paul Gauguin, *Where do we come from — What are we — Where are we going?,* 1897

and intentionally so, raises its arms and stares in astonishment upon these two, who dare to think of their destiny. A figure in the centre is picking fruit. Two cats near a child. A white goat [dark green in the painting]. An idol, its arms mysteriously raised in a sort of rhythm, seems to indicate the Beyond. Then lastly, an old woman nearing death appears to accept everything, to resign herself to her thought. She completes the story! At her feet a strange white bird, holding a lizard in its claws, represents the futility of words. It is all on the bank of a river in the woods. In the background the ocean, then the mountains of a neighboring island. Despite changes of tone, the coloring of the landscape is constant, either blue or Veronese green. The naked figures stand out on it in bold orange.[7]

Then, providing the title, he adds: "So I have finished a philosophical work on a theme comparable to that of the Gospel."[8] Whether couched in Christian or in other religious terms, the religious question was in Gauguin's bones, as his writings disclose.

The Flemish artist James Ensor also was haunted by the religious question and by the place of the Christ figure in human life. The titles of his paintings of the life of Christ (1885) indicate his admiration for the Christ figure and how he sees the events: *The Gay: The Adoration of the Shepherds; The Cruel: Jesus Presented to the People; The Ardent and Radiant: The Entry into Jerusalem; The Sad and Broken: Satan and the Fantastic Legions Tormenting the Crucified; The Tranquil and Serene: The Descent from the Cross; The Intense: Christ Ascending into Heaven.* Although some of these drawings, which were the basis of etchings, are reminiscent of Rembrandt, others show originality and imagination. In the following three years he produced such paintings as *The Dead Christ Watched over by Angels, The Cathedral, The Tribulations of St. Anthony,* and *The Rebel Angels Struck Down,* but it was his painting *The Entry of Christ into Brussels* (plate 62) in 1889 that created intense opposition, even to the point that it was not exhibited until 1929. This 8½- by 12-foot canvas is described by Libby Tannenbaum:

Faces quickly brought to life in a single sweep of a thick brush dipped into vivid color, multiply in a composition vibrant with pure, clear, and even harsh brilliance. The enormous canvas represents the whole contemporary Brussels world as it might come out into the streets to render gala homage to the entering Savior. The Christ himself, a tiny figure seated on an ass, is almost lost in the background. The real subject of the pictures is the delirious

[7] *Bulletin of the Museum of Fine Arts* 34 (Number 203, June 1936) 37.

[8] Ibid., 38. For an extensive treatment of Gauguin's religious views and works, see Ziva Amishai-Maisels, *Gauguin's Religious Themes* (New York: Garland, 1985).

62. James Ensor, *The Entry of Christ into Brussels*, 1889

mob, the soldiers, workers, rustics, the bourgeois around the platform in the foreground, who recognize this event as an occasion for the blaring horns of the town band and every sort of buffoonery.[9]

Yet we who see these mask-like figures can also see the Christ figure and, above all, the contrast between a vile, indifferent humanity and the Christ. Ensor, disillusioned by humanity to the point of being an observer, cannot let the Christ figure go, though he was anticlerical regarding the institutional church.

Christian Subjects in the United States and England

Concurrent paintings of religious subjects in the United States and England, although different from each other, showed less complexity. Thomas Eakins's *Crucifixion* of 1880 (plate 63) is powerful because of its intense realism. The crucifixion was unique as a subject in his work, but there is no profound religious affirmation inherent in its depiction or style. Henry Ossawa Tanner's *Annunciation* and *The Saviour* (plate 64) or Elihu Vedder's Lazarus paintings disclose a naturalness that is touched by an element of the haunted rather than mystery. Albert Pinkham Ryder's *Jonah* (plate 65), in contrast, evokes the full range of religious events and sensibilities. John Dixon, Jr., discusses the Jonah painting in terms of the range of its delineation of nature, God, and the Jonah drama. "The *Jonah* is one of the greatest sea paintings. . . . The Lord God controls the power of the earth and human tragedy. The will of the sea and the will of the human being are subject wholly to the will of God."[10]

These artists, to which one might add such names as Robert Loftin Newman, Moses Ezekiel, or William Rimmer, painted religious subjects without commissions for churches. Their depictions are competent, but neither their paintings nor their own psyches apparently were deeply involved in the subjects they portrayed. They expressed an art no longer nourished by the vital beliefs of a religious community.

Prominent among the few who received church commissions was the Roman Catholic John La Farge, whose only Roman Catholic commission was for the Church of St. Paul the Apostle in New York City. His main commissions were for Episcopal churches, such as Trinity Church, Boston,

[9] Libby Tannenbaum, *James Ensor* (New York: Museum of Modern Art, 1951) 74.

[10] John W. Dixon, Jr., "The Bible in American Painting," in *The Bible in American Arts and Letters*, edited by Giles Gunn (Philadelphia: Fortress; Chico, CA: Scholars Press, 1983) 171–73.

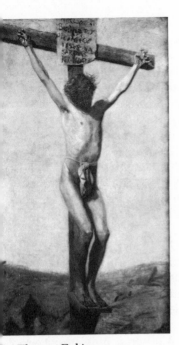

3. Thomas Eakins,
 Crucifixion, 1880

64. Henry Ossawa Tanner, *The Saviour*,
 ca. 1900–1905

5. Albert Pinkham Ryder, *Jonah*, ca. 1885

and the Church of the Incarnation, and the Church of the Ascension, both in New York City. Working in easel paintings, mural paintings, and stained glass (where he was noted for the discovery of an intensely opalescent glass), La Farge exhibited a wide-ranging competency. His *Visit of Nicodemus to Christ* (1880) (plate 66) represents academic painting at its best. It is more an illustration of the subject than an exercise in stretching our imagination. But La Farge does represent the return of the painting tradition to Episcopal churches on the eastern seaboard. The largest commission that had religious subject matter was not for a church but for the Boston Public Library, where John Singer Sargent conceived and carried out a design called *The Triumph of Religion* (plate 67).

Although the religious paintings in the United States reflected the continuation of subjects no longer nourished by the tradition, the pre-Raphaelite approach in England was a deliberate attempt to find nourishment from the past for the present. For this group, mainly represented by Dante Gabriel Rossetti, William Morris, William Holman Hunt, John Everett Millais, Edward Burne-Jones, and their prophet, John Ruskin, contemporary life was overly commercial, ugly, and full of social problems. They longed for a society formed by analogy to the Middle Ages and the Renaissance. Their art forms, from paintings to the craft tradition, were drawn from this earlier period, evoking a simpler life, humane but bordering on the sentimental. John Everett Millais's *Christ in the House of His Parents* or *The Carpenter's Shop* (plate 68) may serve as an early illustration of this group. Here we see the carpenter's tools, the bench, a floor full of shavings, and the figures posed as if they were models standing about. The painting evokes a simpler life-style than the one in which Millais lived, but it does not evoke religious sensibilites or mysteries.

Whereas paintings by Manet and Gauguin were unacceptable to the religious perceptions of the time, the paintings in the United States and England of the same period created little stir. Their style and content were largely illustrative of what people already believed or did not believe. It is not surprising, then, that some saw more religious significance in secular paintings of the time, such as works by Paul Cézanne or Vincent van Gogh, in which nature or natural things were painted as if their reality were laid bare. It is for this reason that Paul Tillich could say that "it is not an exaggeration to ascribe more of the quality of sacredness to a still life by Cézanne or a tree by van Gogh than to a picture of Jesus by Uhde." [11] It is a way of saying that artists, freed of a religious tradition that no longer informed them, were forming more fundamental perceptions in art no

[11] Paul Tillich, *The Religious Situation* (New York: Henry Holt, 1932) 57.

66. John La Farge,
 Visit of Nicodemus
 to Christ, 1880

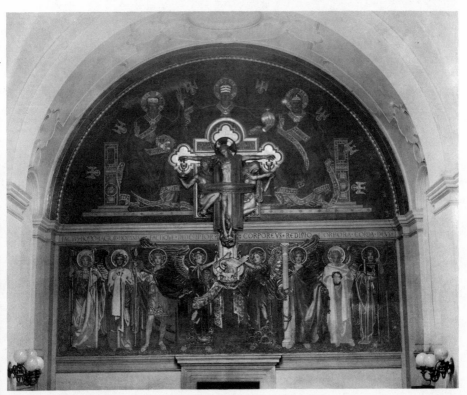

67. John Singer Sargent, *Dogma of the Redemption, The Triumph of Religion*, 1895–1919

68. John Everett Millais, *Christ in the House of His Parents*, or *The Carpenter's Shop*, 1849–1850

longer related to the conventional religious tradition. That divorce is evident in van Gogh, whose theological views are well known through his letters. This has made him a favorite of many theologians, but his art is free of those views in both style and content.

Expressionism as a Religious Medium

In the last decades of the nineteenth century and the first decades of the twentieth, a group of artists emerged whose expressionistic style was a vehicle for religious meaning. The style was sometimes free of traditional iconography and sometimes used it directly. Here the style discloses the tensions and anxieties of human life. Edvard Munch's nudes or *Madonna* (plate 69) disclose exquisite beauty, with touches of the ravages of time and of known vulnerability. *The Shriek* or *The Cry* shows a woman in unaccountable, intense fear, and *Jealousy* shows the contained explosive powers in a human triangle. In the *Dance of Life* the human drama unfolds through the images of a young woman, a woman united with a man, a woman in old age. This series is not unlike that used by other artists, but in Munch's work the psychic forces of each stage and their interrelations are inescapable. For Munch, psychic forces have religious meanings.

With Franz Marc and Wassily Kandinsky we have the beginning of abstraction as a vehicle for spiritual understanding. Since Kandinsky will be referred to later in the discussion of abstract expressionism, Marc is the subject of attention here. Believing that we must move behind and beneath appearances in order to see reality, Marc set the stage for abstraction and for alternatives to that which appears on the surface. Marc believed that the art of the past should simply be abandoned, for it no longer serves us. The human in humanity's venture has been lost or covered or cluttered. The truly original humanity is better represented through the animal world. In his early works he used sheep, with partly biblical allusion, as he did also in his *Young Boy with the Lamb* or *The Good Shepherd* (plate 70). But his repertoire of animals included weasels, deer, cows, and particularly horses. In abstracting from humanity's lot in order to locate the human, Marc used color more than sharp outline as an expressive medium. He used blue, yellow, and red, as did Kandinsky, to indicate various spiritual estates.

In such paintings religious factors are suggested but are hardly obvious. Marc was involved with Paul Klee, Oskar Kokoschka, Alfred Kubin, and Erich Heckel in an abortive art project on the Bible, for which he actually executed prints on creation, centering on the emergence of various species, as in *Birth of the Horses* (1913).

70. Franz Marc, *Young Boy with the Lamb,* or *The Good Shepherd,* 1911

69. Edvard Munch, *Madonna,* 1895

Two of the expressionist painters, Max Beckmann and Emil Nolde, executed specifically religious and Christian subjects. In 1908, Beckmann did *Resurrection*, modeled after Rubens and El Greco, with portraits, including himself, in the foreground. In 1916–1918, he returned to the theme of resurrection in a canvas that he never finished, in which doom—the effects of Word War I—is everywhere. In spite of the theme of resurrection, destruction is present in each of the various tableaux. Again, Beckmann is to be found among other portraits in the foreground. In *Descent from the Cross* (1917) (plate 71), the body of Christ is held by the soldiers, who are above the viewer's eye level, at an angle that moves from the lower left to the upper right of the painting. At the lower right, we look down on the mourning women, who no longer observe the cross. The eye moves to the Christ figure, dead but with traces of a human history. In *Christ and the Woman Taken in Adultery* (plate 72) of the same year, the same angular figures are present in a crowded scene; only the person looking from behind a fence has his eyes open. Christ is most conscious of the man behind the fence, as if he is already addressing those who wonder about the act of mercy that has just taken place; the woman still clutches Christ as he himself is already focused elsewhere.

Using subjects that are not specifically religious, Beckmann also executed several triptychs, a form consciously taken from the religious tradition, as in *Departure*. This painting is full of allusions to the events of the time, not literally but symbolically. Beckmann was dismissed from his university position, temporarily hid in Berlin, but in 1937 left Germany never to return. From 1933 on his paintings appeared in the Nazi exhibitions of decadent art, and in 1937 ten of them formed part of the large exhibition of alleged German degenerate art in Munich.

Emil Nolde also found his paintings among those considered decadent by the Nazis. Nolde himself was a Nazi, a Nordic with an antisemitic outlook, who only late in life, as he had to hide his paintings, began to see the problems in Nazism. Nevertheless, Nolde, politically naïve and full of prejudice, had tremendous sensitivity to the internal, if not external, dynamics of the gospel in the paintings he did prior to the rise of the Nazis. His style, particularly his brilliant use of color, made it possible for him to convey religious subjects with extraordinary power. In *The Last Supper* of 1909 (plate 73), Christ is the center, much as in Rembrandt's *Supper at Emmaus* (plate 48), but Christ holds the chalice as figures crowd around him. In the following year, Nolde did ten religious paintings, among which is the brilliantly colored, agitated *Dance Around the Golden Calf*. In 1911 he began the nine-part cycle of *The Life of Christ*, the center piece of which was the *Crucifixion*. In 1912 he did the striking triptych of *Mary of Egypt*, followed in 1915 by the *Entombment* (plate 74). In 1926 he did *Christ and the*

71. Max Beckmann, *Descent from the Cross*, 1917

72. Max Beckmann, *Christ and the Woman Taken in Adultery*, 1917

73. Emil Nolde, *The Last Supper*, 1909

74. Emil Nolde, *Entombment*, 1915

Adulteress, a subject that was depicted also by Beckmann, and in 1929 *Christ Among the Children*. Nolde's depictions were full of power and meaning, in contrast to the academic and obviously acceptable art that created no objection. From early on, long before the Nazis, his paintings were rejected for exhibition. Having bought *The Last Supper* for the Halle Museum, its director was officially censured for the act. Although the *Life of Christ* series was exhibited at the international exhibition in Brussels in 1912, it was rejected by Roman Catholic clergy. Protestants objected to his biblical paintings mainly because of the Jewish type of figures. His paintings thus found no place in the church.

II

THE
TWENTIETH
CENTURY

6

PERCEPTIONS OF THE SPIRIT IN AMERICAN PAINTING AND SCULPTURE

The Cultural/Theological Setting

In *The Education of Henry Adams*, published in 1918, the twentieth century opens with a chapter entitled "The Dynamo and the Virgin." Here Adams speaks of two contrasting powers, the one a power that had dominated European thought since the time of Constantine, the other a new power just then coming into being. The rivalry between the two was disturbing to Adams. The power of the Virgin had been unrivaled, but now it was becoming little more than an object of sentiment. The power of the Virgin had raised the cathedrals, those monuments of extraordinary religious and cultural imagination. Steam, Adams opined, could not build a cathedral. Steam could only create a factory or a business culture, being so relentless in its form that the human equation was absent.

Yet even Adams was fascinated by what the dynamo portended. He could not fully enter into its world, anchored as he was in the past, but he could watch, absorbed. There were other observers, less fascinated by the Virgin's power, who also were uneasy about this new dynamism in their midst. They, too, held that the new culture's formative energy pushed human perceptions aside and that the new culture exhibited no interest in forming new artistic forms. For business whatever was new was good; culturally speaking, the same individuals accepted only the repetition of the forms of the immediate past. Many artists were upset by the fact that the new industrial magnates, the harbingers in America of a new and vast patronage interest, were so singularly concerned with art of the European and sometimes of the Oriental past, and that they gave their support to an art establishment that repeated the past in the form of an irrelevant academicism. The distinguished sculptor Augustus St. Gaudens was a close

friend and sometimes a traveling companion of Henry Adams. Yet Adams was distressed that, culturally speaking, his friend understood the power neither of the Virgin nor of the dynamo. Instead of feeling the intense power of the Virgin or forcing something human from the dynamo, St. Gaudens simply rang dispassionate changes on older, elegant forms.

This familiar, late-nineteenth-century world of St. Gaudens, with its commonly accepted canons of taste and competence, was challenged by twentieth-century modern art. But since the new forms of the vanguard artists defied the common rubrics of art, many considered the work of these artists degenerate and barbarian, the product of a decaying Europe, not of an emerging culture that would be situated both in Europe and in the United States. This immediate reaction, one might add, is not an unfamiliar lament in American history. Sensing this reaction to their ideas, some of the artists even tried to turn the designation "barbarian" to their advantage, for in times of social tension the barbarian ingredient can become a two-edged sword, as, for example, among the Fauves and the German expressionists.

The discontent among artists, which began between 1900 and 1910 and which resulted in a totally new international art in the 1950s on the New York scene, was part of a broader cultural ferment. Theoretical science, literature, theater, and theology, as well as the visual arts, reflected the tension of striving for new perceptions. Common to all was the effort to break away from domination by the new scientific discoveries and banalities connected with technological creations and comforts.

Until the middle of this century, however, the struggle was exacerbated by the fact that every attempt to come to terms with the issues compounded the problem. For all the aura of progress surrounding its creation, the Newtonian world had stifled the human imagination, as Marjorie Nicolson has so eloquently shown in her examination of Newton's *Optics*. And instead of opening up the world, nineteenth-century evolutionary discoveries came to be understood in terms of the acceptance of social struggle, or, more frequently, they were used as validations of social and moral progress. Technological developments, though geared to the alleviation of human suffering by means of the creation of abundance, also shrank human artistry and initiative by creating a preoccupation with system and law. Even Protestant liberal theology, although it was free of the shackles of seventeenth- and eighteenth-century dogma and ritual, formed so close an alliance with scientific and evolutionary developments that it came to equate a limited moral view of humanity with divinity.

Two of the dubious attempts to overcome this materialistic and moralistic cultural stance have persisted into our own time. In one of these orientations, the material world is given spiritual characteristics. The new science, it is affirmed, has abandoned its old preoccupation with discrete, hard

particles, and deterministic categories are no longer applicable. Science, in short, has turned spiritual. Although this approach was prominent more in the fields of aesthetics, philosophy, and theology than in literature or the visual arts, it did represent a powerful thrust, even though there is no really valid reason to consider the new views of the material world as spiritual.

The second attempt, one that was more important to many artists, was the positing of a moral and spiritual world that existed alongside the scientific and material one, a world that obeyed laws as consistent and definite as those of the more familiar world. This approach may be found in spiritualism, theosophy, Christian Science, Boston Personalism, even in Protestant theology in the work of such men as Henry Drummond and William Adams Brown, and in the philosophy of religion, as exemplified by Eugene Lyman. Just as nineteenth-century artists saw Swedenborgianism as a way of relating two corresponding worlds, so artists such as Kandinsky and Lyonel Feininger saw theosophy as a way of affirming a world beyond the material one. Mathematical and abstract forms also transcended the religiously banal, as well as too limited a view of the material world.

The twentieth century has had to fight to regain, as part of the constitution of humanity, the modalities of imagination and spirit. Simply positing a spiritual realm alongside the material one, however, was not sufficient to accomplish this. Both in the arts and in theology such a tactic led to the identification of spirit with meaning. Kandinsky and his followers did this in art, and at times Paul Tillich did this in his theological view of the visual arts. If meaning and spirit are the same, then all art may be considered spiritual and religious; and if it is not spiritual and religious, then it is not art, for it has no meaning. Definitionally, this circular idea cannot be disputed, but it need not be accepted.

By the 1940s and 1950s the contours of humanity delineated in literary and theological works no longer separated the material and the spiritual, and humanity was no longer defined as spirit (angel) or matter (devil). Rather, humanity exhibited its own dynamics, including perceptions of depth and breadth amenable to art and religion alike. We can characterize this development as perceptions of the spirit, a terminology applicable to theological, cultural, and artistic expression alike. Indeed, the phrase provides an angle of vision or perspective through which diverse styles of art may be seen in a common context.

The Struggle for New Perspectives

One of the ironies of the early-twentieth-century art scene is that precisely when an academic tradition of art had found acceptance among the more

affluent in the culture, its role was challenged from two directions, the new art from Europe and the work of American artists who strove for perceptions independent of both academic art and the European influence.

The controversial Armory Show in 1913 brought European artists of the vanguard—among them Cézanne, Gauguin, Van Gogh, Henri Matisse, Pablo Picasso, Kandinsky, Alexander Archipenko, and Marcel Duchamp—to the attention of the Americans. The public reaction to their work was negative, indeed passionately so, though that reaction is difficult to understand now since, for most of us, these artists have become part of our world. Theodore Roosevelt's reaction to the Armory Show may serve as an example. In spite of his Rough Rider association, Roosevelt was among the most urbane and educated individuals ever to occupy the presidential office. Yet he found the art in the Armory Show to be retrogressive to the point of primitive. The reaction from the press to the new art form and its American emulators was equally negative. Given these reactions, American artists of the vanguard who wanted to break with what they considered an academically sterile past had no recourse but to organize their own exhibitions with whatever help and encouragement could be found. Pioneering in such exhibitions was the group known as "The Eight," gathering around Robert Henri, and the individuals associated with Alfred Stieglitz and his Photo-Secession Gallery, also known as Gallery 291. Neither the Henri group nor those associated with Gallery 291 formed a common school; artistically, they were quite diverse. The common thread among them was a concern for new departures in art in alliance with, but not in imitation of, the developments abroad.

Stieglitz, who first opened his gallery in 1905 with the purpose of the encouraging new horizons in photography, became the agent for introducing avant-garde European painting and sculpture to America. He showed early drawings of Auguste Rodin and Matisse in two separate exhibits in 1908—five years before the Armory Show—and subsequently works of Henri Rousseau, Cézanne, Picasso, and Henri Toulouse-Lautrec.

Equally important was Stieglitz's encouragement of American artists, some of whom had studied abroad, by providing a context for their work, particularly exhibitions and sales. Among these artists were Charles Demuth, Arthur Dove, Marsden Hartley, John Marin, Charles Sheeler, Abraham Walkowitz, Georgia O'Keeffe (who subsequently married Stieglitz), and Max Weber.

It is surprising that the organizer of the controversial Armory Show, Arthur B. Davies, was not influenced by this European art. His attempt to break into new directions took a quite different form, one so out of the emerging stream that it was largely ignored in his own time. After experimenting with various styles, Davies settled for stylistic forms related or

analogous to the distant past, for he felt that such forms provided spiritual perceptions not apparent in the art of the recent past or the present. His own predilections were apparently more pagan and Greek than Christian, but his visionary world was not alien to, and indeed was sometimes related to, a Christian iconography. In Davies's works there is a rhythmic grace in which nature appears peaceful and in which the human form joyfully cavorts in the world. Probably the uninhibited posturing, yet graceful style of the dancer Isadora Duncan influenced Davies, as it did other artists.

But to Davies the greater significance of his work lay in his and Gustav Eisen's rediscovery of the theory of inhalation. This theory, they believed, originated with the Greeks, who felt that a "divine and spiritual birth of life" and an "apotheosis of emotional and spiritual beauty" constituted humanity and was expressed through its artistic figures at the moment of the full inhalation of the chest. This alleged scientific discovery is important because of the assumptions inherent in it: namely, that otherworldly powers are naturally manifest in this world within the human form. There is a kind of heaven on earth, a "once-born" quality in which our vitalities are strictly positive, thus making us free of despair and guilt. Love, harmony, and beauty are one, and their source is God. Thus, Davies's nudes are like angels from another realm, freed of the traditional appendages or attributes. They are symbols, freed of literal interpretations and executed with the competence of a fine artist.

Davies's works cover a wide range of subjects: classical mythological themes such as unicorns; spiritual themes like *Madonna of the Sun* (ca. 1910) (plate 75) and *Sacramental Tree* (1915); ancient themes not unrelated to Christian substance in suggestive, primordial contexts; and nature themes in which nature and humanity are often joined in dance and praise. Davies's paintings disclose transcendent life in peaceful, positive, and active contexts, where there is no need to return to a past or to plan a future. The paintings are neither pastoral nor paradisal exercises, but ontological expressions of his vision of how things are.

Whereas Davies provided us with figures that had an icon-like quality in their stillness, Abraham Walkowitz, a member of the Stieglitz circle, represented both stillness and movement. Returning from Europe in 1907, Walkowitz portrayed heads, which were subsequently published under the title *Faces from the Ghetto*. These heads represent arrested movement and can be said to be icons of character. In contrast, his many drawings of the dancer Isadora Duncan represent the essence of motion. Though he had seen her dance many times, Walkowitz never wanted Duncan to pose for him, for it was in movement that she symbolized the glorious abundance of creation. Drawings of heads and of Isadora represent two sides of one reality—arrested movement and abandonment to movement. Perhaps both

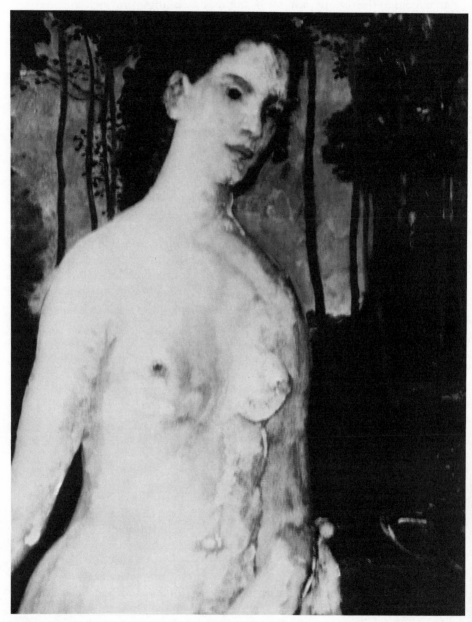

75. Arthur B. Davies, *Madonna of the Sun*, ca. 1910

sides are represented in Walkowitz's *Creation* (1913) (plate 76), in which the swirling forms are themselves representative of creation and creativity.

A similar impulse to express structure and movement as an analogue to creation is found in the work of Morgan Russell and Stanton Macdonald-Wright, though in their work the movement is more potential than actual. Neither line nor form in itself, but color as form and structure, was their medium. For them, color had reached its highest point in Cézanne, composition in Rubens, and freedom of form in the cubists. Now another step needed to be taken: the use of color as the formal and dominating principle of composition. All obvious subject matter had to give way in order to create an aesthetic and an art. Color alone created the form, the content, and the basis of emotional response. The utilization of color to trigger the desired emotional responses is strikingly similar in the theosophical views of Annie Besant and C. W. Leadbeater in *Thought Forms* (1901), in Wassily Kandinsky's *Concerning the Spiritual in Art* (1912), and in Stanton Macdonald-Wright's *Treatise of Color* (1924). However one views the similarities and mutual influences, Russell and Macdonald-Wright made color the commanding center of painting. Many of the early synchromist paintings show the traces of a cubist background; nevertheless, overlapping and interpenetration of color across the cubist facets create an ambience of their own, like a new creation.

It is not by accident that Russell and Macdonald-Wright saw their own works as analogous to creation itself. Russell in his *Creavit Deus Hominem* (1913) and Macdonald-Wright in his *"Oriental." Symphony in Blue Green* (1918) (plate 77), for example, believed that they expressed nothing less than the soul and form of creation, seen through the penetrating work of the artist's use of color. Russell's gradual departure from such painting and his eventual conversion to Roman Catholicism and Macdonald-Wright's further transformations of his art on the basis of more extensive studying of Chinese thought and art confirm that original religious thrust.

It is in Joseph Stella that the powers of creation, both in the new technology and in nature, are wedded in one vision. Of Italian background, he was interested in the Italian futurist movement, which exulted in the speed, dynamism, and energetic rhythms of modern technological and industrial forms. For the futurists, such forms represented a new beauty, a new way of seeing the world. But it was the American rather than the Italian scene that furnished the major focus for Stella's art. His *Brooklyn Bridge* (1919) and his scenes of New York skyscrapers have the aura of religious discovery. It is as if the forces of nature, direct from the hands of the Creator, had been seen and assembled anew by humans, discovering and unleashing hidden powers in new constellations. For a time, at least, it was the celebration of

76. Abraham Walkowitz, *Creation*, 1913

77. Stanton Macdonald-Wright, *"Oriental." Symphony in Blue-Green*, 1918.

such powers, rather than the effect of industrial life on the human drama, that preoccupied such artists as Stella.

When he had completed *Brooklyn Bridge*, Stella tells us, he had a new vision in which his Italian heritage and his fascination with nature took a new form. The result was *Tree of My Life* (1919). Although central, the tree is almost eclipsed by the luxuriant growth, behind which, in turn, there appear animal forms. Here the forces of nature have a surrealist dynamism. One can compare nature, the direct work of God, and its vital, graceful forces, to the quivering, unbent beams of the Brooklyn Bridge. Ironically, the forces of industrial civilization had led Stella to see the vitalities of nature in a new way. In his *Nativity* (1919) (plate 78), all the vitalities inherent in creation—line and contour, vegetation and sexuality—combine to form a symbolic and intense portrayal of the conception of life.

It is in Arthur Dove and Georgia O'Keeffe that the source for art is found in an appropriate rendering of the forces, forms, and mysteries of nature beneath its surface manifestations. Forms are abstracted from nature in order to convey such perceptions; yet each form expresses nature's structures through the concrete experiences of particular places: for Dove, the Finger Lakes; for O'Keeffe, New Mexico and Canada. Moreover, as O'Keeffe noted, their works bore the stamp of each place and could not have been done anywhere else. However abstract in style or universal in meaning, the paintings disclose their settings. Although their works portray an ambience of place, they do not reveal any historical struggles, in contrast to the works of many of their contemporaries. Characteristic of Dove and O'Keeffe is a consistency of and preoccupation with their visions of nature. These visions carried them through and somewhat apart from the vagaries of historical existence, even when they were personally affected by them. Their visions of nature do not totally expunge the tragic elements of existence, but there are no actual historical references to tragic events.[1]

Arthur Dove was an early American abstract artist interested in disclosing spiritual forces in and through the world of sense and matter. He tried to make the invisible forces inherent in inanimate objects—the power and

[1] John Marin, too, belonged to the Stieglitz circle, though he came to the group at a relatively advanced age, having studied painting in this country and in Europe before the Stieglitz group came into existence. In New York, Marin painted scenes of the city, with cubist and futurist ingredients. He soon discovered Maine, and, from about 1915 on, it increasingly became the inspiration and setting for his paintings. Like Dove and O'Keeffe, Marin was not interested in painting mere appearances. He became interested in using watercolors and paint, much as Dove had, to determine the composition of his subject. One is impressed by the color and mood of his Maine scenes, but the essence and the secrets of nature, so crucial to Dove and O'Keeffe, are neither sought after nor purveyed. For all the beauty, a depth of perception seems missing.

78. Joseph Stella, *Nativity*, 1919

tension that lie beneath the surface—visible. The transformation of nature by disclosing the structure beneath the visually obvious through the use of color as the primary mode of composition provides a stamp of ultimacy or religiousness. The divinity Dove consciously portrayed was evident in the perfections of creation, the attributes of essential reality expressed in the brilliance of color and form. In Dove's work, materiality was made into the highest spirituality. Dove believed that nature is a series of epiphanies or transfigurations. This belief could have been behind Dove's decision to name a series of early compositions *Ten Commandments* (1912). Stieglitz later called this work *Nature Symbolized,* and the latter title is probably more intelligible to us, particularly if a correspondence between title and painting is sought. Like Barnett Newman in the *Fourteen Stations of the Cross* (1958–66), Dove may have been astounded by the number of paintings in the series. They represent "nature and nature's God," with echoes of a distant biblical understanding. Similar, though somewhat more explicit, are *A Cross in the Tree* (1935) and *Telegraph Pole* (1929) (plate 79). The latter has all the characteristics of an ordinary telegraph pole on which the crossbeams that hold the wires sag and are held up by angular braces from below. The cruciform pole dominates the canvas, but clearly beyond it and through it one sees the tensioned forms of nature. In the 1930s, Dove's paintings, which heretofore had been confined to forms of nature that one could characterize as earthbound, increasingly included sun and stars and their effects on nature and the human scene. The spectral vision thus broadened, as one can see in such examples as *Sunrise #1* (1937) and *Sunset* (1937), or *Long Island* (1940).

Georgia O'Keeffe alone of the Stieglitz group had no direct contact with European modern art. Throughout her long painting career, there pulses a vision that is uniquely hers, even through its gradual transformations. Her works of the 1920s disclose the serenity and internal forms of nature, much like the works of Dove; her powerful paintings of the 1930s and 1940s have somber or ominous undertones which reflect her New Mexican and, for a time, also eastern Canadian experiences; her works of the 1960s and 1970s reflect new and joyful experiences, her extraordinary vision of rivers or clouds seen from the air.

There are Pascalian features to O'Keeffe's vision. A small flower is so large that it eclipses the world it inhabits; it has even become a world itself. Obversely, the infinite vistas of nature are delineated by clear forms, their essence expressed in concrete boundaries, which ordinarily would be the denial of infinity. All this is done through economy, by stripping things so bare that their cluttered contexts are removed. *Black Cross, New Mexico* (1929) (plate 80) illustrates this point very well. In this painting O'Keeffe has given us the spirit of a place, a single location in which nature and

history are focused. The work captures the intertwined Spanish Roman Catholic soul as it exists in this exotic barren land. In another setting the cross would not be the same, but here the cross and nature belong to each other, with an ominousness that yet discloses transcending moments and ultimate hopes. O'Keeffe herself tells us how different her *Cross by the Sea, Canada* (1932) is from her New Mexican work: "In New Mexico the crosses interest me because they represent what the Spanish felt about Catholicism—dark, sombre—and I painted them that way. On the Gaspe, the cross was Catholicism as the French saw it—gay, witty." [2] In the Canadian version, the cross and nature are not intertwined: the cross, though ultimate and secure in its own way, represents an ironic element in front of the unlimited sea. Perhaps her Roman Catholic background helped O'Keeffe to sense the unity of nature and history; yet neither of these is a Roman Catholic painting.

O'Keefe's paintings of her patio door, of cow skulls in which there is again the suggestion of a cross, and of pelvic bones through whose sockets the blue of the sky is seen, like the crosses, form a single pattern of human affirmation and a relentless, passionate fascination with the mystery of nature. Her nature mysticism is not one in which the self is lost; rather, it affirms the soul's affinities with the forces and structures of nature. This is no less true of the flower paintings. Seizing upon a facet of a flower, showing it to us in a way we would not ordinarily see it—like the cross across the whole sky or the sky through the aperture of the pelvic bone—O'Keeffe uncovers the mystery of nature and its curious affinities. O'Keeffe was offended when some saw only an expression of sexuality in her paintings of flowers; she said that she did not see that aspect at all. One surmises that, for her, sexuality was so inherent in life that it should not be singled out as *the* mystery; sexuality is one among *many* mysteries of existence.

Two additional remarks may be made about the artists we have just considered, all of whom came to the attention of the artistic world between 1910 and 1920. First, although they are concerned with spiritual perceptions and with a new direction in art, their approach is mainly through a conception of life that is anchored in stability and movement, which they understand as an act of creation. Moreover, the sources and vehicles for expression are primarily tied to finding an adequate understanding of nature. When their work touches on traditional iconography, it is from the standpoint of nature. Creation, not redemption, is their focus, though what they purvey is not necessarily contrary to the redemptive theme. Second, some of the artists, such as Dove and O'Keeffe, became more prominent in

[2] Katherine Kuh, *The Artist's Voice: Talking with Seventeen Artists* (New York: Harper & Row, 1960) 202.

79. Arthur Dove,
 Telegraph Pole, 1929

80. Georgia O'Keeffe,
 Black Cross, New Mexico,
 1929

the years after 1920. Since art history, like other historical writing, tends to stress the emerging figures of a given time, the ongoing life of an artist often receives scant attention except in monographs on the individual or when a distinctive style emerges within an artist's work. For example, although we have just discussed O'Keeffe's early work, it is important to remember that her significant painting career, longer than most, ran into our own time.

Diverse Perspectives and Directions

The art of the period between World War I and the early 1940s was diverse in its perspectives and directions. The city and its technology were both lauded and attacked. Regional artists retreated from worldwide and city problems into their own orbits of experience. Still other artists had a cosmic vision, one undergirded by religious traditions from both East and West. Jewish and black artists, more than those who reflected the culture at large, created works of art that reflected their religious heritage.

The artists of the first two decades, discussed in the previous section, were struggling for new alternatives in a bourgeois and commercial culture, and they shared a common optimistic mood. In the period now under consideration, such optimism was sometimes intensified through an artistic interest in the city and technology, as in the work of Charles Demuth. Stella's *Brooklyn Bridge* was an example of a vision of the city akin to a religious aura, as were some of the early works of Abraham Walkowitz and Georgia O'Keeffe. Much of the work of Charles Sheeler exhibits the magical mystique surrounding the forces and forms of industrial buildings or the new skyscrapers. The spirit of such adoration is surely evident in the art of Charles Demuth; his *Incense of a New Church* (1921) (plate 81), in which the incense is the smoke of an industrial factory, is one example. Such works represent an early, almost religious fascination with the forms of the new factories and the transformation of the city.

In marked contrast to the power and awesome possibilities inherent in the factory and in the city stands the reality of life lived among the bridges, the sanitized factories, and the elegant skylines. Works such as Reginald Marsh's *Twenty Cent Movie* (1936) or Willard Sheets's *Tenement Flats* (1934) echo the difficult and oppressive lives of the Great Depression. Social passion and injustice are striking in many of the murals done under WPA auspices, and particularly in works by Ben Shahn and Philip Evergood. The *Passion of Sacco and Vanzetti* (1936) represents Shahn's passionate recognition of an unjust crucifixion, when an industrial society became afraid and overly protective of its own creations. Yet Shahn's protest arose out of

81. Charles Demuth,
 Incense of a New Church,
 1921

82. Charles Burchfield, *Sun and Rocks*, 1918–1950

When author e.g.. ?

a vision of humanity's greatness and potential. It was the strength and passion of Shahn's many paintings of Sacco and Vanzetti that made them into a form of protest while keeping their quality as art.

Humanity's dignity is also the theme of those self-conscious Americans whose credo in life and art called for a retreat from the cities and factories to villages and country. But if the emphasis is on dignity, it is not without dark and somber undertones. Charles Burchfield, a nature mystic mainly associated with Ohio and New York, sought to disclose the soul of nature by utilizing color and light to show the Creator through the creation. A closer look, however, discloses the decay within nature, its eerie and ominous characteristics beneath its glory; and in the villages he portrays, the buildings suggest that they, too, are part of the somber, oppressive fabric of existence. There is hardiness in the life force exhibited in this art, but it is experienced against the darkness of existence, as if against great odds. Even a painting such as *Sun and Rocks* (1918–1950) (plate 82) uses abstraction to show gnarled forms of trees, rocks with contorted figures, a strange land in which the cross-shaped light of the sun and play of color do not banish dark forebodings.

The midwesterner Thomas Hart Benton portrayed life with great realism. In his art the hardiness of working people, frequently the bearers of heaviness but never of tragedy, is conveyed by a surging line. In contrast, the Iowan Grant Wood saw irony in existence, incongruity and humor in the very things in which he tended to believe, as in *American Gothic* (1930) or in *Parson Weems' Fable* (1939) (plate 83). But for Benton and Wood, the spiritual is peripheral to an understanding of their art. The works of John Steuart Curry, however, cannot be fully appreciated if one does not understand the impact that his spiritual perceptions had upon his works.

Curry, known mostly for his John Brown murals in the Missouri State Capitol, disclosed a lively sense of the invasion of otherworldly powers, both in these murals and in his *Baptism in Kansas* (1928) (plate 84). In the Missouri murals, John Brown is a victimized prophet, upon whom the power of another world has laid its hand with unalloyed clarity. In *Baptism in Kansas*, allusions to the source of baptisms are exemplified by the parting heavens and by the doves, symbolic of Christian baptism. When one looks at the baptizing preacher and the assembled group, one is impressed not by the "tender mercies from above" but by the seriousness of the act being performed, by the mandate and its good and evil consequences. As in the case of the Brown murals, Curry has caught the urgency of the event, a suggestion that such righteousness portends fearful and ambiguous consequences for those who do not fall within the common orbit of baptism. One is haunted by what Curry has conveyed in his captivating perception of a particular time and place.

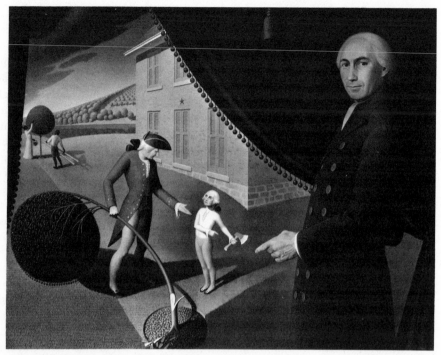

83. Grant Wood, *Parson Weems' Fable*, 1939

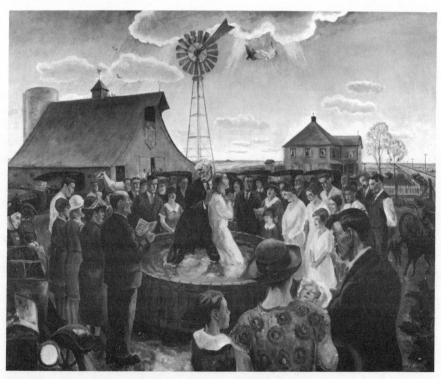

84. John Steuart Curry, *Baptism in Kansas*, 1928

In Marsden Hartley the religious impulse is expressed in forms that suggest rootage in a Christian past, and this religious impulse is cast in the familiar, terrifying world of loneliness and death. Widely traveled though he was, that world brought him little comfort, and he settled in Maine, where loneliness apparently does not seem strange. The figures in his paintings, to use Hartley's own words, have an "archaic" character, reflecting the discomfort of an oppressive presence. Perhaps his painting of John Donne, whose haunted face he so eloquently portrays, is a symbol of Hartley himself. Hartley's art is laden with contradictory symbols expressing emptiness, human strength, and religion—sometimes indirectly expressed, at other times explicitly so. Religious subjects occur more often in the last decade of his life. An example is his *Three Friends* (1941), in which the central figure, crucified yet crowned with an irregular halo, is surrounded on one side by a clown and on the other by a wrestler, both with crucifixes; they exemplify suffering in diverse modes. Similar iconographic motifs can be seen in *Christ Evicted* (1941–43) and *Christ Held by Half Naked Men* (1940–41). In some works secular and religious meanings mingle with multiple innuendos. The haunting mystery of Hartley's landscapes, such as *Mont Ste. Victoire* (1928), *Northern Seascape Off the Banks* (1936), or one of his New Mexican works discloses a reverence, a silence before the world. That silence is no less real as one encounters the human figures who resignedly live their brief and uncertain lives on the sea. *The Lost Felice* (1939) and *Fisherman's Last Supper* (1938) (plate 85) project back into this world the presence of persons no longer living but whose lives were undoubtedly as tenuous as their projected presence in the painting.

Daily incidents, with their religious overtones including an implicit Christian iconography, also occur in a series of nine drawings of lobster fishermen done around 1940. The scenes of the fishermen reflect biblical influences: it is almost as if the lobstermen were reliving the drama from the Nativity to the Holy Family to the Deposition to the Resurrection. Hartley wants us to recall that St. Peter was also a fisherman. The silent, unbelieving-believing lobstermen recapture these ancient events in a vision that is also contemporaneous.

Religious subject matter formed a significant part of Augustus Vincent Tack's work—indeed, most of his murals and almost a fourth of his paintings and drawings. In his work traditional iconography was increasingly broadened to include influences from such sources as Hinduism, Eastern Orthodoxy, Western antiquity, and theosophy. These religious traditions enriched his fundamentally mystical orientation, which was initially nurtured by his Roman Catholic faith but was continously broadened through his conviction that the mystic paths, though many, were one. *Rosa Mystica* (1923) is a good example. The central figure of the painting is a visualization

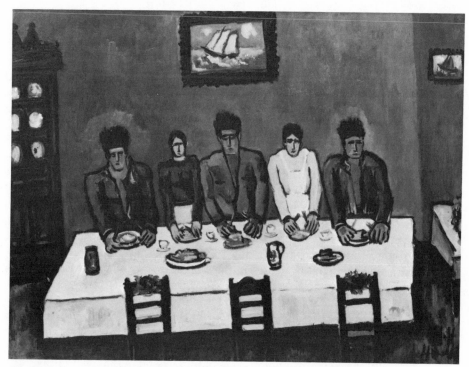

85. Marsden Hartley, *Fisherman's Last Supper, Nova Scotia,* 1938

86. Augustus Vincent Tack, *Spirit of Creation,*
(Time and Timelessness), 1944

of an image of the canticle to the Virgin Mary. Yet the Orient-inspired land-
scape and the frontal posture for the Virgin take us out of the traditional
Western mode. In *Voice of Many Waters* (ca. 1924), a more abstract work,
nature becomes the personification of God, whose voice, as suggested by
Ezekiel and the book of Revelation, is that of many waters. In this painting,
the mystical vision of many paths is given form in the depiction of nature
and provided with a scriptural allusion.

The oneness of the divine and the human is at the heart of Tack's mystic
art. *Spirit of Creation (Time and Timelessness)* (1944) (plate 86), an oil
sketch for the fire curtain at the Lisner Auditorium at The George Wash-
ington University, is no more abstract than *Voice of Many Waters*, executed
two decades previously. It affirms the conviction that creativity is an in-
gredient in eternity, and time in timelessness. One can see humanity's own
creative powers to be nothing less than its identification with the divine.
Symbolically, but abstractly, the spiral, including whirlwind and whirl-
pool, and the winged victory in the sketch, express the twofold nature of
creation, that of God and the human. A positive joyousness pervades the
life of humanity, for it is anchored in creative eternity.

A successful portraitist throughout his life, Tack began his experiments
with color and abstraction as a matter of personal interest, without neces-
sarily intending that they become a part of his painting career. In 1915,
through the encouragement of a patron friend, Duncan Phillips, and
through personal associations at the Century Club in New York, Tack began
a development that dramatically affected his subsequent artistic career.
Increasingly, configurations of color dominated his nonportrait paintings,
evoking meanings rather than explicitly disclosing them. These early
abstract paintings, however, never lose the suggested contours beneath
them. They are among the earliest abstract paintings on the American
scene, but their powerful new forms seem somewhat distilled to those who
come to them from a familiarity with abstract expressionism, in which
every recognizable form has been removed. For Tack, abstraction included
the hinted-at contours of nature, lapped and blurred by color with only a
trace of line. Nature and humanity were seen in forms that suggested the
transcendent forces inherent in them. The coincidence of color as form and
color as chosen value combined with symbolic emblems on occasion, forged
a medium appropriate for expressing the conjunction of immediate things
and their ultimate ground. Tack's paintings in this genre were exercises in
transfigurations.

Mark Tobey, like Augustus Tack, moved from a circumscribed religious
outlook to a broader view of life. Tack's Roman Catholicism was flexible
enough to include ever-widening vistas; Tobey's Congregationalism was
superseded by a conversion to the inclusive Baha'i faith, in which all

religions are considered to be separate paths to one reality. Tobey believed that this outlook determined the content and the aesthetic form of his art; and, indeed, among artists in the twentieth century, Tobey seems unique in feeling the direct influence of religion upon his art. The nature of the Baha'i faith, however, makes that claim intelligible, for it is at once comprehensive and open. Particular subjects within Tobey's works have their roots in the Baha'i faith, and all of his works can be seen—and are seen by him—to belong to this context. *Conflict of the Satanic and Celestial Egos* (ca. 1918) (plate 87), for example, a Blake-like painting executed soon after his conversion the the Baha'i faith, discloses the forces which threaten humanity and which can be overcome only if humanity identifies itself with the forces of peace and victory. *Rising Orb* (1935) is a self-conscious Baha'i painting in which horizons from beyond are breaking into the horizon of this time, a hopeful portent for the future.

It is suggested here that the message conveyed in these paintings is didactic rather than spiritual and that other influences that led Tobey toward a more abstract style resulted in a more spiritual art, in exact proportion to the disappearance of an explicit religious iconography. Tobey himself recognized this. Although acclaimed by the Baha'i movement, he was not interested in a Baha'i art, maintaining that in our world, where literacy is high, art especially must be free of particular moorings in order to express its transcendent thrust. Tobey himself was a cosmopolitan spirit, at home in skid row and in affluent society, in the East and in the West, always open to widening horizons in the quest for the fullness of humanity. He combined many influences—Chinese, Japanese, geographical (Pacific-Northwest), Indian, Medieval, Coptic, Egyptian—into a single, expanding vision of humanity and the God-given possibilities that are affirmed with integrity. Science and the material world were not despised by Tobey, but his empathy was with the spiritual rather than the material.

Tobey's questing spirit was given a new focus through his exposure to the thought and art of the East. Aspects of the human spirit for which one had to contend in the West were assumed in the East to be life's center. Tobey was influenced not only by Eastern thought but also by the calligraphy and by the brushstroke of black ink characteristic of Eastern art. Tobey's period of so-called white-writing paintings, such as *Threading Light* (1942) (plate 88), *The Way* (1944), or *Homage to the Virgin* (1948), in which the lines form an energetic, structured maze, reflect the influence of calligraphy in particular. In point of fact, they are not strictly calligraphic; nevertheless, they are drawn from that source. The white-writing paintings have a life of their own, using line rather than color as the basis of the composition. In some of these, the lines alone form the painting; in others, human figures and incidents find their limited space, reminding us of their incorporation

87. Mark Tobey, *Conflict of the Celestial and Satanic Egos*, ca. 1918

88. Mark Tobey, *Threading Light*, 1942

into the totality of the world. The black-brush paintings provide another ambience, for in them the metaphysicial and spiritual context and the recognizable form, whether of nature or of humanity, form a unity.

Much of Tobey's work was done in Seattle, where he lived a major period of his life. It was there that Morris Graves, twenty years Tobey's junior, first felt the power and scope of Tobey's art. His friendship with Tobey and his frequent visits to the collection of Eastern art in the Seattle Museum early set the direction of his own work. Alienated from the barren upbringing of his particular Protestant heritage, Graves became interested in religions of the East, particularly in Zen Buddhism. The Eastern regard for beauty, nature, and peace increasingly captivated him; indeed, if there is an American artist whose world and spirit are essentially Eastern, it is Graves. Even his reappropriation of Christianity centered in its mystical aspects, in figures such as Meister Eckhart and Jakob Boehme. Eastern spirituality emanates from every stroke of his paintings, yet his paintings initially appear to have less of an Eastern influence than Tobey's.

Most of Graves's life has been lived in the midst of nature isolated from the surrounding world, in houses and landscaping of his own making, in tune with, and undisturbing of, nature's rhythms. His life and his art are attuned to listening to nature, to sensing and recording in his art the harmonious life forces to which we belong, forces that can be wounded but not destroyed. Central to much of Graves's work is the depiction of the animal world, particularly birds, to convey humanity's spiritual transcendence, humanity's belonging to a world in which the distinction between oneself and reality gives way to an essential unity. The bird particularly exhibits transcendence in the midst of its own fragility. Graves utilizes Eastern symbols in such a way that the assumed meanings—such as the bird representing humanity's spiritual transcendence; the gander, humanity's highest transcendence—are conveyed in exquisite line and muted, yet singing, color. The minnow, to use another example from the animal world, is the symbol of renewal and faith, an occurrence as from nowhere, in the midst of crisis. *Hold Fast to What You Have Already and I Will Give You the Morning Star* (1943) (plate 89), a reference to Revelation 2:25–28, surely has been given an Eastern interpretation. It is interesting, however, that Graves has used the chalice not as an Eastern or a Western symbol but as his own code for spiritual birth, a suggestion that creation's initial shapeless forms emerge into specific structures—such as the chalice. Here a historic religious association is directly related to nature's own manifestations. Perhaps it is in this context that one can understand why Graves destroyed a whole winter's work spent at Chartres, sketching the Cathedral. Nothing in that man-made structure could really fit his spiritual perceptions, try as he might in the midst of suggestively deceptive parallels.

89. Morris Graves, *Hold Fast to What You Have Already and I Will Give You the Morning Star*, 1943

Tobey and Graves, artists joined by the geography of the Pacific Northwest and an interest in the East, also share the notion that a total world view influences one's art, however consciously or unconsciously. Tobey was an optimist, affirming not only the grandeur of humanity but also its progressive overcoming of the forces of evil. Graves is an Eastern mystic, moving into his own world of order and peace, akin to the way he sees nature.

During this period several artists, possibly conscious of their Jewish religious heritage, executed works with religious subject matter, including biblical and historical themes. These artists include Abraham Rattner, Hyman Bloom, Saul Baizerman, David Aronson, and Jack Levine. All, with the exception of Baizerman, who began his career several years earlier, have been active from the early 1940s to the present. In addition to the fact that their subjects are derived from much the same sources, they share an interest in the human figure, either abstracted or deliberately distorted, which remains visible and central to their conception of life and art. Depending on the context, the figure discloses a lyricism, a pathos, or the arrogance and incongruity of the powerful. The mood of their art ranges from exaltation to pathetic degradation, from human transcendence to human ensnarement. The full range of human emotions and situations is portrayed, much as in drama.

In the early 1940s, four black artists emerged on the national scene: Horace Pippin, William Johnson, Jacob Lawrence, and Romare Bearden. Of these, Pippin, a primitive painter with considerable talent, was self-taught. Although the works of Lawrence, Johnson, and Bearden convey primitive artistic tendencies, they all had professional training. Their flat-appearing figures are the result of deliberate choices, utilized to convey powerful emotional content and to demand a response, as is evident in Johnson's *Mount Calvary* (1939) (plate 90).

It is interesting that Jewish and black artists, unlike those who reflect the traditional Protestant or Roman Catholic backgrounds, can use traditional iconographic subjects without being banal. They have found artistic means by which the subjects appear fresh. Whether or not that is because the tradition is more vitally incorporated into their lives than among those who form the dominant culture is a subject for further consideration.

The Abstract Expressionists: Their Formative Thrust

In the decade following World War II, the group known as the New York School or, in terms of style, the abstract expressionist movement came into existence. They asserted that "the subject [of the paintings] is crucial and

90. William Johnson, *Mount Calvary*, ca. 1939

only that subject matter is valid which is tragic and timeless." By subject they meant the essential, foundational, ontological meaning. Artistically, they declared themselves for the large canvas "because it has the impact of the unequivocal." They favored flat forms "because they destroy illusion and reveal truth." These tenets, as carried out by the various artists, led to a variety of styles, but for all of them the act of painting, the emotion-charged moment when the artist confronted the canvas, became the creative "moment of truth." [3] The application of paint in spontaneous and freely flowing gestures left traces of the artist's movements—the flow of line and form, the drips and splashes of paint—all of which became part of the total work.

Common to the new abstract expressionists was the judgment that artists were rearranging the known world around them rather than penetrating to fresh, primordial conceptions. Their wrath was particularly focused on the American regionalist painters, a fact that itself testifies to the wide-spread prominence the regionalists then had. Contemporary artistic currents from abroad, which had more vitality in New York than abroad because of the presence in the city of European expatriate artists, were only attractive for a time. The new painters felt that the European currents did not really challenge the painting tradition of the past several hundred years. Impressionism and expressionism were considered different ways of seeing a world of nature already monotonously portrayed by landscape artists. Cubism dissolved the world as known, rearranging figures and events in terms of planes and successive angles of vision and movement, but it still was based on figures and events.

Surrealism, the most helpful source for early attempts to overcome the past, moved the center of attention from the external world to the dynamics of the world within. It affirmed the passion and action of the painter as well as the viewer. It provided a common world of humanity affirmed in both existentialism and psychology. For some of the abstract artists, the surrealist's dimension was particularly mediated by the painter Arshile Gorky. His painting, *The Diary of a Seducer* (1945) (plate 91) is at once an expression of the literary world of Soren Kierkegaard's existentialism and of contemporary psychological breakthroughs. In the last analysis, however, the abstract expressionists found the surrealist world to be a fantasy in which familiar elements were juxtaposed without a positive vision of the world. Although they were interested in both existentialism and the surrealist interior world, they did not share the negative side of existentialism or the

[3] Adolph Gottlieb and Mark Rothko, "Statement, 1943," reproduced in *Theories of Modern Art*, ed. Herschel B. Chipp (Berkeley: University of California Press, 1968) 545.

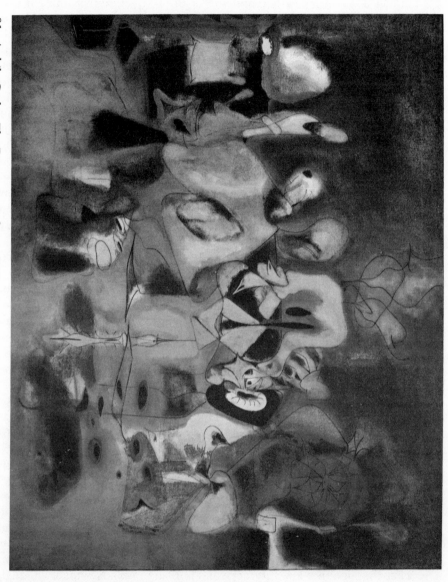

91. Arshile Gorky, *The Diary of a Seducer*, 1945

fantasy of surrealism. A concern for the mysterious dignity of humanity, not degradation or fantasy, was their controlling passion.

Adolph Gottlieb and Mark Rothko, with the help of Barnett Newman, provided one of the early manifestos of the abstract expressionists. It was Barnett Newman, however, who saw how radical a new beginning must be. It is doubtful that his fellow artists understood him at that point, which accounts in part at least for his artistic isolation from many within the group. For Newman, the last obstacle to be overcome was the artistic work of Piet Mondrian and, to a lesser degree, Kandinsky. In Mondrian, squares are still painted on canvases; hence, the traces of the visible world, certainly not a new world, still predominate. Newman decided that the canvas itself must declare the shapes of a new creation, and on the issue of color his opinion was similar. In *Who's Afraid of Red, Yellow and Blue* (1969–70), Newman, in a deliberate reference to Edward Albee's *Who's Afraid of Virginia Woolf*, turns on end the primary color schemes of Kandinsky and their theosophical background. Instead of treating the primary colors as being incompatible and needing modulations to create a harmony among them, Newman paints them brilliantly adjacent, creating an ambience that has a life of its own.

Newman was totally, personally involved in the act of painting and depended on nothing outside of his own deep responses to create a painting. His sitting, waiting, thinking, doing, experimenting were acts of thought and spirit that entered into the act of painting. He did not depend on—indeed avoided—the ancillary helps conveyed by sinuous line or form as an emotive ingredient. But art so conceived demands a similar discipline on the part of the viewer. When the contours and forms do not in themselves convey enticing qualities but operate only in total configurations, discipline is demanded of all of one's sensibilities. Seeing, then, does not provide immediate, easy emotional responses. Whereas many of Rothko's color areas immediately entice and encompass one, Newman's color paintings demand the total passionate act of our being as an essential ingredient of their power to disclose.

The self-conscious attempt of the abstract expressionists to start over is part of the cultural fabric of the late 1940s. Existentialist literature, philosophy, and theologies varied in their estimate of and in their prescription for human life. In all forms, however, authentic existence meant a turning inward, a distinct disavowal of the historic past, which could only be used as insight for the present, if at all. Kierkegaard and Newman, different as they were in their basic affirmations, shared the rejection of the past precisely because they knew its scope and burden so well. Newman, although rhetorical, is serious in his declaration that the first human was an artist. This is apparent in his naming paintings *Day One* (1951–52) or *Genesis—*

The Break (1946), his interest in the Indian mounds of Ohio, and his interest in primitive art.

The attempt to start over is not a return to the stage before creation. Newman's vision is not retroactive or naïve; nor is it prospective, looking toward a future that has not yet come. It is introspective and ontological. Present humans may be artists only if and when they know that the first human was an artist and when they return to these primordial roots. Historical, archaeological, and psychological investigations, insofar as they provide primordial roots and recurring symbols, are reflected in the early work of the New York School. The new symbols, unlike the iconographic symbols of Western Christianity, had originated outside the Western art tradition. They were at once new and ancient, disclosing depths of the spirit not made banal by recent Western history.

The early pictographs of Gottlieb, the exhibitions of primitive art arranged by Newman for the Betty Parsons Gallery, and the cryptic secrets of early Jackson Pollock paintings represent some of the early attempts to create a new art—and with it a new world. The same can be said of the ovoid and rectangular patterns, male and female, of early works of Rothko. Like the theologian Paul Tillich, for whom fresh theological affirmations were possible only in a freshly reconstructed world, these artists were striving for a view of the world and of art as a single, life-and-death issue. The question of art was a question of life; and life, of art.

In the full development of abstract art, the ancient, primitive elements, both Eastern and Western, gave way to formal, primordial elements. Within the context of that development, Gottlieb and Rothko remained border figures. Adolph Gottlieb's paintings move from his early pictographs, through visionary landscapes, to the bursts that suggest cosmic dimensions. They move from ominous notes, such as the *Evil Omen* (1946) (plate 92) or *Black Enigma* (1946), to such a painting as *Expanding* (1962), whose cosmic glory sustains rather than frightens us. Mark Rothko's mature paintings, on the other hand, are aesthetic creations of glorious or somber color, in which the "shapes of the colors," to use his own expression, are the performers in a drama, or as Peter Selz has suggested, surfaces that are masks for underlying currents and turmoil. Rothko's paintings are analogues to the human psyche, paintings before which the modes and moods of color find their echo in both the calmness and the turmoil of our inner selves. In the painting series that culminated in the Rothko Chapel (plate 93) in Houston, Texas, Rothko had moved to cosmic levels where the human psyche is stretched beyond itself. It is this extension into the cosmos rather than their liturgical setting which makes these paintings difficult for the viewer to respond to, but also ultimately more rewarding. They represent Rothko's historic moment of transcendence. As the paintings previous to the

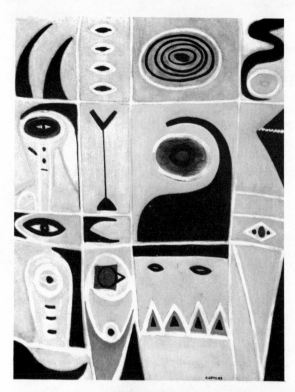

92. Adolph Gottlieb,
 Evil Omen, 1946

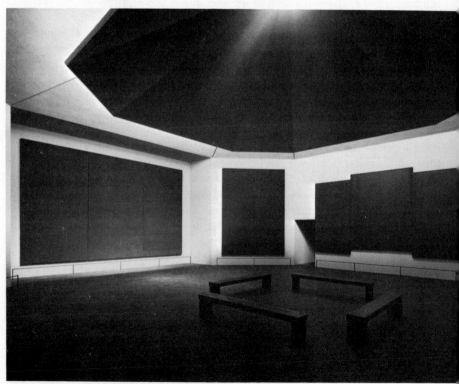

93. Interior of the Rothko Chapel, 1971

chapel series are resonances of the human psyche in positive, though ambiguous ways, and the chapel paintings represent cosmic dimensions, Rothko's last paintings disclose ominous psychic forces, symbolic of his own death.

Pollock and Newman represent abstract expressionism in its most radical form. For them, the means and the concept are one. Neither recognizable figure nor seductive line nor bright color has merit as such in a painting: the act of painting and the painting are one creation. After that, it is only the painting and the viewer that matter, just as is the case with modern poetry. The late W. H. Auden, when asked what a particular poem meant, turned the question around, asking, "What does it mean to you?" He could never reject what was said in reply; he could only hope that it came from an arduous, serious encounter with the poem, similar to that experienced by the poet. In our present inquiry one might say the same of the painting, the painter, and the viewer. The relation of painter, painting, and viewer provides us with a clue for comprehending abstract expressionism and modern art in general. When the subject matter of art no longer comes from the external world, it can only come out of the internal world of the artist. Such internal perceptions or vision may have many ingredients, including mind and emotion. While recognizing that emotion has played some role in academic art—except as it became moral sentiment or merely sentimental—abstract expressionists redeemed and utilized the driving power of both body and mind as definitive of our psyche, as did Gestalt psychologists. Pollock and Newman recognized that their visions were total; therefore, only total responses were appropriate. Criticism by artists of aesthetic theories was directed not only against learned taste but also against unenlightened emotion. Newman, for example, rejected the aesthetic mode in favor of an ethical mode, one as wide as humanity itself.

As visual objects, the works of Pollock and Newman are quite different. In the period of his major drip or action paintings, Jackson Pollock painted with studied abandon, controlling his random and rhythmic movements to create patterns of line and color that seem as free and as orderly as life itself. In his major works, the affirming vision of life and reality, in nonobjective contours that are at once free and determined, is conveyed beyond the boundaries of chaos or pattern. His execution, rapid as it was, consisted of a total immersion with the materials of his painting. Yet they contained no illusion, no tricks. They demanded something of the viewer: a deep discipline in seeing. The new creations of Pollock and Newman are like nothing before in the painter's world. They strive to be primordial. Yet they do portray how reality is perceived; that is, they are neither this-worldly nor otherworldly. Their transcendence is in their very presence. They are heroic, tragic, grand, sublime—that is, ourselves when freed of many of the overlays of history. They are, analogously, meant to be like God's pure creation.

The use of numbers as titles by abstract expressionists is consonant with this transcendent view of the artistic process. *Number 1, 1948* (plate 94) or such designations as *Untitled, 1951,* made it possible to view a painting without being encumbered by a title suggesting what one should see. When titles were provided, they usually emerged upon completion of the work: the new creation cried out to be named, and the naming was not accidental. There is a difference between painting a subject already named or conceived in words and a creation that, though planned, emerges in its own way, defining itself.

Although the titles are not accidental, neither are they full of inexhaustible or necessarily precise meanings. Newman tells us that he did two paintings, thought of calling them Adam and Eve, continued to do four, and then knew he would do fourteen, eventually calling them the *Stations of the Cross* (plate 95).[4] His paintings declared themselves not by beginning with an iconography familiar since the seventeenth century but through a perception of suffering that declared its own affinity—though not identity—with traditional associations with the stations. Abstract expressionists in this sense declared their independence, insisted upon the integrity of their own perceptions, and then, through titles, disclosed their affinities to historic realities. This is no less true even if one admits that many titles could be different from what they are or that in some instances they might be interchanged.[5]

Ad Reinhardt shared the basic orientation of the Abstract Expressionists and, like Newman, became one of the chief sources for the minimalist impulse in art. The paintings of Newman and Reinhardt seem to convey a minimum of means, but the carefully applied layers of paint are hidden beneath a delicate surface that does not call attention to itself. However, the two are artists of quite divergent directions. Reinhardt stood against the

[4] Jane Dillenberger, *Secular Art with Sacred Themes* (Nashville, TN: Abingdon, 1969) 99–100.

[5] When the late Thomas Hess used the kabbalistic tradition to understand Newman's titles, suggesting that they are codes or secrets that Newman kept to himself, he seemed to betray his own fascination with the kabbalistic tradition rather than illumine Newman. In the kabbalistic tradition all names are mirrors of psychic and/or religious states; thus a kabbalistic interpretation is possible for everything in creation. That is its fascination, but such a mystical view of the world was foreign to Newman, though one would not doubt his knowledge of the tradition. In conversations that I had with Newman on theology and art covering almost a decade, the kabbalistic tradition was never mentioned. I suppose Hess might have used that to support his theory of Newman's secrets, but that would not have been the Newman that I and many others knew. Since Hess resorted to the esoteric and secretive, one cannot refute him, but one can declare him wrong. More important, for Newman naming was derivative, a second state, the act of recognition, not the identification of art objects with specific historic interpretations, more or less esoteric.

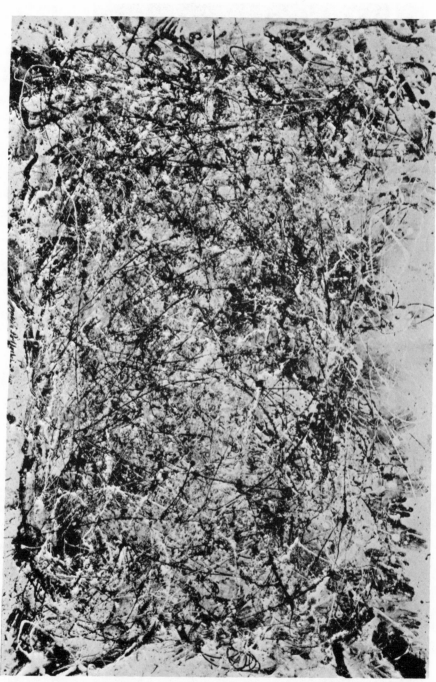

94. Jackson Pollock, *Number 1, 1948*, 1948

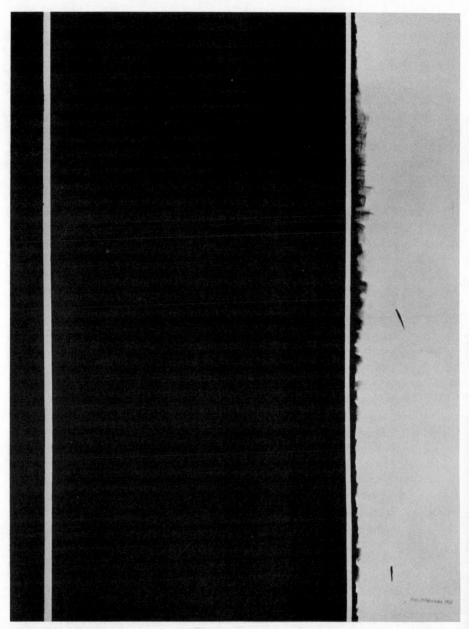

95. Barnett Newman, *Station #12*, 1965

tradition of art and further believed that once the traces of the past were eliminated, one had reached the limit and essence of art. In principle, this meant that one could hope for painting in its final state, that is, the final painting capable of being repeated without old or new accretions. Such negation of all historic traces—the *via negativa* which arrives at the mathematical zero, or merely the horizontal and vertical thrusts within the order of things—is itself the product of history and reflects the Eastern artistic and religious tradition, as well as the influence of Thomas Merton, both of which Reinhardt admired. Whereas Newman believed that his art conveyed the grandeur of humanity and creative forces in their primordial settings, Reinhardt intends his paintings to express a static, negative unknowing. Reinhardt represents the confluence of Eastern spirituality and the linguistic minimalism of the West. In contrast to his Lutheran upbringing, he found in Eastern religion the closest analogues to what he intended in his art, namely, that reality could be expressed only in terms of itself. Reinhardt wanted art to be art, not subject to possible contamination by anything else, even religion. It is ironic that Reinhardt's so-called black cross paintings—which he understood in the mandala vertical and horizontal sense—should nevertheless have Christian associations, and that a series of them, all of the same size, were exhibited by the Jewish Museum (plate 96). Such ironies would have delighted Newman, the man and the artist. For Reinhardt, such ironies would not be fitting for an artist, but were perhaps appropriate for the man as human.

Rothko's dark paintings for the Rothko Chapel, Newman's *Stations*, and Reinhardt's black paintings raise the question of the role of color among the abstract expressionists. Reference has already been made to Newman's *Who's Afraid of Red, Yellow and Blue* and his response to the inherited tradition of primary colors. Color, which predominates in pure form in much abstract expressionist art, frequently gives way to black and to its corollary, white. When the question of art and meaning emerges, the experiments, and many of the works, turn out to be black and white. The abstract expressionists did not consider black to be ominous, but rather primordial—that is, more elemental than the primary colors and their derivative combinations. A fresh way of seeing the world is represented here because we do not, as Doug Adams reminded me, see the world in black and white.

Death prematurely took its toll among the abstract expressionists we have considered. However, Willem de Kooning and Robert Motherwell continue to paint, and Clyfford Still painted through the 1970s. Their works testify that the vitalities within that school have not come to a halt, even if there is no generation of direct successors. The art of the seventies is obviously different from the creations of the fifties, but the continuity is unmistakable.

96. Ad Reinhardt,
 Abstract Painting, 1960–1961

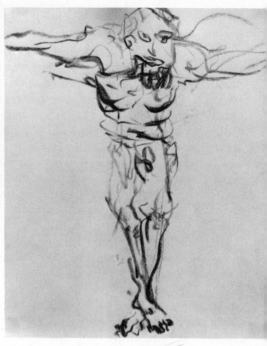

97. Willem de Kooning, *Untitled Drawing,* 1966

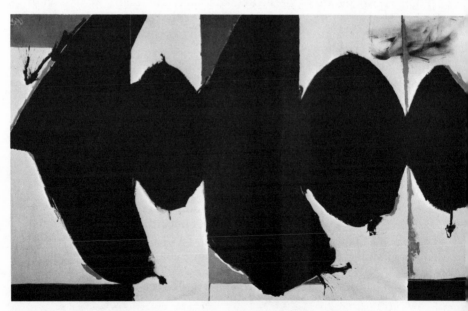

98. Robert Motherwell, *Elegy to the Spanish Republic, 108,* 1965–1967

Willem de Kooning is most widely known for his paintings of women. Sensuous and grotesque, these women with distorted faces and bodies are painted with a sheer power of color and interrelated shapes. De Kooning frees woman from the traditional canons of female beauty and makes her into an image of humanity's grandeur and misery, and he discloses the irony of it all with humor. In a series of Six Untitled Drawings (plate 97), one finds echoes of the crucifixion. De Kooning has a Kierkegaardian and Dostoievskian view of reality, a vision that translates itself into the various transmutations of his paintings and drawings. On occasion, the iconographic suggestions help to keep in balance both positive and negative ingredients. Like Goya, de Kooning occasionally crosses the boundary of humanity's dignity. His more recent paintings, however, embed the human figure in landscapes, in a positive ambience with nature. An intense lyricism of line and color is particularly evident in a triptych done with St. Peter's Lutheran Church in New York City in mind. Placed at least temporarily behind the altar and beneath the ascending window, the painting provided a symphony of color, with echoes of religious symbolism, suggesting forms particularly appropriate for the liturgy. He painted it, he said, as a kind of thanksgiving, for he remembered that in his youth he had traveled throughout Europe and had seen the paintings on the walls of churches; these had inspired his life.

Robert Motherwell does not blink at the cruelty of humanity, as his *Spanish Elegies* (1950s) disclose. With their historical reference to the Spanish Civil War, the *Elegies* (plate 98) are a meditation on death but are pervaded with a sense of continuing life. His interest in Charles Baudelaire, Stéphane Mallarmé, and the surrealists prepared him for the tragic sense of life; yet the positive and joyful side of life has always been equally important. This natural penchant to measure the heights and depths has been nourished by extensive reading and exposure to people and events. When translated into his art, his thought loses all concrete references and is transmuted into ontological declarations. Having literally faced the prospect of death in recent years, Motherwell is actually more life-affirming in what he is now doing than in his previous work. A new poignancy has entered into all that he does.

Sculpture in the Abstract Tradition

With Richard Lippold we move from painting to sculpture, from color to configurations of space. Trained in music, Lippold was in his mid-twenties when he turned his full energies to steel and wire sculpture. He has appropriately described his new-found career as his continual love affair

with metal. For Lippold the artist's total vision is determinative of both the intent and the form of art. Lippold, too, is impressed by the way in which modern science has changed our perception. Things are no longer solid: their structure is an illusion. From the midwestern plains of Lippold's childhood to the expanses of the galaxies, space—the space we see everywhere—is the dominant focus of contemporary humanity, as was the devil for medieval humanity. Space is the constant in which the small and the vast are present, a context full of antinomies and tensions. Humanity itself bears analogies to such alleged contraries, for humanity comprises body and mind, uneasy in their relations but constitutive of life. To see humanity's venture not as a retreat but as expressive of pulsating possibilities is to know something of God—at least the seeking of God. Life has consistency in the flux of its struggles; agony is part of any life that creatively and joyously accepts divergent tendencies.

Lippold seems to suggest that in the infinity of space are tension and calm, analogous to human life. If we question the source for such an insight, reminiscent of Pascal, Lippold reminds us what science has taught about our world. He adds that there is an element of truth in the Zen "quiet beyond turmoil," though as a Westerner he cannot accept it as a total philosophy. He also points to the contribution of psychology to human understanding. But most of all, he informs us that the artist finds confirmation in other disciplines for what the artist has quite independently come to know.

Helping us to see through space and to see space shaped while not having shape is crucial in Lippold's metallic creations. Solidity has disappeared, and space becomes part of a constellation, providing us with new avenues of perception. Beauty is the creation of an object that includes space as an element, disclosing the epitome of the cosmos and of humanity. Art incorporates dichotomies as essential to each other, creating something more in the process: the whole is more than the sum of its parts. Art is always many things in an essential unity. Lippold states that art is "a believable totality of expression at once sensuously seductive, intellectually intriguing and emotionally moving" and "the artist is neither monk nor harlot, but something of each. Seduction is his business, but with a spiritual trap at the end."[6] In Lippold's art eros becomes agape without losing its character as eros.

Technically, Lippold uses metal or wires of small scale compared with the spatial area that the work of art includes. Thus, in the baldacchino above the altar of St. Mary's Cathedral, San Francisco (plate 99), the wires

[6] Richard Lippold, "To Make Love to Life," *Graduate Comment* (Detroit, MI: Wayne State University Press) 3/1 (October 1959) 2.

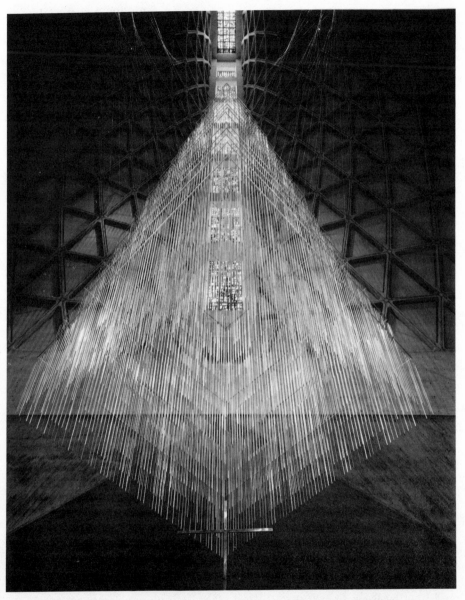

99. Richard Lippold, *Baldacchino for St. Mary's Cathedral*, 1969–1970

are small though numerous. For *Orpheus and Apollo* (1962) in the lobby of Avery Fisher Hall at Lincoln Center, New York, the pieces of metal, large in themselves, are relatively small when one considers the space the entire work occupies.

Louise Nevelson, eschewing traditional bronze or marble except for some outdoor sculpture, has used pieces of wood wrested out of contexts no longer viable, to create boxes, columns, and walls that produce their own environment. Using one color (either black or white or gold), she strives for a total impression, the parts forming a whole rather than calling attention to themselves. The total environmental effect, however, is not without echoes of things we know, and the net result has echoes of a representational nature. Her columnar works are like personages, "presences," as she herself calls some of them; others are like altars or cathedral facades, suggesting both the Romanesque and the Gothic. She herself does not regard them as religious, but as "images of feeling."

Although her walls suggest environments, only recently has she had the opportunity to design a total environment, a meditation chapel as part of the St. Peter's Lutheran Church, New York City (plate 100), erected beneath a skyscraper and set in the context of spaces designed for myriad urban activities. Columnar forms near the altar evoke the Trinity, and the wall configurations are trinitarian in the Augustinian sense—that is, the structures are triadic, as if life and reality affirmed such a structural foundation. Considering the difficulties inherent in present-day church commissions, Nevelson's genius is apparent. She could have ignored the religious sensibilities, or she could have provided an obvious iconography in which the Trinity accosts us. She has succeeded by being herself.

Isamu Noguchi, with his Eastern regard for nature and its small, unique vistas and objects and a Western concept of the vastness of nature and the technical means of dealing with it, has wedded East and West in approximately equal proportions. Noguchi was reared in Japan until the age of thirteen and has frequently returned. His incorporation of that ethos into his work is as authentic as his Western modalities are. From his Eastern background has come the profound respect for the material he uses: that these must not be abused, that they must retain their inherent character. Believing that one must use what is at hand, he has a natural preference for wood and stone, both elemental, directly of the earth. He believes that tension—the defiance of gravity, a balanced stress that almost seems to undo itself—is part of the fabric of what we daily see and experience.

Noguchi, like Lippold, finds space to be central to the sculptural act; however, everything is in the placing. Noguchi, unlike Lippold, believes that spaces hide rather than constitute the essence of sculpture. Sculpture is the ordering and animating of space, a poetic translation of nature that

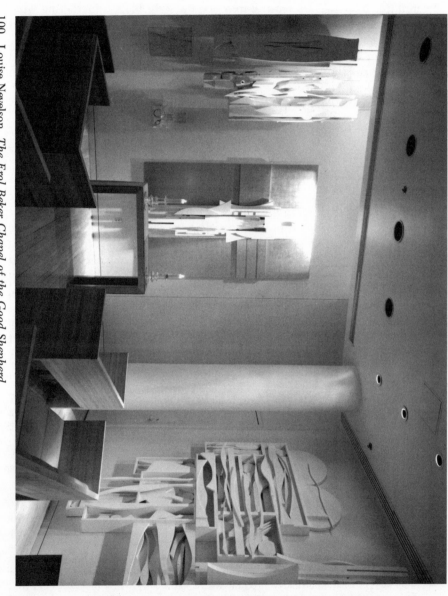

100. Louise Nevelson, *The Erol Beker Chapel of the Good Shepherd,* Interior view of *Trinity, The Cross of the Good Shepherd,* and

takes us to the essence, an emotive essence that moves us. Sculpture is using the elemental things of nature in minimum form for maximum emotion and meaning. The *Cross Form* (1958) (plate 101) has a simple structure with multiple meanings—a cross, a torso, even a light plug, representing what are and have become elemental forces of our existence. Noguchi's conviction that one works with the materials and places at hand, including the uncertain world of commissions, has led to great variety in his work and to major collaborations with other artists. Several rock gardens have been done in conjunction with architects, and his stage creations for Martha Graham disclose other facets of his imagination. In all of them, the evocative possibilities of the elemental are crucial.

Painting and Sculpture in Recent Decades[7]

In many, though not all, of the artists in this period, there is a return to the human figure, though in a way that would not be intelligible without the impact of the abstract expressionists. Nathan Oliveira's paintings, too, have the painterly surface of the abstract expressionists and the expanding vistas of the California environment. The figure emerges from the delicate field of color into a direct confrontation with us without ever becoming fully delineated, as in *Spirit II* (1971) (plate 102). The psychic and spiritual substance is disclosed in a veiling of the figure that is also its unveiling.

One of the most individual of the contemporary figures is Jess, a San Francisco painter and frequent working companion of the poet Robert Duncan. He calls his works *Translations,* and some of them *Salvages.* The

[7] In the context of this section, I have decided not to deal with pop art or the minimalists. But a note on both may be in order. Pop art came to its height in the sixties, but its seminal foundations were in the fifties, in the work of Jasper Johns. Johns confronts us with the humor and irony of words, letters, and numbers in arrangements that transcend their obvious ingredients. In line with his interest in Wittgenstein, Johns sees in word and numbers the self-transcending or spiritual center that constitutes humanity and reality, or being itself. For Johns, it seems, words and numbers can disclose their power only when freed from the all-too-familiar settings. Johns's works, although rooted in ontological premises, are ordinarily not seen as spiritual perceptions; yet they parallel the concern with hermeneutics and epistemology in the field of religious studies. Artists such as Donald Judd and Robert Irwin take their departure from the minimalist impulse in abstract expressionism, particularly from the work of Barnett Newman. Their work, however, is quite different from the abstract expressionists. While the latter intended to convey more with limited, elemental means, artists such as Judd and the minimalists generally have no ambition to convey more than the thing itself or what immediately meets the eye. As in the early Wittgenstein or in linguistic analysis, to which minimal art is related, there are no nuances, no call to emotional response, no question of style or taste, no previous idea of what is expected.

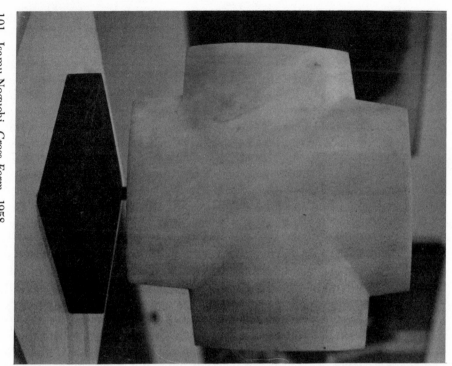

101. Isamu Noguchi, *Cross Form*, 1958

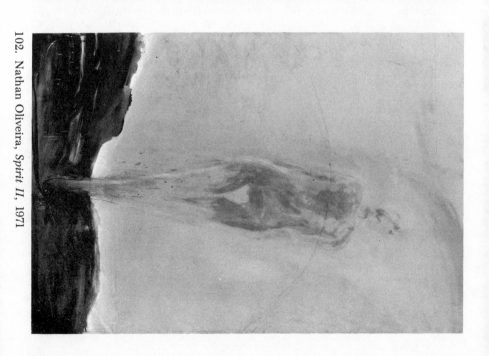

102. Nathan Oliveira, *Spirit II*, 1971

known and the unknown, depicted through layers of paint that hide and disclose in their rich and sometimes shifting configurations, make up the translations and the salvaging contexts before us. To experience perceptions of the past, not only in their delineated spaces but also in their continual unnerving, astounding presence, is to be positively surprised at the conjunctions that make up our existence. In actuality, each *Translation* stems from a concrete suggestion—a photograph or an illustration, or perhaps a passage of a poem or a document—for example, *No Traveller's Borne, #21* (1965) (plate 103). But the connections established in the painting and the transformations wrought in the process elicit responses from sheer delight to an almost divine madness. Past, present, old, new confront us as the medium and the message.

With the art of Stephen De Staebler we enter the world of contemporary sculpture. Since De Staebler has an Episcopalian background and did an honors thesis in religion at Princeton on St. Francis of Assisi, he has a background appropriate for a "religious" artist. However, he would be the first to object to such a designation, and rightly so, for he knows that, although art proceeds from the depth of one's own perceptions, a too-consciously-held religious stance frequently results in illustration. There is, however, a gnawing concern with religious issues in both his person and his art. Fundamentally, De Staebler is a sculptor for whom clay is the earth—ancient and with a life of its own that must not be violated. De Staebler's sculpture is not polished or symmetrically formed, but instead expresses an archaic barren terrain, full of past and latent power. In his only formal religious sculpture, the sanctuary of the Newman Center Chapel, Berkeley, the chancel area is shaped like a mound of earth, out of which emerge altar, tabernacle, lectern, and chair. Dark grays, earth colors, and rich oranges with the texture of leather or hide give the impression of organic entities, and behind the altar hangs the corpus, crucified on a cross of earth (plate 104). De Staebler has also created a series of massive ceramic seats, with shapes that are comfortable to those who have discovered nature's contours. But they are thrones rather than traditional chairs, for they evoke a presence and suggest the need to be occupied and the pleasure of being cradled within the seat. Their earthbound stability, rent with fissures and cracks, discloses both hidden power and the ravages of time.

De Staebler has more recently completed a body of figurative work. Unlike the corpus at the Newman Center, most of the sculpted figures are incomplete effigies. They are made of pieces, partially for ease of ceramic firing but also as a deliberate artistic device. In fact, at times De Staebler breaks a figure into pieces after it has been fired. He loves to place a foot or other member of the body by itself; while concentrating attention on the fragment, he suggests the total human being. His figures, caught in a

103. Jess, *No Traveller's Borne*, 1965

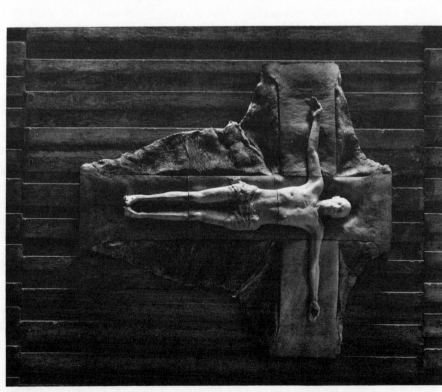

104. Stephen De Staebler, *Crucifix*, 1968

continuum of dissolution and completion, are locked into the earth from which they are made, yet they are hauntingly free. Currently, De Staebler is working on sculpture that forms the walls of rooms, that is, work in which the sculpture appears as the wall itself. A project of this type now under way is for a conference center room at New Harmony, Indiana.

Mark di Suvero works both on the small scale and on the grand. He was born in China of Italian parents and majored in philosophy at Berkeley while working in sculpture. An accident made it necessary for him to work in a wheelchair for several years, and his various versions of hands (some begun at an earlier date) as well as other smaller creations were encouraged by the situation in which he had to work. As in the work of De Staebler, the part suggests the whole, so that *Pierced Hand* suggests both man and crucifixion. But in di Suvero's case, it represents also an interest in the tradition of Rodin. Most of di Suvero's sculptures are of large scale, many placed out-of-doors. Like many other artists, he was interested, in his earlier works, in the particular properties of the materials he encountered—weathered wood, oxidized chairs, etc. More recently, however, previously used materials from other contexts disappear, and the emphasis is on design. That many of his sculptures have large-scale movable and shifting parts expresses the happy accident of discovering that various parts were in a balanced equilibrium.

It has been said that di Suvero's works are sculptural equivalents of the brush lines of paintings, such as those of Franz Kline, and in fact di Suvero does brush lines for his sketches of sculpture. Although this analogy is suggestive, the net effect of his sculpture is beyond such analogies. Where Lippold wants us to see through spaces, and Seymour Lipton to enclose them, di Suvero provides hieroglyphic graphs linking sky, earth, and buildings, a signature of their forces and thrusts. His titles, too, are suggestive, such as the traditional Christian-classical motifs—*St. John the Baptist* and *Theseus and Ariadne*—or *Praise for Elohim Adonai* (plate 105) and *Nova Albion*. (Did he know William Blake, "Visions of the Daughter of Albion: The eye sees more than the Heart knows"?)

Robert Smithson did a series of drawings in Rome during 1961 in the midst of a profound crisis of spiritual exploration. Smithson had a nominal Roman Catholic background, and in these drawings we see traditional iconography, draftsmanship, and imagery that are reminiscent of Francisco de Goya (plate 106). But Smithson is more publicly known for his earthworks, near one of which, the posthumously completed *Amarillo Ramp* (1973), he was killed in a plane crash. He executed a series of "Non-Sites," situations in which the transformation of an area of nature, usually an abandoned site, was made visible to museum-goers by piles of earth, mirrors, and photos of the site. Smithson also did drawings, in conjunction

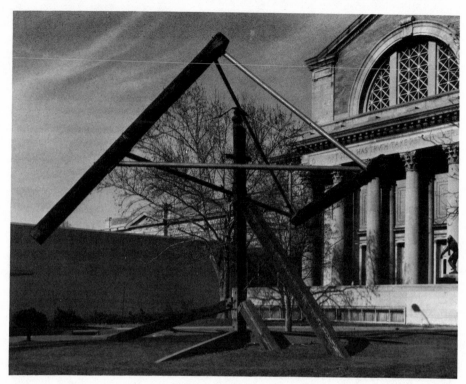

105. Mark di Suvero, *Praise for Elohim Adonai*, 1966

106. Robert Smithson,
 Demons and Angels, 1961

with architectural engineers, for the Fort Worth-Dallas Airport, but the designs were not accepted.

There is a mystique in Smithson's conception of the earth, analogous in his own mind to Newman's preoccupation with the Indian mounds of southern Ohio. The spiral jetties, the uncompleted circles, the ramps appear on the one hand like the surviving traces of planets and, on the other hand, like primordial eruptions from the center of the earth. It was not nature, he suggested, but the earth that interested him. Smithson was interested in primordial symbols, and he read omnivorously in religion and psychology from Blaise Pascal to Carl Jung.[8]

In the work of George Segal, the shock of recognition is in seeing clearly what we had seen inchoately before. His creations, generally white plaster molded upon living models (sometimes later cast in bronze), mirror through the subtle nuance of posture the isolation of individuals in familiar settings. He has turned this "aloneness" to full advantage in several biblical episodes of intense personal encounter, such as *The Legend of Lot* (1966), two differing versions of Abraham and Isaac—the first, *Abraham's Sacrifice* (1973), at the Tel Aviv Museum and the second, *Abraham and Isaac: In Memory of May 4, 1970, Kent State University* (1978) (plate 107), which is now beside the Princeton University chapel, after having been rejected by Kent State University—and *Jacob and the Angels* (1984). A group of figures, cast in white bronze, called *The Holocaust* (plate 108), dedicated in 1984 and commissioned by the city of San Francisco, is placed on a site near the California Palace of the Legion of Honor, where the ocean reaches into the San Francisco Bay. One haunting figure stands facing out from a barbed-wire fence, while behind him ten cadaver-like figures lie in a random yet structured pattern, among whom one sees Adam and Eve and Abraham and Isaac; and Abraham is shielding Isaac's face. Forty years after the events, horror and peace are intertwined in Segal's conception. This work and the two versions of Abraham and Isaac have created considerable controversy. Segal is a powerful artist whose sensibilities cut to the center, but he is also a warm, unassuming person who has been somewhat startled by the furor his vision elicits.

Alfred Leslie is arrestingly distinctive among contemporary artists. His self-announced program is "to put back into art all the painting the

[8] See the interesting and suggestive theological interpretation of Smithson's earthworks, including reference to statements by Smithson himself, in Patricia Runo's chapter, "Reclamation, Resacralization, and Regeneration: Approaches to the Environment in the Art of Smithson, Singer and the Harrisons," in *Cry of the Environment: Rebuilding the Christian Creation Tradition*, ed. Philip N. Joranson and Ken Butigan (Berkeley, CA: Center for Ethics and Social Policy; Santa Fe, NM: Bear & Company, 1984) 279–95.

107. George Segal,
*Abraham and Isaac:
In Memory of
May 4, 1970,* 1978

108. George Segal, *The Holocaust,* 1984

Modernists took out," to create "an art like the art of David, Caravaggio and Rubens, meant to influence the conduct of people."[9] Such an aim means a dramatic return to the human figure and to what was once called history painting. In Leslie's paintings the figures are large and frontal, and light and color are used in such a way as to make details more dramatic than they are in real life. The figures confront one on the edge of effrontery, with an undeniably majestic character behind the boldness of clothes and flesh. Frequently there are historical allusions: the *Act and Portrait* series (1968–70) is a human triptych; the *View of the Connecticut River as Seen from Mount Holyoke* (1971–72) announces what has happened since Thomas Cole's *The Oxbow*. The *Killing of Frank O'Hara* (1966), which refers to the accidental death of the art critic, poet, and friend of Leslie, is a working painting for a cycle of five entitled *The Killing Cycle*. The contemporary figures, including O'Hara, emerge in the painting in a format reminiscent of Caravaggio's *Deposition*. In *The Raising of Lazarus* (plate 109), two human figures are cast respectively as a standing Christ and the still bound but erect figure of Lazarus. In both of these paintings representing historical subjects, Leslie's aim is to show that, from an artistic standpoint, one can reclaim such subjects, that they do not need to be abandoned, that they can take on new vitality. Hence, it should be clear that the artist is not interested in such paintings as subjects of faith or unfaith, either his or that of the viewer. How the viewer responds cannot, of course, be controlled. Some will see in the *Raising of Lazarus* a profane version of a traditional subject, some a depiction of the story in fresh ways, some an exercise in artistic creativity.

Cleve Gray, prominent from the sixties into our own time, is associated by some with the abstract expressionists. But the gestural character of his unique style was influenced by the art of the East, not by the abstract expressionists. The places in which he has worked have also left their mark—Rome on his series *Roman Walls*, Japan on his so-called Zen paintings, or Prague on his series *In Prague* (1985). He has done triptychs, but his most ambitious series is the *Threnody* cycle. Vertical dark forms move toward the center of three walls, where mutations of brilliant red anchor the room. Painted in the tragic period of the early seventies, the cycle confronts the problem of death and life, creating, as Gray said, "a dance of death and life around the room." Realizing, writes Gray, "that the depiction of tragedy often requires an element of hope, I chose a positive red for the central figures of the 'apse' wall. Unexpectedly but inevitably this figure became the climactic point of the room. In the midst of death it had to offer the hope of life, just as blood is both the palpitating fluid of life and the

[9] "Statement by Alfred Leslie," Allan Frumkin Gallery, New York City, November 1975.

109. Alfred Leslie, *The Raising of Lazarus*, 1975

fleeting evidence of death." The red wall became "a metaphor of life, which receives its essential meaning and structure from the certainty of death." [10] On the occasions when the paintings are installed in a large room designed by Philip Johnson, their ambience creates a special and somehow sacred space, more encompassing than any chapel or church painting scheme I know. Here the paintings define the space and place.

Recently Gray has also designed vestments with lyrical line and with colors of the church year. In 1985, he painted resurrection themes (plate 110), stating that "I buried everyone in the *In Prague* paintings and now they've decided to come alive again and be happy!" [11] The figural allusions to be found in some of his earlier works now become distinct silhouettes, new creations of a transcendent, spiritual nature.

The late seventies and the eighties present special problems of interpretation with respect to artists who first came into prominence in these decades. First, we are so close in time to the creations of these artists that the winnowing of history has not taken place. Second, the promotion of artists as media events has never been so prominent or so successful. Fame comes quickly, but it may also fade away. Third, the new generation of artists is working in an eclectic setting, aware of the past and the recent past, not interested in either rejecting it or continuing it. Hence, their visions, although related to the past, are highly individualistic. They do not reflect a school of painting, though many of them have contact with each other. Fourth, they belong to a new figural age, not one that replaces abstraction with realistic figuration, but one that sets figures in various tableaux, full of cryptic references and juxtapositions. Historic allusions are not a repetition of the past; they may be a fresh reappropriation in positive, transformed meaning; a spoof with an irreverent reverence; a deliberate portrayal of multiple meanings of differing levels, a double-edgedness; or outright ambiguity. Finally, many of their works may be said to express spiritual perceptions in a direct, unembarrassed, conscious way. This has been recognized by Grace Glueck and John Russell in their reviews of the art world in the *New York Times* in the spring of 1985, by Michael Brenson in the spring of 1986, as well as among others writing on the art scene. [12] It has also been evident in a series of exhibits on both coasts, which were organized around the theme of the spiritual. Works in these exhibits may be more

[10] "Threnody," a statement by Cleve Gray, Neuberger Museum, Purchase, New York, 1975.
[11] Letter to Jane Dillenberger, 31 December 1985.
[12] See the following articles in the *New York Times:* Grace Glueck, "Religion Makes an Impact as a Theme in Today's Art" (7 April 1985); John Russell, "Anselm Kiefer's Paintings Are Inimitably His Own" (21 April 1985); and Michael Brenson, "They Seek Spiritual Meaning in an Age of Skepticism" (11 May 1986).

directly suggestive of the spiritual than, say, the works of the abstract expressionists or the nature painters of the past, but they do not belong to a church or liturgical tradition. Spirituality in the arts is still largely outside the church.

There is recognized competence and religious expression in some of the works of the so-called neo-realists, Jean Michel Basquiat, Jonathan Borofsky, Robert Longo, and Julius Schnabel, though one cannot escape the question whether their competence is related to a vision significant enough to assure their place in history. Nevertheless, the graffiti-like images of Basquiat are replete with crosses and crowns that are more than incidental. The canvases of Julian Schnabel include saints, ceremonial vessels, the crucifixion, and the Christ figure. Longo's works frequently are in triptych or trinitarian form, a fact that he does not find insignificant. Moreover, he sees them as environments that may create the "climate of a temple, or a battlefield," but which, in the light of the past and the present, are full of hope. Grace Glueck, referring to his work called *Friends*, writes that it is "a crosslike icon," and for Longo himself the work evokes "the figures of the Medici tombs, the cross, but also a billboard scene, and the movies." [13] Especially interesting and competent is the German artist Anselm Kiefer, whose series *The Departure from Egypt* was featured at the Marion Goodman Gallery in the spring of 1985. As in the works of the artists just mentioned, the historical allusions in Kiefer's paintings are multiple and suggestive, but the style depends less on cryptic symbols and more on the use of paint with shellac, sand, woodcuts, photographs, photographic paper, straw, clay, string, and twigs, as John Russell has pointed out.[14] Surface and texture are fundamental in his evocations. The uneven texture, with its grays, blues, and browns, in various combinations and mutations, provide an ambience in which events and landscape are forged in an incredible unity. In the series *The Departure from Egypt*, which title also represents one of the paintings, along with *The Miracle of the Serpents*, *The Golden Calf*, *Pillar of Clouds*, *The Staff*, *Aaron*, and *Exodus* (plate 111), we are not assaulted by the depicted events but are brought into their historic-natural habitat.

Leaving these currently much-discussed figures, we turn to exhibits that have featured the spiritual or the religious. Grace Glueck has called attention to an exhibit at the Pratt Institute Gallery in 1981, called "Religion into Art"; the show called "Cruciform" at the Barbara Gladstone Gallery in 1982; the exhibit at the Jewish Museum in 1983, entitled "Jewish Themes/ Contemporary American Artists"; the show called "Saints" at the Harm

[13] Glueck, "Religion."
[14] Russell, "Anselm Kiefer's Paintings."

111. Anselm Kiefer, *Exodus*, 1984–1985

Bouckaert Gallery in 1983; and the show of food offerings in homage to African saints, as contrasted with Western images, in the exhibit called "Santa Comida"in 1985. To these one might add, "Paradise Lost/Paradise Regained: American Visions of the New Decade," at the United States Pavilion, 41st Venice Biennale in 1984, or some of the works in the Whitney Museum of American Art 1985 Biennial Exhibition, such as Gregory Amenoff's *Beginnings,* Doug Anderson's *I Conquered Weakness by Giving in to It,* Jedd Garet's *To Rule the World,* Ned Smyth's *Tree of Life,* or Frank Majore's detailed works *For Your Eyes Only* or *The Temptation of St. Anthony.* In all of these the allusions and illusions are multiple, kaleidoscopic in character. In the spring of 1986, the Whitney also featured an exhibit entitled "Sacred Images in Secular Art," and in the fall of 1986 the Los Angeles County Museum of Art will open its new building with an exhibition entitled "The Spiritual in Art: Abstract Painting 1980–1985."

Finally we turn to two exhibitions in 1985, one on the East Coast called "Precious: An American Cottage Industry of the Eighties" at the Grey Art Gallery and Study Center of New York University,[15] and the other entitled "Concerning the Spiritual: The Eighties" at the San Francisco Art Institute.[16] Both of these exhibitions featured a group of young artists. In the "Precious" exhibit, Adrian Kellard, who was reared in a working-class Roman Catholic family, confronts us with a large shrine, carved from wood and painted in bright colors, central to which is the crucified Christ figure, taken directly from Michelangelo. The Christ figure is flanked by two clown faces, and we are reminded of Georges Rouault. Over the top is written "Dying you destroyed Death," and on the back side is the *Resurrection* (plate 112). Of the juxtaposition of Christ and the clowns, Kellard states that it has "to do with the Saviour being both God and man. And they also have to do with culture—the same culture that would hang a crucifix at home for religious reasons would hang a clown as art."[17] However we may view this boldly expressionist creation, it echoes the *Isenheim Altarpiece.* But it also represents an attempt to get us to see the iconography afresh.

A startlingly different attempt to overcome our traditional ways of seeing is found in the works of Joni Wehrli and Michael MacLeod. In Wehrli's *Adam and Eve with Serpent, Baptism of Christ* (plate 113), *Saint George (and the Dragon), Saint John on Patmos,* dogs have been substituted for the human figures. Startled, if not initially offended, one gradually looks with

[15] Thomas Sokolowski, *Precious: An American Cottage Industry of the Eighties* (New York: Grey Art Gallery and Study Center, New York University, 1985).

[16] *Concerning the Spiritual: The Eighties,* edited by Kathy Brew, designed by Peter Belsito, curated by David S. Rubin (San Francisco: San Francisco Art Institute, 1985)

[17] Glueck, "Religion."

112. Adrian Kellard, *Shrine*, 1985

113. Joni Wehrli, *Baptism of Christ*, n.d.

new eyes. Brought up in the Episcopal Church but not currently a member of any church, Wehrlí tells us that her intent is not iconoclasm, that she associates "tenderness" with dogs, and so she has adopted them as models. She wonders if animal innocence may not be closer to God than the materialism and greed of our culture. In MacLeod's sculptural creation, a dog stands on a plaque, itself incised with cross and the words *Fiat Voluntas Tua*. The posture of the dog is that of having just picked up a newspaper, nose high, about to sprint to its owner, but the dog holds a cross, not a paper. MacLeod intends us to see the cross in a new, unfamiliar context, taking us out of the indifference created by its expected locations.

Diversity is characteristic of this exhibit. One could add Hunt Slonem's *St. Martin de Pores*. This painting shows a Peruvian ascetic saint dedicated to the poor in the first part of the seventeenth century, of which the artist has done thirty versions. Another artist, Claudia De Monte, has invented an alter ego for herself, Saint Claudia, whose powers both spoof and gently tease us about the role of the saints. Thomas Lanigan Schmidt's *Eastern Orthodox Communion Vessels*, done lovingly even if in tinsel form, strikes a familiar note, a nostalgia for opulent things of the past, particularly in the recognition that they are ambiguous for us.[18]

The "Concerning the Spiritual: The Eighties" exhibit at the San Francisco Art Institute, like the one at New York University, had a diversity of work full of historical allusions. But the selection was also different, as the East and West coasts are different, for in California there is a tradition that builds on earlier West Coast artists such as Wallace Berman, Bruce Conner, Jay DeFeo, Jess, or Nathan Oliveira. Although without a long history, the West Coast has its more recent forming memories. The range of this exhibit moves from the works of Lita Albuquerque, with its Smithson/Jess-like concern for nature and the universe, to the specific evocations of Eva Bovenzi's religious subjects such as *Fra Angelico's Door* or James Rosen's Madonna images, such as *Madonna Enthroned, Madonna and Child*, and *Angel*, all of which are based on specific works of art from the past. Rosen starts by painting Giotto's *Madonna Enthroned*, and then he gradually covers the painting over with layers of gray pigment until the forms are almost obliterated and leave only shadowy traces. Yet, in some ways they are like Oliveira's Spirit paintings, in which the figures are not receding but emerging for us.

In Jean St. Pierre and Jim Morphesis the spiritual dimensions are most explicit. St. Pierre, inspired by a musical composition by Olivier Messiaen,

[18] Seeing Schmidt's treasures on the same day as the "Treasures of San Marco" at the Metropolitan Museum of Art made me particularly aware of both nostalgia and the transformation of symbols.

did a series of paintings in 1975–76 entitled *Twenty Contemplations of the Infant Jesus*. These small white paintings exhibit both calm and motion, with the human soul vital; their format is reminiscent of the work of Wallace Berman. Mostly black with only line tracings of white are his two *Lazarus* paintings, done between 1980 and 1984. Here the white lines, as much in their character as lines as in their color, exhibit the emergence of life out of death, of light out of darkness.

Jim Morphesis's works represent transformations of historic subjects. In *Colmar Variation*, the pastel shapes in abstract form follow the contours of the Grünewald altarpiece. In *La Tempesta* (1981) Morphesis uses acrylic, oil, wood, collage, metal wire, and gold leaf to frame a replica of Diego Velázquez's *Crucifixion*. Likewise *Oracle* (1983) is related to Velázquez, and *Destiny* (1982) (plate 114) to Bellini's *Pietà*. *Fortress* (1981) is a cross of various media placed on a wood panel. Given the fractured, broken, yet unified elements that make up the cross, the ordinary has been made extraordinary, if not transcendent. The cruciform shape occurs also in two works by Craig Antrim, one etching of 1982 entitled *Talisman Suite III*, in which a hand is imposed on a cross-form on a mandala, and the other, an untitled 1983 oil pastel on paper, in which a cross and a halo appear in a sea of red. The description merely gives us an iconographical report. Actually, the historic references are subtle rather than blatant, and the color, reminiscent of abstract expressionism, itself conveys spiritual dimensions. Here traditional iconographic subjects and the painting medium form an arresting unity.

Looking at the works in exhibits on both coasts, one would hardly want to place any of the art, with possible exception of the cross by Morphesis, in a liturgical or church setting. The artists seem to represent individual, cultural, religious phenomena. They are more specific in religious symbols than many of their predecessors, but are less a part of the historic traditions. History for them is not tradition but a series of analogues, personal religious affirmations, or ironic comments.

Taken as a group, the artists in the decades of this century share a passion to express perceptions, vast or limited, which undergird humanity with a fullness denied to it where the goals and outlook are dominated by a material, technological, business culture. Such perceptions may be said to be spiritual rather than material, without negating the latter. The distinction between the two is not between the ethereal and the actual or physical. Rather, the spiritual exhibits a regard for ultimacy or acknowledged meaning conveyed by, but not identical with, the world of sense. In contrast, there is significant art that makes no claim to spiritual perceptions but is an artistic mirror on our world in its immediacies. Such art may be serious,

114. Jim Morphesis, *Destiny*, 1982

playful, or satiric and can be received for what it is. Who has not enjoyed the creations of pop art, with its ambiguous, tantalizing character?

Although art of the twentieth century abounds in spiritual perceptions, it is only ambiguously related to historical religious traditions. Traditional religious subject matter, when it does occur, is seldom understood in or related to traditional historic meanings. When traditional subjects are delineated in traditional terms, they are apt to have less power than works of art with nontraditional subjects, and frequently they show less artistic excellence.

Twentieth-century artists are forming perceptions rather than expressing perceptions already held. Artists no longer reflect religious traditions but create and express new spiritual perceptions, which we are invited to share. The sources for such perceptions are many. In part they represent individual transformations of residual religious traditions; they reflect a renewed interest in all that has been encompassed by the word "nature"; they express a continued and renewed interest in the art and to a lesser degree the religion of Eastern traditions. In the modern world, the spiritual perceptions of artists and the full scope of a religious tradition seldom coincide. Most of all, the sources seem to well up from within, representing humanity's assertion about its own nature and value, in and through the complexity and variety of humanity's existence. It is as if the perceptions were as wide, and as fascinating, as creation itself.

7

THE CHURCH, ART, AND ARCHITECTURE

Church Art and Architecture

Of the dozens of artists discussed in the previous chapter because their works indicated spiritual perceptions, only four have significant work in chapels or churches: Stephen De Staebler (Newman Center Chapel, Berkeley) (plate 104); Louise Nevelson (Erol Beker Chapel, St. Peter's Lutheran Church, New York City) (plate 100); Richard Lippold (St. Mary's Cathedral, San Francisco) (plate 99); and Mark Rothko (Rothko Chapel, Houston) (plate 93); and one, George Segal, because Kent State University turned down his work, now has his *Abraham and Isaac: In Memory of May 4, 1970, Kent State University* standing beside the Princeton University chapel (plate 107). The particular works of De Staebler and Nevelson for the respective chapels, as well as Segal's *Abraham and Isaac*, were discussed in the previous chapter. The baldacchino by Lippold in St. Mary's Cathedral in San Francisco redeems the unique but hardly distinguished space and contrasts sharply with the otherwise undistinguished works of art in the building. Suspended from the pyramidal-parabolic ceiling, the thousands of silvery, metal rods, catching the air and light, cast an aura of mysterious presence over the altar. The mystery is evoked in a stable yet vital creation of exquisite beauty.

The beauty of the eighteen dark maroon/black Rothko paintings and the way in which the darkness becomes luminous in the Rothko Chapel makes one aware of being in a special place. The chapel, made possible by the vision of John and Dominique de Menil, has not been without problems. Although nothing can overcome the rather nondescript building, a more distinguished one having been rejected by the artist, it was possible to work out the skylight in such a way that the Texas sun does not wash out the subtlety of the colors. In the beginning, the building, located next to the University of St. Thomas, was administered by agencies physically too far

192

away. However, the construction of the Menil Museum nearby has made the area a place and space for people and events. Consequently, the chapel will have a more active life.

On the European scene, the earliest of the notable churches is that of Notre Dame de Toute Grâce in Assy, France, near Chamonix, for which artists were beginning to be commissioned as early as 1939. At Assy works include the mosaic on the facade, *The Virgin of the Litany*, by Fernand Léger; stained glass from designs by Georges Rouault; *Saint Dominic* by Henri Matisse; *St. Francis of Sales* by Pierre Bonnard; a tapestry in the apse, *The Apocalypse*, by Jean Lurçat (plate 115); *Crucifixion* by Germaine Richier; a tabernacle door by Georges Braque; a ceramic mural in the baptistry, *Crossing of the Red Sea*, by Marc Chagall, as well as a plaster bas-relief on the basis of Psalm 42, and two stained-glass windows; near the entrance a sculpture by Jacques Lipchitz.

A cursory glance at the subjects will confirm that there is no iconographic scheme related to the liturgy or to the theological scope of the church's affirmations. Baptism alone is represented among the sacraments. Narrative scenes, so prominent in earlier churches, are absent. The subjects were determined by the individual artists in conversation with Canon Jean Devemy, to whom had been entrusted the plan of the building, and Father Marie-Alain Couturier, who in the light of associations with Devemy took over the general schematic development at the end of the Second World War. For Couturier the church at Assy represented the possibility of once again bringing great artists into the orbit of the life of the church. He worked with each artist rather than with a liturgical or thematic scheme, though many of the subjects have to do with healing and are thus appropriate for this church, which is in a region of many sanatoriums. To Couturier's way of thinking, great art for the church comes from great artists, not from their religious stances. In this conviction, he had to stand against the church of his time. Jacques Maritain, for example, although interested in the revitalization of art in the church, believed that art for the church must be done by believers. But Couturier held that such a practice had only led to poor art in the past. He was interested in using the competent artists he knew, quite apart from their religious convictions, as long as they were willing to do the commissions. But for the Vatican in the fifties, modern art, the worker-priest movement, and unbelief formed a single fabric that the church should reject.

Georges Rouault, a devout Roman Catholic, was commissioned for work at Assy when he was seventy years old—his first commission by the Roman Catholic Church. He was attacked by the Roman Catholic right because his work was considered devoid of beauty, full of agony, and individualistic and private rather than communal. The major attack on Assy, however, was

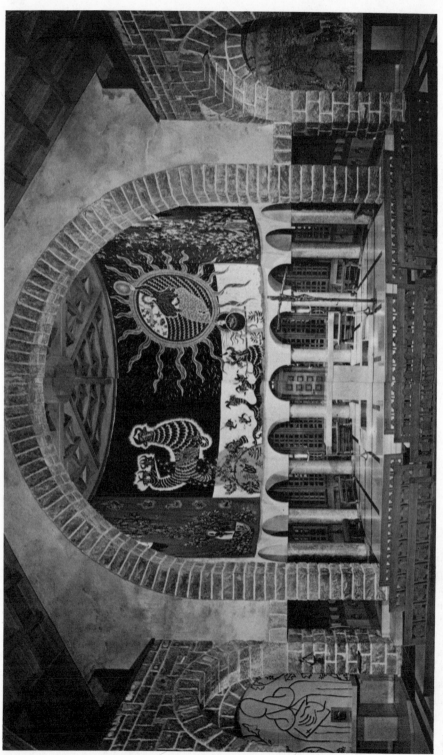

115. Jean Lurçat, *The Apocalypse*, 1945

directed at other artists. Jean Lurçat's apocalyptic tapestry, based on the twelfth chapter of the book of Revelation, is nontraditional in its delineation of paradise and the Apocalypse, but this was not the real issue. Lurçat was a Marxist and therefore an unbeliever. He had agreed to do the tapestry only because he was a friend of Couturier. Fernand Léger, too, who did the brilliant, colored mosaic on the facade wall, *The Virgin of the Litany*, was suspect because he had programmatically announced that the materialism of his own work was a substitute for the sentimental and outmoded representations in the church. Germaine Richier's *Crucifixion* was directly attacked, indeed removed from the church, though it has recently reappeared. In her sculpture, the body of Christ suggestively emerges from the cross, not uncharacteristically resembling the craggy and weathered wood of her sculpture in general. An atheist herself, Richier nonetheless confessed that in doing the sculpture "unconscious things of a unique kind were being translated."[1]

Less controversial but still troublesome to the church were the works by the two Jews Jacques Lipchitz and Marc Chagall. Although Lipchitz believed that Judaism and Christianity were linked like no other two religions, he insisted that he not be misunderstood in his sculptural creation of the Virgin, with its tear-shaped form—Mary with the dove descending and the lamb. On the back of the sculpture—both on the one at Assy and the one that Jane Owen secured for the Roofless Church in New Harmony, Indiana—appear the words: "Jacob Lipchitz, Jew, faithful to the religion of his ancestors, has made this Virgin to foster understanding between men on earth that the life of the spirit may prevail" (plate 119). Chagall's place is more ambiguous. Sought-after as a potential convert to Roman Catholicism, Chagall, though proud of his Jewish heritage, professed no religion of his own apart from the poetry inherent in all religions. His ceramic wall in the baptistry, the *Crossing of the Red Sea*, can be interpreted as an Old Testament paradigm of the New, but his crucifixion within it, like his other crucifixions, in intention reflects the suffering of all humanity, and of the Jew in particular. Agony and joy, pieces of the world that reflect both, are juxtaposed in unfamiliar patterns of incandescent power. Unlike Rouault, Chagall did other commissions for religious communities, such as the stained glass for the Hadassah Hospital in Jerusalem and windows for a considerable number of churches. But the range of his religious subjects in paintings is to be found not in church or synagogue but in the Chagall Museum of the Bible in Nice, France.

[1] William S. Rubin, *Modern Sacred Art and the Church of Assy* (New York and London: Columbia University Press, 1961) 16.

In this early attempt at Assy to reintroduce significant art into the church, the artists may be divided between those for whom this was their only religious commission and those who later undertook other commissioned projects. Assy itself, in the years after its creation, unlike other projects, was the victim of organized opposition. The Vatican increasingly attacked modern art—though now it has a collection of relatively safe modern art—identifying it with all the modern forces that the church opposed. The worker-priest movement was suppressed, and the Dominican interest in the arts was sidetracked. In that confusing history, theologians and philosophers like Maritain and Marcel were on the conservative side. The hoped-for mutual alliance between the artists and the church, for which Couturier had worked, had eroded on the one side through the increasing independence of the leading artists and, on the other, by the increasing conservatism of the church, in which Tridentine conceptions of beauty and purity were reasserted in a world moving in the opposite direction. Given those pressures, it is a miracle that Assy happened at all, that it stands as a monument that inspired others.

The Chapel of the Rosary in Vence, France, set in the hills just a few miles from the Riviera, is a modest though carefully designed building. The interior is totally the creation of Matisse—doors, pews, candle holders, sanctuary lights, and vestments. On the rear wall are the Stations of the Cross (plate 116), done not in the traditional spacing along the wall but as one composition in which the eye rather than the body does the moving—but in a direction opposite to what would be natural, a deliberate effort that Matisse intentionally requires of the viewer. These drawings are suggestive and cragged (faces are not defined except for that of Veronica), and the question is posed whether this represents a Matisse who has lost his grip in old age or whether this is a style deliberately used to evoke the agony inherent in the message. Jane Dillenberger has suggested that the form is deliberate, the other works of Matisse in the chapel showing the sure grasp of his use of line and color.

> Those who question the skill and artistic judgment of the artist as they study the broken contours of the black enamel—at times washy and transparent and at other times gluey and thick on the tiles—should look from this panel to the Ave panel on the adjacent nave wall. In this mural the Madonna holds the Child in her arms, and both are surrounded by great blossoms. Here the lines flow freely in billowing, sensuous shapes that seem to expand under our gaze. The contours have the exuberance and grace of Matisse's earlier art. The subject matter here, as in the St. Dominic panel on the wall next to the altar, is of those who inhabit eternity. The joyous atmosphere of the light and color-filled place of worship is focused in these compositions and in the rich hues of the Tree of Life windows of the apse. But the *Via Crucis* on the back wall

116. Henri Matisse, *Stations of the Cross,* 1948–1951

shows the anguish of life and death, the ugly, discontinuous lines communicate the tragic significance of this one death.[2]

In his book on Matisse, Pierre Schneider interprets the work of Matisse in such a way that there is a connection between his earlier work and the chapel.[3] According to Schneider, Matisse's long lifework was one of eliciting the sublime and the sacred in a world in which the horizons of belief had shrunk. This he did by color, by abstraction that is not totally abstract, by flat dimensions reminiscent of the Byzantine, and above all by the use of light, usually without shadow, as at once medium and reality, a sign of the transcendent. Such a use of color and light is the essence of the chapel, whereas the Stations show the shadowy side of existence and the rhythm of deliverance. On the basis of Schneider's work, one can say that in the chapel project Matisse's traditional religious discontent is transformed in a process in which the vitalities of life, symbolized in color and light, are related to a Christian message seen again with fresh eyes.

The church of Notre Dame du Haut in Ronchamp, France (plate 117), designed by Le Corbusier, sits on a hill, and hill and building soar upward in utter harmony, a feat accomplished by the soaring roof line. The architect used stained glass and color throughout, but these features do not call attention to themselves but to their part in the architectural whole. The light coming through the windows does not call attention to the windows but to the shadows and color modulations cast on the interior. Notre Dame du Haut is entirely an architectural masterpiece, a building that faces inward and outward in accord with its role as a pilgrimage church.

La Tourette, a monastic building in Eveux, France, also designed by Le Corbusier, indicates some of the problems inherent in creating a distinguished building. Here the monks, whether because of dislike of the building or because of the press of visitors, have virtually abandoned the new building, utilizing the older portions. Troublesome as visitors may be, in the case of the Chapel of the Rosary in Vence the sisters have solved the problem by scheduling their services at times other than when the building is open to the public.

For England one could mention various commissions, such as the work by Henry Moore and Graham Sutherland for St. Matthew's Church, Northampton, England. Most prominent is Coventry Cathedral, which Sir

[2] Jane Dillenberger, *Style and Content in Christian Art* (Nashville, TN and New York: Abingdon, 1965; reprint, New York: Crossroad, 1986) 222–23.

[3] Pierre Schneider, *Matisse* (New York: Rizzoli, 1984). The plates are excellent and the interpretation, although based on art-historical knowledge, is far-ranging and exceptionally suggestive.

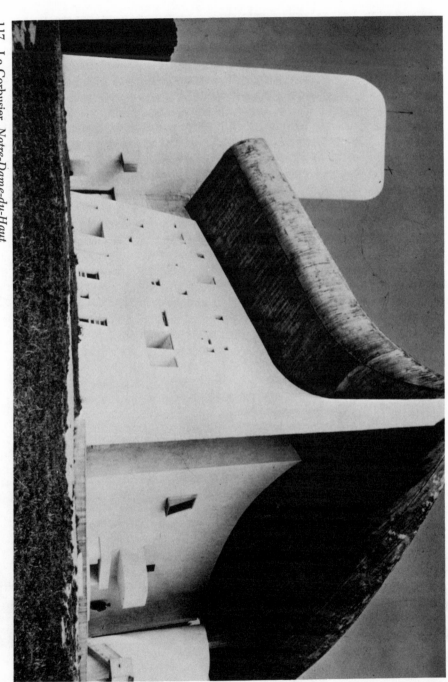

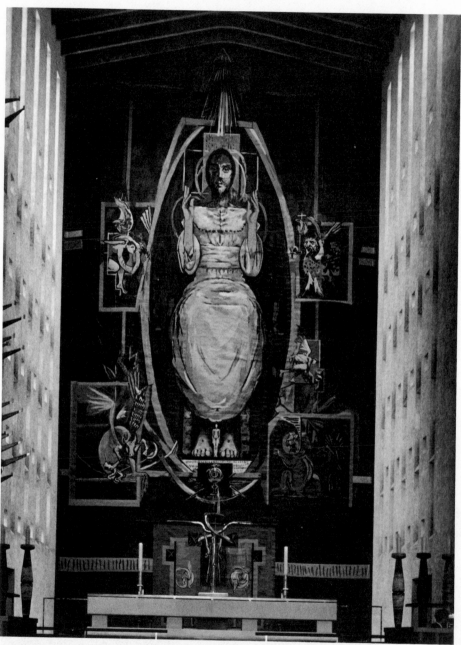

118. Graham Sutherland, *Christ Tapestry*

Basil Spence erected alongside but in integral connection with the bombed-out cathedral. Impressive as the attempt was to combine the old and the new, Coventry Cathedral is more noted for its large tapestry, designed by Graham Sutherland and woven in Aubusson, France (plate 118). Seventy-five feet tall and thirty-eight feet wide, the tapestry dominates both by size and by the central figure of Christ in glory, in which ovoid forms of body and composition draw the eye. Christ has his hands raised in blessing, and the countenance, as in Eastern depictions, is majestic; but it is also compassionate. Around the central figures are found the witnesses to the crucified and resurrected Christ as described in the book of Revelation (4:6ff.), a description that traditionally became the marks and signs of the four evangelists. Present too are St. Michael—to whom the cathedral is dedicated—with the Trinity above and the crucifixion below. But the dominating figure of Christ is so compelling that the other figures are but accompanying notes.

Attention should also be called to additional buildings in the United States. We have already indicated that another version of the tear-shaped Virgin by Lipchitz was acquired by Jane Owen for the Roofless Church, designed by Philip Johnson, in New Harmony, Indiana (plate 119), site of restored nineteenth-century buildings of the utopian community begun by Robert Dale Owen. There, at the end of a walled-in area, about half a city block in size and consisting of trees, shrubbery, and a central standing/seating area, stands the beehive-like roof, a kind of outdoor baldacchino, beneath which those performing the liturgy can stand or sit against the backdrop of the sculpture by Lipchitz. Across the street is the Paul Tillich Park, and in the opposite direction, the Visitors' Center designed by Richard Meier. Currently Stephen De Staebler is completing a sculptural wall for a new conference center. In New Harmony, the best of modern architecture and restored Owenite buildings exist in complete harmony.

The Abbey and University Church of St. John the Baptist, Collegeville, Minnesota (plate 120), designed by Marcel Breuer, represents a significant blending of art and architecture. Built just before the liturgical changes emanating from Vatican II, the building represents an older liturgical tradition, a space not easily adapted to contemporary modes, but grand in its form and style. If one were to include a distinguished building with a religious function, which also has a chapel, one would want to note Hartford Seminary by Richard Meier (plate 121). Those looking for obvious clues to a building are distressed that one cannot guess the function of the seminary from its exterior, as one can the neo-Gothic buildings across the street. Viewers with more discriminating eyes see a building that by its very form embodies what it is about and provides clues that elicit our response rather than assault us. The chapel, praised by architects and considered the jewel of the building by many visitors, currently does not function well for

119. Philip Johnson, *The Roofless Church*

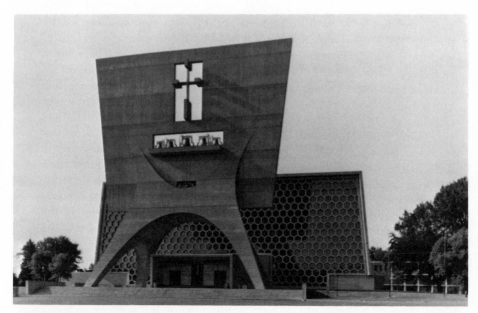

120. Marcel Breuer, *The Abbey and University Church
of St. John the Baptist*

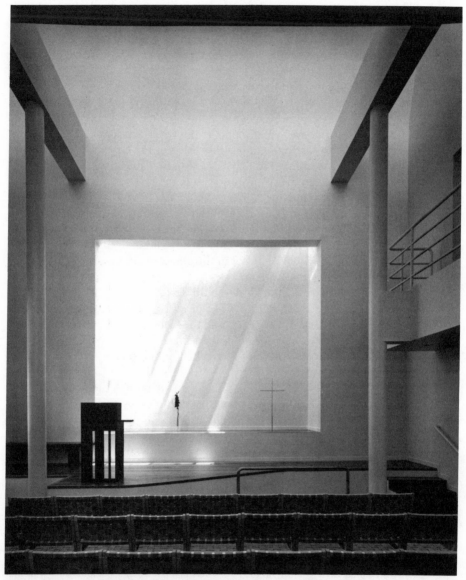

121. Richard Meier, *The Chapel of Hartford Seminary*

the informality of the worship style of the seminary, a style in which the range of liturgical possibilities have not been explored.

The community center and the chapel at Candler School of Theology, Emory University, Atlanta, designed by Paul Rudolph, is a graceful building, well suited to its function. The center is perhaps more universally acknowledged as an example of style and beauty than is the chapel (plate 122), which, like that at Hartford Seminary, has its fans and its detractors. The various levels, surrounding a central floor core, provide an intimacy for large numbers of people or divide the congregation, depending on orientation. One suspects that in this instance congregational usage is a better clue to meaning than the eye which beholds the space without use.[4]

Perhaps the most jarring juxtaposition exists at the Crystal Cathedral in Anaheim, California (plate 123). Here is a stunning glass structure, designed by Philip Johnson, in which exterior and interior alike present visual delights. The organ and the area in which the liturgy is conducted are neither distinguished nor consonant with the building. Two outside sculptures, Job and the Good Shepherd, are as banal as the plethora of Jesus paintings by Heinrich Hofmann and Warner Sallman found to this day in numbers of Sunday school rooms or in the offices of clergy—and sometimes even in the offices of theologians.

If stained glass were included, we could stretch the number of buildings by adding the First Presbyterian Church in Stamford, Connecticut, designed by Harrison and Abramovitz, and the Community Church in Pocantico Hills, New York, which has stained glass designed by Chagall and Matisse. During the same period, Pietro Belluschi did competent churches in the Pacific Northwest. Frank Lloyd Wright and Louis Kahn were commissioned to do some churches and synagogues. Although theirs were better than most church architecture, their great buildings are museums, not churches, as the Solomon R. Guggenheim Museum in New York City and the Kimball Art Museum in Fort Worth indicate.

A number of conclusions can be drawn from this survey. First, although the projects mentioned have considerable distinction, they are few in number, considering the number of churches and the populations they

[4] Aesthetically, the organ case in the chapel appears larger than it should, though some contend that the size of the organ case was essential to the exceptional quality of the music—a point about which there is a difference of professional opinion. Moreover, Paul Rudolph planned an oval table/altar that would have been in line with the contours of the chapel. Candler's Don Saliers vigorously argued for a rectangular table, a point that he won by apparent insistence. He talked of a theology of the rectangular, which seems to me to raise more problems then it solves. It is my own judgment that this magnificent space is compromised and that it would have been better if Rudolph's own perceptions had been followed. Indeed, it is not too late for that to happen.

122. Paul Rudolph, *The Chapel of Candler School of Theology*

123. Philip Johnson,
*The Crystal
Cathedral*

represent. Indeed, this was already true in the nineteenth century. In the United States, one can think of the decorative works of the late neo-Gothic revival and the work of artists such as John La Farge at Trinity Church, Boston, and the churches of the Ascension and St. Thomas in New York City. Compared with the medieval period, in which architecture, artifact, and art coalesced in common cultural aspirations, the number of significant commissions is few, and the setting, of course, is entirely different.

Second, many of the commissions of the last decades stem from the moving spirit of unique individuals: Father Couturier at Assy, Jane Owen for New Harmony, Indiana; Dominique de Menil for the Rothko Chapel; Ralph Peterson for St. Peter's Church, New York City; the sister who nourished Matisse in his illness, for Vence. Surely one could say similar things for Hartford and Emory. If one adds the influence of the arts in relation to the church, one thinks of Eloise Spaeth, who, with her late husband, Otto, started a liturgical renewal, exhibited for years in the journal *Liturgical Arts*, and who over the years has promoted better art for Roman Catholic churches. If one extends the matter of influence to the general public, one would add J. Irwin Miller for his spearheading the architectural renewal of Columbus, Indiana, and his role at Christian Theological Seminary, Indianapolis; and David E. A. Carson, for the Peoples Bank building in Bridgeport, Connecticut, designed by Richard Meier.

Nothing happens without the initiating decisions of individuals. But it makes a great difference whether the decisions reflect and have the support of the community or culture at large, or whether they reflect only the vision of the individuals with resultant indifference or hostility from the public. A pattern of individual initiatives may start new directions, but creative individuals cannot create a future without eventual public support. Paradoxically, at the present moment there is more widespread interest in the visual arts than has been true for generations. But so far that has not translated itself into interest and support for art, much less significant art, in the church.

Third, art and architecture are in an uneasy relation with each other in the projects we have mentioned. The Church at Assy is notable for its paintings and sculpture. The same is true of the Matisse chapel in Vence, the Rothko Chapel, the Nevelson chapel, St. Mary's Cathedral in San Francisco, and the Newman Center Chapel in Berkeley. Architecture predominates at Ronchamp, La Tourette, St. John's Collegeville, and Hartford Seminary. Protestantism, with its accent on auditory rather than liturgical or sacramental space, tends toward the former in its art. It is conscious of forms but uninterested in, uneducated about, or suspicious of the sensuous nature of the visual arts of painting and sculpture. Protestantism has lived so long without the visual that the loss of that human and spiritual resource is

seldom recognized as an issue. Architecture is Protestantism's art form. In recent years, even the Roman Catholic Church, which historically was such a patron of the arts, has done little in that direction. Although the Vatican has belatedly started a collection of twentieth-century religious art, it has done so through receiving gifts rather than as a patron that commissions and shapes a collection. Thus, the whole wing devoted to contemporary religious art is, for the most part, filled with works that are not at all representative of the leading artists of our time. The United Church of Christ, noted for its interest in promoting the arts generally, has not been as imaginative in the visual arts as in the other arts. Yet this church body is the recipient of a major collection of art by black artists. In short, churches seem to have joined the general wave of interest in the visual arts, without returning to or advancing toward the significant inclusion of art within their structures and liturgical life. The result is that the arts are among the activities in which individuals participate, and which may diversify and enrich what they already know.

Fourth, the introduction of art into the churches, when it does occur, may result from perceptions formed by artists of many persuasions—and probably not from the artistic convictions directly born out of the faith of the community that is providing the commission. We know that this was precisely the issue at Assy. Yet there may be a convergence of the two, as in the instances of the Rothko and Nevelson chapels. When the church pushes its own limited view of what an art work should express, it frequently places the artist in a difficult, even inhibited, posture. Sometimes the result is that the explicitly religious works may have less integrity and power than secular art or religious art that has no explicit religious subject matter. The works of the Roman Catholic Rouault, for instance, are more interesting and profound when clowns and prostitutes are depicted than when he deals with religious figures and the Christ. It follows that the mere commissioning of artists by the church is not enough. The issues of the competence, vitality, freedom, and spiritual perception of the artist are essential ingredients, which, in the twentieth century, are only tenuously related to the faith and the shape of the believing life of the church. The churchly cultural ambience of the Middle Ages has disappeared; the psychic posture that suppresses the sensuous vitalities remains an ingredient of our culture. That is why some of the great art produced for the church in our time has come from nonbelievers or from those residually related to the life of the church. In the seventeenth century the issue arose: Can the non-regenerate do good theological work? The answer was, Yes, if there are enough regenerates around.

That problem and its answer reflected a recognition that the leading and dominant orientations of seventeenth-century culture were still basically

Christian but that other perceptions were beginning to be powerful enough
to demand attention. In our time, the problem is more complicated, for a
single orientation no longer exists. Perceptions have become multiple or
pluralistic, while the church has lived for some time without an awareness
of the sensual as a powerful force in the visual arts. Today, many of the
perceptions needed and absent in the church are being formed afresh by the
artists themselves. That intensifies the issue as one moves from the virtual
divorce of the two to new potential alliances and possibilities. From Assy
and Vence to the Rothko and Nevelson chapels, the issue is both threat and
possibility. There is considerable discussion these days about whether paint-
ings may convey spiritual or religious conceptions. Hilton Kramer, former
art critic of the *New York Times*, and Thomas Messer, director of the
Guggenheim Museum, can write and talk in such terms, particularly in
regard to the paintings of Mark Rothko. That development does not solve
the problem for the church, particularly when its own perception of the
content of a work of art is dependent upon particular iconographic
recognitions.

We live in a secular society with transcendent yearnings but with no
transcendent structure. In conservative groups, materialism and religious-
ness form a unity in which an individual piety accepts the material world
without question. But that makes the material an end in itself. Only that
material which has not been made an end unto itself is able to convey
another reality in and through its own sensuousness. It opens a sensibility
that can be said to be spiritual. A spirituality unrelated to the material
world is ethereal, *other*-worldly. There is, therefore, a connection between
the material and the spiritual, but not between materiality and spirituality.

Changing Architectural Styles — Bane or Blessing?

From the time of Constantine, house churches, churches that were deliber-
ately planned not to be distinguishable from other buildings, were suddenly
replaced by visible and prominent structures of the church. Buildings
symbolized the official position of the church, and their number and size
increased as populations became Christianized. The suddenly accelerated
building program meant that no single artistic style had a chance to
develop. Yet in the history that followed, various styles reflected the view
of the particular time of the nature and practice of the Christian commu-
nity. Many architectural styles were adapted; others emerged. Ironically,
people felt rather doctrinaire about the styles they supported.

The recognition of Christianity under the aegis of the emperor Constan-
tine resulted in a massive building program, which used the prototype of

the Roman basilica. The result was that the churches, which previously had had no exterior visible signs, became, under Constantine, the most dominant and monumental of buildings, though few remain from Constantine's time. The original St. Peter's is a case in point, both because of its style and because government sponsorship meant that the building was completed in less than five years' time. St. Paul's-Outside-the-Walls, which was rebuilt after a fire in the nineteenth century, still shows the plan and proportions of the fourth-century church. Only government-sponsored projects could deliver such results. The first distinctly developed architectural church style, and one that incorporated the visual in terms of mosaics, was also under imperial sponsorship, namely, the Byzantine development. The dome over the altar, which was known as the dome of heaven, united heaven and earth, emperor and people, clergy and laity in a common place of sanctification.

The Romanesque churches built with the principle of barrel vaulting and rounded arch as appropriate to masonry, grew out of the monastic development. Romanesque painting of interiors, vigorous in the South, was restrained in the North. The medieval cathedral, related to the emergence of major city cultures, reflects the transformation of Romanesque into Gothic by the entrepreneurial bishops marshaling the resources of a new society with a particular theological vision. The result was that engineering and theology were fused and hard to distinguish, with the light from stained glass and the graceful pointed arches fusing technology and piety.

In the Reformed and the believers' church traditions of Protestantism— and this includes Anglicanism until the nineteenth-century Tractarian movement—two architectural consequences followed. One was the recycling of medieval buildings, and the second was the eventual erection of newly needed buildings in the light of the new theology. Medieval buildings, whether cathedral or local, were stripped of art and artifacts and put to uses appropriate to the new forms of worship. Altar or chancel sections were largely sealed off or turned into janitors' or sextons' rooms, accumulating debris that later turned out to include long-lost treasures. That was appropriate, of course, for a nonsacramental church in which the Mass was no longer central. No altar placed at the end of the building was needed for performing the mysteries, no aisles for processionals carrying the Host, no vistas for seeing the Host. But until the nineteenth century, as Doug Adams and Marian Card Donnelly have shown, a table was placed at the end of the central space, with a pulpit elevated behind it.[5] The table was

[5] Doug Adams, *Meeting House to Camp Meeting: Toward a History of American Free Church Worship from 1620–1835* (Saratoga, NY: Modern Liturgy-Resource Publications; Austin, TX: The Sharing Company, 1981); Marian Card Donnelly, *The New England Meeting Houses of the Seventeenth Century* (Middletown, CT: Wesleyan University Press, 1968).

one of communion and assembly—therefore symbolically important—but subject to the Word from the elevated pulpit. In the nineteenth-century revival tradition, the table lost its pivotal place and the pulpit became a lectern.

In both the buildings in London by Christopher Wren and in the buildings in New England, the space was an auditory one rather than one that served visual purposes. It is interesting that in the medieval cathedral, the pulpit, stone-hewn and therefore hard to move, remained amid the people where it always had been and where it was in early Protestant buildings. But gradually the newer churches curiously placed the pulpit at the end of the major space, which removed the pulpit from the midst of the people to a focal point symbolically similar to the more ancient and traditional altars. It was a way of saying that the pulpit replaced the altar. Symbolically this change took the pulpit away from the midst of the people and invited the emphasis on preaching as performance. The Tractarian movement within Anglicanism, although it returned the Mass and the altar to the chancel end, mainly incorporated the pulpit at the edge of the chancel. Many of our nineteenth-century Gothic buildings have this feature, as is evident in the unfinished Cathedral Church of Saint Peter and Saint Paul in Washington, D.C. This modified neo-Gothic tradition became more or less the standard church to be built in the early twentieth century, even among those who no longer shared or knew that tradition. It was not unusual for Methodists to place altars against the chancel end, with lectern and pulpit at the forefront of the chancel, just when the Second Vatican Council created a theological and liturgical ambience in which Roman Catholics pulled the altars away from the end walls so that the priest could get behind them and face the congregation.

These diverging views of liturgical usage, particularly in the first half of the nineteenth century, led to two major views of architecture. One was based on the earlier New England Protestant model of a plain, auditory space, built on the village green and usually punctuated with steeple. Its architectural integrity or simplicity, free of all embellishment except for modest wood moldings or stenciled biblical texts, is its source of beauty. One could view it as a simple gospel—but one that is so simple that it brackets out interesting cultural vitalities appropriate to life. The simple shape was appropriate to a principled, narrowed humanity expressed as an extended biblical commonwealth. The biblical material itself was considered to be the appropriate model. The gospel was not the source of illumining, of shaping, or of baptizing the lively currents of life and cultural expressions around it. It was a culture of its own—a model allegedly based on scripture.

The critical question is whether the gospel is meant to form society in its own terms, either as a total society as in the original New England or as a New Testament alternative within a larger society. Or is the gospel meant to be a forming, creative ingredient in diverse cultures, making many new creations? Is a New Testament description of community a model directly to be emulated, or is it an analogy for us as to how the gospel forms society or societal patterns and relations? As a direct model, the living social organism of the New Testament, it seems to me, becomes static, as if much of its life were not time-bound. Such models have the limited vibrancy of all imitative systems. That is why the New England system could not survive, though it took the world temporarily by storm; and that is why reactionary and repristinating movements have meteoric rises and falls.

The New England architecture is the adequate and rightful expression of that relatively pure, restricted view of the gospel and of human existence. The late-nineteenth-century classical structures for both church and civic buildings continue that view, creating neoclassical versions of auditory space. It is interesting that public and church buildings in the classical style could seldom be distinguished from the exterior, particularly when the steeple was not added or when the steeple was hidden from view by other buildings or trees. There is surely no compelling reason why, in twentieth-century society, churches need to be recognized as such from afar. Indeed, steeple vistas have long been superseded by the height of other buildings, even in the absence of skyscrapers.

The nineteenth-century interest in neo-Gothic buildings was related to a theology opposed to both Protestantism and Roman Catholicism, but one in which the sacramental realities again became central. Most of such buildings were Episcopal, sometimes built through the work of distinguished architects such as Richard Upjohn, but more frequently they evolved from pattern books and from the visit of interested parties to the English scene. Not infrequently other denominations also opted for the neo-Gothic mode, hardly recognizing that these neo-Gothic buildings were based in a wholly antagonistic theological position. This was the time when theories about the inspiring arches of the neo-Gothic buildings, which were likened to the ancient groves of trees ascending heavenward, were an ever-repeated refrain, and when mystery was reinforced by subdued stained-glass windows that were meant to diminish light. In the medieval period stained glass was meant to bring in light; the grime of ages, not design, now makes cathedrals dark. Anyone who has been at Chartres recently and has seen the cathedral after the cleaning of some of the windows will know more nearly what a medieval building with stained glass was like.

Architecture, like the other arts and theology, reflects the theories and the

fashions of a time and occasionally forges the future in constructing grand
and transcending creations that survive the ravages of time. Certainly one
can say of twentieth-century architecture in relation to the church that it
has followed no particular dogma, that it has frequently tried to provide
the versatility appropriate to church life, that it has had a due regard for
the appropriateness of space and an economy of means. Sometimes the
dictum of "form follows function" leads to a utilitarianism that does not
allow for changing functions nor provide a structure that also speaks to the
human spirit simply in terms of itself. A building that does not function is
a disaster. A building in which form merely follows function only acci-
dentally has a tomorrow, for it has no being by which architecture as art
adds something to us as we inhabit it. Sometimes it is said that if architec-
ture must make a statement, it will do so in any case. Putting it that way,
however, returns the question to the abstractly verbal. Would it not be
better to say that architecture provides a reality in its own right—a space
that is different because we are in it, but which also makes us different by
being in it? The subtleties and sensibilities experienced vary with respect
to individuals who inhabit space. Many of us cannot inhabit some spaces
with ease. None of us is unaffected. Architecture ought, then, to combine
function with a spatial reality that transcends the function. In that sense
good architecture for the body politic does not differ from good architec-
ture for the church. In both instances function and a reality beyond it are
crucial.

We have already touched on the issue of how a church is recognized as
a church. Certainly when the church was the center of the life of a commu-
nity its visible centeredness called attention to itself from every angle of
sight; reality and symbol were joined. Today the church is not the center
of the community, though it may be a center for a segment of a community
that overlaps with other communities. Surely there is a way in which
church buildings may be recognized that lies somewhere between the tradi-
tional steeple and the sign "Jesus Saves." That recognition may well have to
do with the form and reality of the building rather than with the obvious
symbols to which we are accustomed. A building such as St. Peter's
Lutheran Church, New York, is interesting precisely because it cannot be
confused with an office building, although it does not have the traditional
signs of a church. Like modern art, St. Peter's as a building could be
declared to be something different from what it is, yet its appropriateness
is recognized when seeing and reality coincide. Were it not for the artistic
quality of the Pomodoro cross recently placed adjacent to the west front of
the church, one might regret the obviousness of the symbol. Now it obvi-
ously is a church; before it was a mystery to be explored in a world tired
of obvious signs.

Protestantism has generally been more interested in architecture than in the other visual arts. Architecture can therefore be said to be the art form of Protestantism. Since the visual arts have seldom been a part of the Protestant heritage, architects have also had to pay little attention to such forms. When paintings are hung in churches, they are usually for a decorative rather than an artistic purpose, and they are hung in places not originally designed with paintings in mind. A working relationship between architects and painters has been minimal. One can imagine what it might have been like if the Rothko Chapel had really been designed in close collaboration with Rothko and his paintings, or one could imagine what the Beker Chapel might have been like if the space had been more appropriate for Louise Nevelson's sculptural creations. We do need some commissions in which the architecture and the other visual arts are wedded in equal proportions, in which genuine collaboration exists between sculptor, painter, and architect.

Since the church has had little regard for the visual arts as such and only a partial interest in architecture, the result has been that the arts and architecture have not had the nourishing spirit of the church. They have been left to themselves—indeed, to the creation of their own spiritual perceptions, whether nourished within or without the church. The artists did not desert the church; the church deserted the artists. This means, of course, that those in the church believe that fundamental realities are expressed elsewhere, namely, in its verbal, word-forming, defining, and naming activities.

Another hurdle also confronts us. A truncated religious ethic believes it helps the poor by modesty without style. It is simply a fact, not a judgment about desirable social policy, that great works of art are created and distinguished buildings are erected and appreciated in cultures where social disparities are pronounced. The poor seldom have our hangups. "The poor you always have with you" is not a declaration of social policy on the part of Jesus—though it is certainly a neglected passage among New Testament commentators—but a recognition, in the context of pouring out of precious ointment, that the senses also serve human spiritual values. There is a sharing in a reality that unites individuals and groups across disparities that is grander than any segment in a body politic. Most of us would not give up the great cathedrals, ambiguous as their creations were from a limited social viewpoint.

The pluralism of our society and of religious institutions both within and without the same institutions has deprived us of the cohesive factors that can unite a culture and its art, but it also sets us free from the inhibiting facets of a too-unified culture. We can, therefore, acceptably experiment in

art and architecture. Having abandoned the dichotomy between preaching and sacraments, we can create multiple foci that are equally important within a single structure. Removing a pew structure, which originally stemmed from an auditory inflexibility, we can move not to atrocious multi-purpose spaces but to multifocused centers, used singly in some services, multiply in others. No longer dependent technologically on particular architectural structures that automatically define walls and windows, the painter, the sculptor, and the architect can work collegially on a tantalizing new possibility.

8

Contemporary Theologians
and the Visual Arts

The Concern with Method and Pluralism

We need to think through for our time the relations among theology, the arts generally, and the visual arts in particular. That involves nothing less than attention to theological method and the artistic mode, their differences and affinities. Attempting to do that, however, immediately means having to come to terms with diverse theological approaches and methods, and their respective relations, if any, to the arts. We face here a new diversity, for a self-conscious preoccupation with method as a condition for doing theology has come to the fore only in recent decades. It is not unusual for contemporary theologians to write one or two volumes on method, with only occasional elaboration of the implications for specific theological concepts. In the past, when a community's beliefs were part and parcel of the fabric of its life, theological method was scarcely on the horizon of consciousness. Even in the theologians of the more recent past—Rudolf Bultmann, Karl Barth, Paul Tillich, Karl Rahner, Bernard Lonergan— theological method was integrally related to theological affirmation.

For Bultmann, demythologizing as existential interpretation places the gospel before us. It is the gospel itself that demands demythologizing, even though Bultmann may have started his pilgrimage facing the question of the impossibility of accepting the biblical world view in the modern world. For Barth, the prologomenon is not a preliminary methodological analysis of the method to be employed, but a preliminary stating of affirmations to be developed, a theological statement that sets forth his method. Though Tillich in his *Systematic Theology* discussed first "Reason and Revelation," he did that primarily because of the expectation of his readers, particularly his American readers.[1]

[1] Paul Tillich, *Systematic Theology* (Chicago: University of Chicago Press, 1967) 1:71–162.

Although Tillich and Rahner did not influence each other, there are similarities between the two in the way in which ontological and analogical thinking is dominant and the extent to which a proper analysis of reason drives to its boundary, to horizons lying beyond but not in contradiction to reason. For both, our humanity drives us both to what we do know and to what we do not know, to the inescapable mystery of our being. Theological method is already theological affirmation. The situation is not dissimilar in the thought of Lonergan, in which in a modern scholastic style various levels and modalities of theological work are spelled out.

Perusal of contemporary works, as distinguished from those of the generation just passed, discloses two main bases for a concern with method. First, we live in a secular world, and if faith is to be credible in that context—it is argued—it must be convincing and intelligible when the procedures of a commonly accepted discourse are utilized, whether that of philosophy or that of other public discourse. Among such interpreters, neo-orthodoxy was a short-lived movement because its emphasis on revelation had no context in ordinary language or in a common universe of discourse. Whereas neo-orthodox theologians believed that it was the existing universe of discourse that needed to be broken in order for faith to be apprehended, many contemporary theologians believe that a proper analysis of human language, philosophically and critically developed, provides a credible context for faith through the removal of false stumbling blocks and in the creation of new human possibilities. The God we thought we knew died because of the poor philosophical grounding of previous theology.

Pluralism within and among religious traditions is the second reason for preoccupation with theological method. Now the search is for a method or mode of analysis that will make it possible to deal with variety while being true to the concreteness of historic traditions. That is why phenomenological analysis is a favored tool for coming to terms with pluralism. But the question arises whether a world that is both secular and religiously pluralistic can be adequately dealt with by a single theological method, for the realities of these two worlds are distinct even as they inhabit the same terrain. In a secular world, the aim is to make credible; in a pluralistic world, it is to analyze existing and accepted facets and make the whole intelligible. In the secular, the goal is to explicate the possibilities of faith; in the pluralistic, to delineate the varieties of faith already present. It is thus not by accident that theologians mainly concerned with the secular question are interested in a philosophical grounding for issues of faith and truth, whereas those most impressed by pluralism are engaged more in phenomenological and structural analysis. Entering from the side of the secular question, one ponders the basis on which faith may be said to be firmly grounded; entering from the side of pluralism, one is concerned with how

one can come to terms with existing faith expressions. Unbelief and belief, if not over-belief, are simultaneously present in our culture, and it is not unusual for many facets of our culture to be present in the same group. Faith and the secular have come to inhabit the same world, with creative and ominous consequences.

Such is the context for the pervasive concern with theological method, and, for the present, it may simply be noted that the result has not been a reigning method, but a plurality of methods and approaches to the theological task. Our concern here will be not with method as such but with three types of method in relation to the arts, particularly the visual arts. The first type is that in which no relation is seen between the arts and theological work; the second is one in which a positive relation is articulated, sometimes successfully and sometimes not; the third is one in which the arts provide paradigms and images that affect the nature of theological method.

The Divorce between Art and Theology

For examples of theologians who do not see the arts, particularly the visual arts, as having a role in theology, Bultmann, Barth, Schubert Ogden, and Gordon Kaufman come to mind. Bultmann wrote poetry and even used that medium in poignant reflective situations. Music and theater delighted him, but the visual arts held little interest for him personally or theologically. In the first edition of *Jesus*, the publisher insisted on plates of the Jesus figure, and Bultmann, according to Schubert Ogden, suggested Rembrandt's work as the only possible choice. For Bultmann, seeing belonged to the objectivizing of the world; hearing to its transformation. The Word of God was not identical with the verbal, but no other area was suggested as a province in which the Word might be conveyed. Apparently a neo-Kantian heritage and personal predilections coincided.

The verbal imagination of Barth is indisputable. His delight in and his writings on Mozart are common knowledge, and Grünewald's *Crucifixion* meant much to him. But he opposed placing stained glass in the Basel Minster, and his theological comments on the visual arts of painting and sculpture in relation to the church were few and mainly negative in character. Images and symbols, he declared, "have *no place at all* in a building designed for Protestant worship." [2] His correspondence with the writer Carl

[2] Karl Barth, "The architectural problem of Protestant places of worship" in *Architecture in Worship: The Christian Place of Worship*, ed. Andre Bieler (Edinburgh and London: Oliver and Boyd, 1965) 93.

Zuckmayer shows the human and cultural concerns so characteristic of Barth, but theology as a discipline is different from all that.[3] Whereas Bultmann's negativity was mainly personal and philosophical, for his Lutheran heritage would not have made him opposed to the visual, Barth's negativity was theological, a part of his Reformed heritage, for as a human being he was interested in the arts.

Influenced by Alfred North Whitehead and Charles Hartshorne, Schubert Ogden has pursued an independent, rigorous metaphysical program, dedicated to providing a foundation on the basis of which one can speak appropriately and convincingly about the central theological concepts, such as the "reality of God" and the "point of Christology"—to use the titles of two of his major books. His logical, sharp mind turns old metaphysical affirmations into new metaphysical realities, into a "transcendental metaphysics of a neo-classical kind"—the term that he uses to characterize his approach.[4] Imaginative and clarifying definition is evident on every page of his writing, and within the confines of a thoroughgoing metaphysical analysis, one is astounded by what one sees and is given to see. The question remains, Are there facets of faith that are left out in the rigor of this method? Ogden would agree that there are, that he is doing theology from a philosophical base, that this is what he knows and does—and, one may add, does so superbly. The further question is, Would adding facets that are left out amplify what he has done or demand methodological change? If the latter is the case, as I think it is, one could still opt for the version Ogden has chosen, provided that one accepts the limitations.

The word "imagination" is a key in the work of Gordon Kaufman, as, for example, in his volume *The Theological Imagination: Constructing the Concept of God.*[5] But the imagination is philosophical rather than aesthetic: only what can be verbally designated belongs to theology. The various disciplines, including literature—but not the visual arts—play a role in theology. For Kaufman, theology is a construction of concepts, centrally a concept of God.

Although most theologians understand their discipline as one that involves second-order discourse, Kaufman emphasizes this point to such an extent that an undue chasm appears between the realities and the concepts. Theology is like a house that is built, and the clue to the character of its inhabitants comes only from what one knows about the nature of the

[3] *A Late Friendship: The Letters of Carl Zuckmayer and Karl Barth*, trans. Geoffrey W. Bromiley (Grand Rapids, MI: Eerdmanns, 1983).

[4] Schubert M. Ogden, *The Point of Christology* (San Francisco: Harper and Row, 1982) 143.

[5] Gordon Kaufman, *The Theological Imagination: Constructing the Concept of God* (Philadelphia: Westminster, 1981).

building. Theology is an exercise in verbal, conceptual, philosophical construction, a series of regulative concepts that Kaufman hopes will be more satisfactory for our time than historic concepts now available. The visual arts have nothing to do with that enterprise.

Affirmations of a Relation between Art and Theology

In the second type of method respecting the arts, the arts are seen in a positive role in relation to theology and theological method. In Edward Farley's *Ecclesial Reflection*, the visual arts play no role in his analysis, but he suggests that what he is doing has the character of theological portraiture.[6] Portraiture, as distinct from ordinary pictures, is multilayered, disclosing many levels simultaneously. It includes "contours, interrelationships, unity—in brief, . . . ecclesiality" as applied to theology.[7] The analogy of portrait painting is helpful, but Farley does not address the issue of the visual as a theological problem. His is a philosophical analysis, trying to be true to the life and shape of the community of faith.

More consistently than most theologians considered in this survey, Langdon Gilkey discusses theological method in direct relation to specific theological issues. The interlude on method in *Reaping the Whirlwind* shows how method arises out of his actual theological pursuits.[8] Gilkey writes: "Since this book . . . is an *illustration* of a coherent and intelligible method, not a book on method, it spends little of its time on the many problems of method."[9] His earlier book *Naming the Whirlwind: The Renewal of God-Language* is specifically concerned with method, and here, too, Gilkey explores the theological task with reference to specific issues.[10] For him method is honed in the doing of theological work; it is not an abstract enterprise. Always probing the assumptions in our culture with a critical, sharp, analytic eye, he proceeds to show the angles of vision that Christian faith brings to the orientations by which we live. That way of doing theology discloses a method—indeed, one analogous to but not identical with that of Paul Tillich. It is a refreshing approach, for the substances of theology and method are simultaneously present.

[6] Edward Farley, *Ecclesial Reflection: An Anatomy of Theological Method* (Philadelphia: Fortress, 1982).

[7] Ibid., 199.

[8] Langdon Gilkey, *Reaping the Whirlwind: A Christian Interpretation of History* (New York: Seabury, 1976).

[9] Ibid., 117.

[10] Langdon Gilkey, *Naming the Whirlwind: The Renewal of God Language* (New York: Bobbs-Merrill, 1964).

Since Gilkey is concerned with total cultural configurations, the world of literature and the visual world, as well as the political, social, and psychological worlds, enter into the arena of theological discourse. From an address given at the Art Institute in Chicago, it is clear that he understands that the arts must contribute to theology not by illustration of what we already know but by what they themselves uniquely do. Talk about the arts must be appropriate to the arts. Art makes "us see in *new* and *different* ways, below the surface and beyond the obvious. Art opens up the truth hidden and within the ordinary; it provides a new entrance into reality and pushes us through that entrance. It leads us to what is really there and really going on. Far from subjective, it pierces the opaque subjectivity, the *not* seeing, of conventional life, of conventional viewing, and discloses reality."[11] There is no evidence, however, that this insight about art in its prophetic and reality-disclosing character has significantly influenced Gilkey's theological work.

For the sake of both theology and the arts, George Lindbeck in *The Nature of Doctrine: Religion and Theology in a Postliberal Age* chooses to apply a cultural-linguistic approach to doctrines.[12] He engages in a linguistic rule game in which it is accepted that constancy of doctrine occurs in changing frameworks. This leads him to be more appreciative of traditional formulations than most contemporary theologians, for he sees them as expressions of central meanings in particular contexts. He finds that a language-game approach makes it possible to take into account the diversity of past and current expressions, though he contends that there is a constancy of doctrine throughout. Grünewald's *Crucifixion* (plate 33) and the Byzantine Pantocrator are united in their object, even if their experiences are historically different. Moreover, Lindbeck believes that in emphasizing how a tradition functions it is possible to honor diverse modalities, for one does not have to choose one among others. His method makes it possible to include "the aesthetic and nondiscursively symbolic dimensions of a religion—for example, its poetry, music, art and rituals"—not as appealing decorations but as expressing basic patterns of religion itself.[13] Finally, however, I cannot avoid the conclusion that Lindbeck's radical agenda has produced conservative conclusions.

In this second category of method, three individuals—Paul Tillich, John Cobb, Jr., and Mark C. Taylor—have been most concrete in their use of the

[11] Langdon Gilkey, "Can Art Fill the Vacuum?" in *Art, Creativity and the Sacred: An Anthology in Religion and Art,* ed. Diane Apostolos-Cappadona (New York: Crossroad, 1984) 189–90.

[12] George A. Lindbeck, *The Nature of Doctrine: Religion and Theology in a Postliberal Age* (Philadelphia: Westminster, 1984).

[13] Ibid., 35–36.

visual arts. But all three also show the problems inherent in a theological
understanding of the arts that is not sufficiently grounded in the arts them-
selves. For Tillich, the visual, like all aspects of human life, belongs to the
world with which theology is concerned. So, the visual arts are interpreted
theologically, just as are literature, politics, and psychology. Tillich's
haunting and devastating experiences as a chaplain in World War I are con-
fronted and illumined, if not consoled, by paintings he saw in Berlin,
particularly Botticelli's *Madonna and Child with Singing Angels*. Indeed,
the visual arts played a role throughout his life. More than any other theo-
logian of his time, Tillich wrote and lectured on the subject at significant
convocations, such as those held at the Museum of Modern Art in New York
and the Art Institute in Chicago. Tillich made the visual vital for many of
us precisely because of his dazzling theological interpretations. But therein
was also the major problem, for a theological interpretation that is grounded
in theological seeing without faithfulness to the artworks themselves is un-
convincing to critics and art historians. The same criticism has been made
of Tillich's interpretation and use of philosophers and psychologists, to
name but two other areas. But the problem is more acute in his comments
on particular artists and painters. His preference for German expressionism,
allegedly for existential, theological reasons led him to view paintings in
other traditions to be less significant. This bias may have been rooted in
temperament, but certainly it is related to his four years as an army chap-
lain in the trenches of World War I, when he experienced a profound
change of religious orientation. For Tillich, art found its height in delineat-
ing the human condition of estrangement.

It is ironic, therefore, that, although Tillich extolled the Renaissance in
cultural and theological terms because of its creative, ordered form, he
considered Renaissance art, which expressed that modality, to be without
religious significance—apparently because the form, for all its religious
subject matter, did not exhibit the anxiety attendant on the human condi-
tion. Obversely, Picasso's *Guernica* is interpreted only in that context.
Furthermore, Tillich's interesting typological analysis does not fit a major
part of the painting tradition. The source of the typology, as Jane Dillen-
berger has suggested, was apparently the art that Tillich knew so well—the
works exhibited in the museums of Berlin and the Museum of Modern Art.
Within those magnificent collections, the typologies work remarkably well,
and they show how well he knew the collections. But that is not all of art.

Finally, one could argue with much that Tillich says of particular artists.
Theological interpretations are not and need not be art-historical ones.
When they conflict with what is known of an artist and the context of that
artist's work, problems of credibility arise. For example, Tillich considered
Giotto's paintings of St. Francis to be the best example of the theonomy of

the Middle Ages. But Giotto, as Michael F. Palmer has pointed out, restored the natural and believed that the world must be observed before it is understood.[14] Though nature appears minimally in Giotto's *Christ and the Magdalene*, the art clearly is set in the world and not in the abstract golden zone of medieval art. The Magdalene's gesture is of infinite yearning, human tenderness, and human poignancy. The strength of Tillich's contention is surely compromised by a knowledge of what Giotto was about.

John Cobb's suggestive use of Whitehead's philosophy leads to clarity on issues of faith in a pluralistic world. Facets of experience from every conceivable angle are brought into a unity of expression, with clarity of statement evident where experiences either diverge or converge. Cobb confesses that, as the years have gone by, Whitehead has been for him even more suggestive on the issues of contemporary life than he had initially assumed. It is thus not surprising that in Cobb's writing the theological imagination is both enhanced and limited by Whiteheadian thought. Whiteheadian or process categories have served as an antidote to the more static categories of traditional metaphysics, but they also, I think, become ways in which the hard and passionate realities of good and evil are curtailed. However, who could not be moved by the range and scope of central isssues that Cobb has so directly addressed year after year? Those issues definitely include the arts.

In *Christ in a Pluralistic Age*, Cobb has chosen to comment on the visual arts, utilizing André Malraux's works, mainly *The Voices of Silence* and *The Metamorphosis of the Gods*.[15] In this use of Malraux, Cobb has been joined by Mark C. Taylor.[16] Malraux's fascinating and useful cultural judgments and schema corroborate for both Cobb and Taylor what they themselves see, namely, a secular development that can be positively rather than negatively understood. For Cobb, the explicitly Christian subjects may have disappeared but the logos is now hiddenly and immanently present, waiting to be named as Christ in a new form. For Taylor, Malraux and Michel Foucault show how in the history of art the death of God, followed by the loss of the self, can be culturally documented. Specifically, both use Malraux's comments on Flemish painting to make their point. Taylor centers on the contrast Malraux makes between Byzantine art and the work of Jan van Eyck, and Cobb contrasts the Byzantine with Flemish art generally and its subsequent developments. Both stress that the reigning Christ

[14] Michael F. Palmer, *Paul Tillich's Philosophy of Art* (Berlin: de Gruyter, 1983).

[15] John B. Cobb, *Christ in a Pluralistic Age* (Philadelphia: Westminster, 1984); Andre Malraux, *The Voices of Silence: Man and His Art* ([1954] Princeton, NJ: Princeton University Press, 1984); idem, *The Metamorphosis of the Gods* (Garden City, NY: Doubleday, 1960).

[16] Mark C. Taylor, *Deconstructing Theology* (New York: Crossroad, 1982); idem, *Erring: A Postmodern, A/theology* (Chicago: University of Chicago Press, 1984).

of Byzantine art was a God removed from the human realm, which was characteristic of that theology. Aside from the fact that the reigning Christ does not need to be interpreted in negative form, both seem to forget that some of the most human and tender depictions of the Virgin and Christ Child appear in Byzantine art. In the light of Malraux, both also interpret Flemish art as an indication of the new human, secular way in which religious subjects are now to be understood. Taylor calls attention to van Eyck's *Madonna of Chancellor Rolin* (plate 29), in which the timeless Christ has been replaced by the babe on its mother's knee in the home of the patron, and the chancellor's gaze, he states, is not on a figure that calls us to transcendence but on the incarnate human figure before him.

Barbara G. Lane in her book *The Altar and the Altarpiece* and Anne Hagopian van Buren in an article in *The Art Bulletin* on the canonical office and the Rolin Madonna reconstruct the location of the painting in the chapel, and the chancellor's gaze centers on the altar, just past the edge of the Child and Virgin, incorporating the two in a single vision.[17] Lotte Brand Philip provides us with an affirmation of the full religious significance of this painting.[18] Since the donor is the chancellor to Philip the Good, whose aspiration was to reconquer Jerusalem for its rightful king, Christ, the legitimate successor of David, the details of the painting now take on new significance. Lotte Brand Philip writes:

> The phantastic cityscape shown in this painting at the foot of the celestial castle, though certainly connoting the Heavenly City of the Apocalypse, points also to the earthly Jerusalem, which is and has always been the symbol par excellence of the celestial one. The glorious buildings to the right in van Eyck's background representation encircle the head of the Christ Child like a crown. While the Child is characterized as a ruler by the orb which he holds, the majestic circle of buildings signifies Him as the uncrowned King of Jerusalem. This idea explains the strange exaltation of the donor in van Eyck's painting. Rolin, as the chancellor of a sovereign who was planning a crusade, is the very man to help the Holy Child and His mother resume possession of their rightful heritage, the Holy Land. The donor, to be more precise, is here portrayed as the chancellor to Christ.[19]

Philip draws attention to Erwin Panofsky's suggestion that van Eyck and the early Netherlandish painters did not distinguish between heaven and

[17] Barbara G. Lane, *The Altar and the Altarpiece: Sacramental Themes in Early Netherlandish Painting* (New York: Harper & Row, 1984); Anne Hagopian van Buren, "The Canonical Office in Renaissance Painting, Part II: More About the Rolin Madonna," *The Art Bulletin*, 60/4 (December 1978): 617–33.

[18] Lotte Brand Philip, *The Ghent Altarpiece and the Art of Jan van Eyck* (Princeton, NJ: Princeton University Press, 1981).

[19] Ibid., 191.

earth as we do, that they transformed "the vision of a distant beatitude into the experience of a world which mortals are permitted to share with the Deity."[20] In this painting, nature and architecture are interwoven with standard religious symbols to form a heavenly vision based on the book of Revelation.

Granted that a change of perception is involved in the transition from Byzantine to Flemish, including all the stages in between, we are still left with the question whether that change is one from transcendence to immanence and a new secular viewing. The interpretation of the heavenly and earthly in Flemish art may make it possible for a more secular view to emerge, but in itself Flemish art belongs more to the medieval than to the modern secular world. It would be better to deal with the works of art than with Malraux's interpretations of art, whose tantalizing perceptions are not grounded in any sense of historical structure.

Nor is the situation improved by Taylor's use of Picasso and particularly of Barnett Newman, in whom, according to Taylor, quoting Thomas J. J. Altizer, we enter into non-art, into the totally anonymous.[21] That Newman himself believed that his paintings expressed the sublime in nothing less than absolute terms may not be instructive to structuralists and deconstructionists, for whom the intention or even the existence of an author or artist is irrelevant. But surely deconstructionists in their wandering pilgrimage should also be open to the possibility that in our wanderings some of us bump into ultimacies that need not be translated into absolutisms. Thus, our wandering may take us not to a situation *between* belief and unbelief, as Taylor suggests, but to *both* belief and unbelief.[22] The literary and the visual are also affirmative in their negations; indeed, they negate in order to affirm.

The Arts as Models for Theological Work

The third approach is the approach of those who understand the arts as essential to proper theological understanding and method and who believe that nothing less than the style of theology is at stake in such an approach.

[20] Ibid., 193.

[21] Taylor, *Erring*, 129. Although I disagree with much in Taylor's theological agenda and on his comments on particular works of art, I am impressed by his knowledge of the visual arts and his deep interest in them, including his own involvement in painting. Thomas J. J. Altizer also has an impressive knowledge of the visual arts. In both Taylor and Altizer, Malraux's interpretations fit into their theological agendas. I do not believe that Malraux is right in his interpretations, though I can see his attractiveness for theologians.

[22] Taylor, *Erring*, 10.

Here we shall briefly consider Hans Urs von Balthasar, Karl Rahner, Ray Hart, and David Tracy.

Largely unknown except as a name because so little of his major work has been translated into English, von Balthasar is a theologian whose intention was to write an aesthetic theology, of which the first seven volumes of a three-part system are oriented toward the visual (*Herrlichkeit*), and the second part is geared toward drama (*Theodramatik*).[23] Thomas O'Meara points out that, although the visual arts are utilized at points in the exposition, the theology is not aesthetic in that sense but in that the means of contemplating God is like the contemplation of art and in that the New Testament confronts us with images.[24] The execution of the work seems less convincing than the thesis.

The question of whether or not the visual arts can be left out of theological work is sharply raised by Karl Rahner. In 1966, Rahner wrote "Poetry and the Christian," and in 1967 "Priest and Poet."[25] In the first he acknowledges that because Christianity is "the religion of the word proclaimed, of faith which hears and of a sacred scripture, [it] has a special intrinsic relationship to the *word* and hence cannot be without such a special relationship to the poetic word."[26] In 1982, however, Rahner addressed himself to the wider scope and issue of the arts.[27] What shall we do, he asks, about the nonverbal arts, architecture, sculpture, painting, and music? If they are "human self-expressions which embody in one way or another the process of human self-discovery," do they not "have the same value and significance as the verbal arts?"

[If that is the case, and] if and insofar as theology is man's reflexive self-expression about himself in the light of divine revelation, we could propose the thesis that theology cannot be complete until it appropriates these arts as an integral moment of itself and its own life, until the arts become an intrinsic moment of theology itself. One could take the position that what comes to expression in a Rembrandt painting or a Bruckner symphony is so

[23] The seven volumes of *Herrlichkeit* were published between 1961 and 1969 (Einsiedeln: Johannes Verlag). To date three volumes have appeared in English under the comprehensive title *The Glory of the Lord: A Theological Aesthetics*, trans. Erasmo Leiva-Merikakis; ed. Joseph Fessio and John Riches (Edinburgh: T. & T. Clark; San Francisco: Ignatius Press): vol. 1, *Seeing the Form* (1982); vol. 2, *Studies in Theological Style: Clerical Styles* (1984); and vol. 3, *Studies in Theological Style: Lay Styles* (1986).

[24] Thomas F. O'Meara, "Of Art and Theology: Hans Urs von Balthasar's Systems," *Theological Studies* 42 (1981): 272–76.

[25] Karl Rahner, "Poetry and the Christian" in *Theological Investigations* (Baltimore: Helicon Press, 1966) 4:357–67.

[26] Ibid., 357.

[27] Karl Rahner, "Theology and the Arts," *Thought* 57 (1982).

inspired and borne by divine revelation, by grace and by God's self-communication, that they communicate something about what the human really is in the eyes of God which cannot be completely translated into verbal theology. . . . If theology is simply and arbitrarily defined as being identical with verbal theology, then of course we cannot say that. But then we would have to ask whether such a reduction of theology to verbal theology does justice to the value and uniqueness of these arts, and whether it does not unjustifiably limit the capacity of the arts to be used by God in his revelation.[28]

It is precisely in contending that the nonverbal provides what cannot be totally translated into verbal theology that Rahner assures art's necessary place. Rahner knows that there is art, even religious art, that does not have revealing character and that there are those whose artistic sensibility is not developed and who cannot see at all. Moreover, there are those whose philosophical gifts keep them confined to that approach to reality, exhibiting on occasion why theology has lost so much of its poetry. Art and theology, different and related, both are rooted in humanity's transcendent nature. They belong to each other. The theological question cannot exclude the nonverbal arts. Yet the manner in which the arts are to be incorporated by theology was not addressed by Rahner before his death.

Ray L. Hart in *Unfinished Man and the Imagination*, as the title itself suggests, sees humanity's imaginative capacities as constitutive of what we may become in the process of living.[29] We are always being completed, and we are always unfinished. Living in that mode, we both manifest and continually create who we are. Hart gives particular attention to the arts, literary and visual, as a paradigm of the imagination which expresses that double aspect of our existence. Moreover, it is clear that the visual is considered to be constitutive and informing of our humanity. The result is that the arts are taken as seriously as the metaphysical; they are not an adjunct to the verbal but provide, as do other modalities, fundamental clues to what we are and are becoming. Here theological method programmatically includes the arts: in fact, the arts become a central imaginative paradigm. It is unfortunate that Hart's recondite style, necessary or not, has kept his views from receiving the attention they deserve. The recent republication of this book, long out of print, may change its previous neglect.

In David Tracy's *The Analogical Imagination: Christian Theology and the Culture of Pluralism*, the title also suggests the particular theological method.[30] Impressed by the plurality of interpretations within the biblical

[28] Ibid., 24–25.

[29] Ray L. Hart, *Unfinished Man and the Imagination: Toward an Ontology and Rhetoric of Revelation* ([1967] New York: Seabury, 1979).

[30] David Tracy, *The Analogical Imagination: Christian Theology and the Culture of Pluralism* (New York: Crossroad, 1981).

materials, in theological history, in approaches to theology, in world history itself, Tracy believes that it is necessary to honor this diversity without theology's becoming simply an array of unrelated perceptions. Building on a historical concept imaginatively refurbished, Tracy argues that analogy is the methodological key, provided that its imaginative use takes due account of both the difference and likeness involved in all comparative work. Utilizing this concept, Tracy ranges widely, thoroughly, and perceptively through historical and contemporary writers in theology, the social and psychological sciences, and the arts. Only the ephemeral, defined as that which excludes other alternatives, is not considered. That which affirms and stretches our sensibilities is worthy of consideration; it is that which has the earmarks of a classic. In a genuine work of art, "'caught up' in its world, we are shocked, surprised, challenged by its startling beauty *and* its recognizable truth, its instinct for the essential. . . . We recognize the truth of the work's disclosure of a world of reality transforming, if only for a moment ourselves: our lives, our sense for possibilities and actuality, our destiny." [31]

For Tracy, theological work now requires new conversations, the analogical tracing of diverse affirmations in their likeness and differences. Tracy may not intend this, but I learned from him the rich perceptions and affirmations that can emerge when one alternately looks at issues from a variety of angles and perspectives. Then a rich mosaic may emerge, one in which the pieces remain partly distinct yet related to a new whole. To execute such a theological task requires the keen knowledge and perceptive sensibilities so characteristic of David Tracy.

Alternative Theological Models

The three foregoing categories include writings that have the characteristics of what we have historically recognized as theologies. Acknowledgment must be made, though space does not permit elaboration, of a group of writings and approaches to the theological task that do not fit the shape of traditional theological systems. They may serve as alternatives, as correctives, or as additional angles of vision. Certainly liberation and feminist theologies set a new agenda. Artistic modalities are understandably not at the center of attention; yet they are frequently and naturally present. The development of models as avenues of exploration, such as in Ian Barbour, opens the theological task to the sciences; works such as those of Clifford Geertz, to social-cultural dimensions; and of Paul Ricoeur, to symbols as

[31] Ibid., 110.

the center of philosophical and theological work. That the structure, style, and meaning of our lives form special unities is confirmed by the work of Stephen Crites on narrative or story, by the essays edited by James Wiggins, by metaphorical theology as developed by Sally McFague, and by biography as represented by James McClendon. Then there are movements that, in spite of their contradictory nature, instruct us in the reading and understanding of texts: for example, the mythopoetic approach, in which, as in Amos Wilder, we learn how to see literal texts in nonliteral ways; structuralism, in which linguistic patterns and common meanings recur in history apart from historic conditioning; or deconstruction, in which meanings are not fixed, but multiple and suggestive, with possibilities in total historic flux. Many of the literary methodologies are creatively used in biblical work by Robert W. Funk.

Concern with theological method has not produced a single method, but itself reflects the pluralism of approaches in our time. John Cobb and David Tracy in particular have given central attention to this issue in their writings—Cobb by learning from that which is different and interpreting it in his own expositions, and Tracy by incorporating new insights in such a way that an ever-widening analogical interpretation is required.

There are many levels in our pluralistic situation. Today we accept that there are different theological motifs in the New Testament. We know that cultural and religious orientations alike bind and divide Protestants and Roman Catholics. We know that life-situations help us to see the gospel in ways we had not seen before, even when they also shrink other perceptions. We know the differences and similarities between non-Western and Western religions. All of these factors have transformed the theological enterprise in recent decades.

Largely absent from the writers we have considered is the view of theology as true propositional statement. The concern with language has become more circumspect, even when the paradigm for theological work remains within the philosophical orbit. Nevertheless, the nature of the arts in relation to theological work still remains a critical question. Rahner has succinctly posed the issue in his recognition that the arts cannot be translated entirely into other modalities, but that what they uniquely disclose must nevertheless have implications for theological work.

III

AN AGENDA

9

Toward a Theology
of Wider Sensibilities

IMPLICIT IN THE preceding chapters is the suggestion
that the visual defines an essential ingredient of our humanity. Yet historic
and contemporary definitions of humanity do not suggest seeing as a special
ingredient. It is at once assumed that we would know so much less of our
world if we did not see, but reflections on who we are quickly move from
seeing to other aspects of the self, as if it were a necessary filter that had
no role in itself.

Defining the Human and Humanity's Vision

Humanity was once defined as *homo faber*, the maker of things, of tools,
of the visible structures that became the substratum of cities. Today tech-
nology, humanity's infinite capacity to fabricate, has become a fabrication
or a lie because of its very achievements. It will undoubtedly once again
need to be defended, not for its onesidedness but against quackery and
reversals, as if nature unattended knew best. Humankind has also been
known as doer, actor, not in this case as technocrat, though it sometimes
came near to that when humanity's doing was social engineering. The crea-
tion of social interrelations, those facilitating structures that expedite,
sustain, and form individuals in their many-faceted interrelations, is a
necessity for the enrichment attendant on spatial contiguousness or on
socialness beyond the instinctual level. Since all human interrelations have
volatile ingredients, humanity is always struggling to create the links that
bind and restrain, even as they are meant to enrich us. Freedom vies with
conformity, and the unique with pluralism. The doing is endless, either
because the achievement of an overriding goal is not possible or, if it has
been attained, because it must be protected.

231

Humanity has been defined in terms of language: the human being is the one who speaks, who articulates structures of thought and being beneath and behind the obviousness of things. That language is the dominant structure of human communication can hardly be denied, but its decadent verbosity is also all about us, telling us how to handle all our other sensibilities. Language forms and transforms, and its many styles and powers could enrich us more than they do. The so-called decline of preaching, or the demise in our time of oratory—so prominent a part of nineteenth-century life—means that the widening, disciplined, imaginative use of language is in short supply. Language frequently makes us without stretching us.

Humanity is defined as "spirit," a word that can refer to the psychic form, soul, and posture of humanity or to an independent entity that may be formed in relation to or in conflict with the world of flesh. Protagonists for the spirit usually assume that its virtue is self-evident, and they are hardly aware that the subtle sins of the spirit are as devastating, sometimes more so, than those of the body.

Humanity is defined in terms of creativity, of being an artist, of the use of imagination in creating new worlds and new forms, ranging from the artistic mode appropriate to the self as such to what the word "artist" usually conveys. But being creative is a relative matter, involving special gifts and talents, and since, in its special form as art, it is not universally shared, only a tamed creativity is prized by the rank and file, including that of the American church.

Humanity is defined in terms of the symbols humans create and live by. That process is more elusive than that of previous definitions. The mystery of symbols, how they come to be and lose their power, testifies to an inability wholly to correlate symbol and humanity. Humans step in and out of symbols and create them without consciousness of their role. Symbols are, therefore, both less and more definitive of humanity. They are the inevitable concomitant of humanity, the air that humanity naturally breathes. Reflection on all that happens is already a step sufficiently removed from the symbol as to destroy the power of the symbol or reality in which it has participated. Humanity, as symbol-producing, does not tell us very much about what we want to know, even though symbols are indigenous to our being.

It would be too far afield and beyond my competence to go into detail about Gestalt psychology or Jungian archetypes or the varieties of structuralism. The former two suggest that symbols do provide a constancy of repetitive structures and archetypes. Consequently, humanity creates and recreates itself out of a substratum of constant mythic realities, variously

named and modulated. The collective unconscious, repeated and built upon, connects humanity's past and present and is thus definitive of its very nature. Structuralism, it seems to me, tries to connect the mythological symbols with the linguistic. In that sense it represents widening horizons, dependent upon total archaeological and archetypal patterns. Its pattern-finding consciousness provides a methodology for analyzing artistic and linguistic expression alike. But the messianic orientation of many of its proponents and the claims made for the method stand in marked contrast to the achievements to date. Fascinating as the method and results may be, they leave one with the question "So what?" Structuralist illumination tells us little, either because it is still new or because it cannot really do so.

The definitions here pursued—and additional ones might be listed—are attempts to define the central ingredient of humanity in terms of which other facets might be added, organized, or oriented. Such attempts at unification do violence to sensibilities that could claim equal significance. The issue arises in acute form when a single, central modality of the self claims an encompassing role. Can the modalities and sensibilities represented in different disciplines and methods be translated into one another? I think they cannot and that attempts to unify disciplines in overarching schemes are wrongheaded: they confuse the vision of a single eschatological coherence with a realizable plan. Humanity's lot is to believe in this vision without acting as if it existed. The attempt to translate the vision into particular actualities demands the recognition that such achievement is beyond reach and that the direct effort to do so frustrates and distorts what might be achievable. Pascal knew this so well when he said "Man is neither angel nor brute; and the unfortunate thing is that he who would act the angel acts the brute."[1] Humanity's spiritual discontent, the endless quest, the nature of creativity itself is thus inevitable. The direct translation of vision into action is exactly the boundary that cannot be crossed; it is the essence of the rent in creation which we cannot attempt to expunge, except at great peril.

The relation of vision to action is indirect and is characterized by the acceptance of circumscribed limits. Only insight and analysis will, in any instance, give us hints concerning whether vision is formative within limits or has been abandoned for specific goals, goals opportunistic or positive in too limited a sense. Discontent is our lot, whether religiously perceived as a rent in creation, the work of the devil, or the basis of creativity itself. Discontent is destructive when piety provides an overlay that hides our true status, or where there is no grace by which to accept our discontent.

[1] Pascal, *Pensées*, no. 358.

The tenuous connection between knowledge and doing, which means that we cannot conflate or separate the two, presents another description of the limits of our achievements and the destructive consequences of unheeding knowledge or action. Vision stands to the range of knowledge as vision and/or knowledge stand to action.

We live, however, in a period when individuals have a renewed interest in organizing all life in terms of overarching conceptions. It is difficult to tell how much is retreat and how much is advance in such endeavors. Today the virtues of forming, and in some sense forcing, values of an alleged Christian character lead to visions of Christian schools that shrink the horizons of concern. They unify at the expense of bracketing out important ingredients. The theological advance that virtually eliminated theological factors as significant ingredients in the relation of the churches to one another has not led to new unifications; instead, a deeper unity—that pious jargon which marks recalcitrance more than insight—has led to narrowing identifications in which prized religious accents take over rather than become the occasions for new stretchings of heart, mind, and spirit. It is not that visions of unity have disappeared; it is, rather, that they have been reduced to more manageable scope, leaving out what does not fit. That development stands in marked contrast to a former vision, equally dubious, of ever-expanding possibilities of unity and unification. The more we know or experience is not automatically grist for unification. The dizzying nature of such discoveries should itself make us cautious. The host of eighteenth- and nineteenth-century projects with "Christian" before them, such as Wesley's Christian Physics, should make us suspicious both of the "Christian" designation and the dated physics involved.

Interdisciplinary projects are both important and necessary. They are more important for the new methodologies they bring, the meshing of different views, than for any final or full unifications. The notion that our thoughts could unify all informing knowledge and insights is precisely what is in question. In principle, theology is related to all the areas of human knowledge. If faith is a way of believing that illumines the entire creation, how could it be otherwise? But the fact of a necessary relation does not guarantee clear results. Perhaps that is why theology has oscillated between overexplaining the world or withdrawing from other avenues of knowledge into the alleged purity of its own creations. It may be fruitful, however, and altogether beneficial when we are forced to deal with facets of experience that defy direct verbal expression, that make us stammer in our struggle for understanding and coherence—not because we are feeble intellectually but because reality in all its diversity will not bow to our thought-forming categories.

Mystery and the Language of Theology

A plea for stammering may be in order. It is an appropriate signal that we deal with mysteries that cannot be encompassed and that shatter our attempts at articulation. At one time language more adequately conveyed that inseparable double modality by which words are a clarifying power of an essential mystery that never permits the translation of mystery into mere clarity. Clement and Origin may have confused faith with *gnosis* and the gnostic vision, but they celebrated the clarifying mystery of both humanity and God. Irenaeus may have been imaginative in his elaboration of scriptural meaning to the point of fancy or whimsey, but the mystery remained intact as he used biblical modes to clarify the meaning of the world. Tertullian may have seemed to court a baroque style to the point of turning mystery into the irrational, but in the tradition of rhetoric in which he worked truth was equivalent to the mysteries that could not be expunged on the basis of any theory of knowledge one knew and practiced. From Augustine through Anselm, one believed in order to understand: faith or mystery gave credence to what one thought and did in a way that illumined the world and one's life more adequately than anything else. Aquinas, too, still operated in that framework while pressing the limits and delights of reason to the point that some facets of faith and reason overlapped and others were beyond reason.

Systematic theology as we know it was not born until the seventeenth century. Aquinas and Calvin are not even exceptions to that statement; they operated with quite different presuppositions. Aquinas divided his work into parts, questions and answers, in the attempt to cover every thought and piece of knowledge in the world. He did not move systematically or logically from one issue to another. He simply declared, or "placed," the next issue. Indeed, the scholastic method was nothing other than dividing the world into pieces, places, and topics precisely because one could not make transitions but needed to cover everything in the created order. Calvin, on the other hand, appears deceptively systematic, but, in point of fact, the *Institutes* grew from its initial version of 1536 to several times the original size, and sections were repeatedly rearranged in the process. Four books with chapters and subsections should not hide the fact that the section on scripture does not belong where it is placed and that the twofold knowledge of God as Creator and Redeemer is not reflected in the organizational structure of the *Institutes*. Every ingenuity of organization disclosed that the mystery would not neatly fit human expression; fissures and inconsistencies were disclosed even as the marvels of clarity were greater than the world had known.

The transitions from Luther to seventeenth-century Lutheranism and from Calvin to the Reformed tradition of the seventeenth century are shifts greater in magnitude than the preceding or succeeding changes in theological approach. They represent the change from the linkage of thought and mystery in ways that permitted the victory to neither, to one in which thought won the victory as the purveyor of mystery. In that process mystery was not expunged, but it was expressed in ways that shattered the world people knew, precisely when what people knew was less susceptible to change than ever before. In that sense, seventeenth-century theologians used intellect, as no one else had done before, in order to break common knowledge. Two illustrations may suffice. Although Luther and Calvin believed the Bible to be true from cover to cover, neither based the authority of scripture on that point, but rather on the conjunction of word and spirit as God became known to individuals in the community of faith. When scripture as true from cover to cover comes to center stage, knowledge claims are made for vehicles which themselves are debatable, which cannot bear the weight placed on them. Similarly, the shift from the virgin birth as guaranteeing the humanity of Christ to that of biology as the basis of divinity made a debatable point bear too much. Even if true, it would not be adequate to the mystery disclosed.

Such shifts were part of the victory of the world of rational thought in all realms. Seventeenth-century Continental scientists and theologians, Protestant and Roman Catholic, used the categories of thought as the clue to religion, thereby claiming at once too little and too much. So confusing was the resultant situation in the seventeenth century that the church accused Galileo of heresy for his heliocentric theory of the universe. Then, in our own time, the church reconsidered the issue without realizing that it was Galileo's rational version of scripture, not his science, that was heretical or on the edge of heresy. But the church could hardly have seen this issue at the time of Galileo, considering how rationalist were the church's own views.

From the seventeenth century into our time the church has had a hard time using declarative language in a way that clarifies without confining, circumscribing, or distorting the mystery. As steward of the mysteries, the seventeenth-century church was tempted to enshrine truth in propositional form, without a due recognition of the limits of an enterprise in which the allegedly superrational was defined in rational terms. The eighteenth-century Protestant world vascillated between rejecting such propositional truth in favor of feelings (mild or revivalist in nature) and of limiting the superrational in favor of the rational as the rightful modality for theology. Protestantism in the first half of the nineteenth century exhibits a vigorous, romantic streak, relating cultural and faith vitalities in creative and

confusing ways. In the latter half of the nineteenth century, the Protestant world abandoned the romantic and the rational in favor of the moral as the reigning modality of theological thinking.

At the same time, from the seventeenth century through the nineteenth, the world of theological orthodoxy continued, whether that of Roman Catholicism, Lutheranism, or the rightist, reformed Presbyterian branches. Orthodoxy fought for the mystery at the center of the gospel in ways that offended new sensibilities born out of the new social and scientific disciplines, whereas the Protestant development previously delineated accommodated itself to the sensibilities of the time but lost the mysteries it had hoped to express. The neo-orthodox movement combined the rigors of thought with the mysteries of faith while accepting the sensibilities of the modern world. It found new ways to express the ancient and enduring claims of revelation and faith. Though most of its theologians are still read, neo-orthodoxy was a short-lived movement, perhaps because it was too complex and dialectical, having to fight on the right and on the left without being carried by any of the broader cultural movements of the time. Theological positions that do not ride the currents of a time may be more correct than their alternatives, but they do not have a cultural future. Conversely, a culturally dominant movement may also take a creative movement in unanticipated directions, as in the seventeenth-century dogmatic formulations of the works of Luther and Calvin.

The church has always had to come to terms with what one *could* believe. From the seventeenth century to about 1950, however, the theological world had to deal with what it was that one could believe religiously in a world that increasingly saw less of a role for the Christian religion. From the fifties to now, there has been shift from "What can one believe?" to its opposite, "What cannot one believe?" (Most anything.) We have come from the repudiation of religious dimensions to their matter-of-fact acceptance. That change may be more generally religious than specifically Christian, but it is a major change nonetheless. From the early church to the seventeenth century, theologians and the church tried to form and make credible the religious and cultural vitalities around them. Hence, Christians were more careful, more sober in what they believed than their contemporary non-Christian, pagan believers. From the seventeenth century until a few decades ago, Christians believed more, were more audacious in their beliefs, than the world around them. We have returned culturally, in terms of the climate of opinion, to the earlier stage when the Christian movement was confronted by strange vitalities within and without. Some today are tempted to reject all the new currents; others have taken them over uncritically.

The time in which we live is hardly a time for great theologians who ride contemporary currents. When and if a more common theological direction emerges, theologians will again become more important and they will see among those working in our time some Pascal or Kierkegaard who worked well in a time out of joint. But times out of joint are also great times that demand resources of spirit and mind less recognizably right or true than those required in more single-minded times. Today there is no discipline, theological or otherwise, accepted as the unifying discipline. That is why we are interdisciplinary. Still, visions of putting it all together remain. The inability to do so leads both in thought and in politics to apocalyptic motifs of a postponed fulfillment or to attempts to take the world by storm. An apocalyptic vision hardly ever remains a vision, a hope against the absence of hope, a transcendent frame of reference of no immediate or final consequence; it almost always slips into a plan of action or inaction. We continually confront the issue of how visions of unity can operate as the spur that leads neither to surrender nor to false claims. Perhaps that is the meaning of "Where there is no vision the people perish." But vision has only indirect, partial, distorted, dialectical possibilities. It is the matrix of doing, not the content of doing. A double division characterizes the human situation. One is between vision and reality; the other is among the sensibilities that do not form a unity, and that, when forced into unity, distort the sensibilities themselves.

Above all, what sight provides cannot be fully or centrally expressed verbally. Augustine illuminates the latter division. In terms of his heritage, he characterized it as the result of the fall. It was as if the fall did not erase the stamp of the Creator on creation but left that imprint in the disarray of three separate contending forces. It was as if the world in which we live bore the marks of the triune God, now disclosed only in the polytheistic split of the marks of the three Persons. His theory forced the analysis; indeed, the three resultant pieces are not always the same in Augustine's writing. There is the physical, the logical, and the ethical; there is also action, contemplation, and discrimination, corresponding to the moral, the natural, and the rational.[2] There is the world of the senses, represented in Epicurus; action, represented in Virgil; and the mind, represented in Plato. In other words, the fall has pulled apart what God had joined together and what now has its unity only eschatologically.

Different modes of the self are dominant at different places and times. Within one time period, one sensibility may be dominant, or several may be operating simultaneously in relative harmony or conflict. The early

[2] See, for example, Augustine *City of God,* 11.25.

church entered a world in which emotion and feelings were fairly domi-
nant and diverse. These feelings were articulated in patterns ranging from
philosophies of sense to theories of gnosis or knowledge. The ancient gods
were at once greater and worse than humans. In that wildly intoxicated
world of sense and knowledge, it was no wonder that a reasoned philos-
ophy, an episcopacy, and the New Testament canon formed an authentic
and orderly tradition. It has surely become apparent in the last thirty years
that we have moved culturally closer to the diversity and passion of the
early church, including its bewildering array of possibilities. We also recog-
nize that we know truth more universally than ever, that less divides us than
before, but that we are virtually helpless against the provincial and paro-
chial passions apparent everywhere. In contrast, the seventeenth-century
Continental world represented a penchant for order in society and in
thought, as the Lutheran, Reformed, and Counter-Reformation theologies
of that time indicate. But in England that time was also the literary world
of John Donne, William Shakespeare, and John Milton, each recognizing
that the old order was over and that the new was uncertain. Hence, disdain,
belief, unbelief, reason, and tradition appear in unequal, uneasy propor-
tions in their works. The eighteenth century divided over the rational and
the affective-emotional, and the nineteenth abandoned the structure of the
rational world in favor of a moral structure, freed of overarching supports
but tinged with sentiment. There were, of course, those fighting for wider
and differing sensibilities, such as Jonathan Edwards in the eighteenth cen-
tury and Horace Bushnell in the nineteenth. But they did not succeed in
winning their day; indeed, history has read them not in terms of their vision
but through the truncated theological programs that followed in their wake.

Sense, Sensibility, and the Visual

In the light of the preceding, it is apparent that language lost its powers of
imagination and became that which declared, defined, set limits. In con-
trast, painting is a suggestive, showing-forth modality, which in the light
of what we know, wrests nuances of meaning. The transition in our history
from linguistic definition as a limiting concept that left the mystery intact
and featured it by showing its boundaries to definition as telling us the
essence of the mystery reduced the power of language as an evocative
medium. The loss of the power of language in this broader sense is hardly
noticed. But some sensibilities—sight, touch, taste—seem to create prob-
lems for us. They more readily call forth distrusted excesses and distortions
than do the verbal sensibilities. That one's sensibilities may be as violated

by an evening of television as by an evening of public gluttony or biliousness hardly occurs to us. The writer Isaac Singer touches the nerve of this issue when he suggests that it appears that God was very frugal in not giving us enough intellect or physical strength, but that when it came to emotions or passions God was very lavish indeed. Only the animal can act in accord with feelings and have no survival problems. The split between intellect and emotion is, for Singer, the essence of life and literature. He agrees with Spinoza that anything can become a passion, even an idea. But Singer reveals his own limited vision in believing that the main passions are sex and power.

The alleged purity of intellect and the seductiveness of the sensual are deep in Western history, though everyone knows—and here Spinoza was right in saying that everything can become a passion—that the passion of ideas and the prudery associated with nazism and communism alike have been more destructive of human existence than the sensuality so readily attacked. The obvious point is that the emotional, which is related to the senses, is a pervasive part of existence. The issue is not intellect versus senses or passion, but how the emotional component is to be channeled in relation to ideas and to the senses. The rules of societal behavior are meant to channel them safely. In the English Protestant moral ethos, which so long dominated this country, the suppression of the emotional and the sensual— an inner-worldly asceticism—denied to the sensual its appropriate role because of the dangers it suggested. That is to deny a part of humanity because of actual or potential misuse. So strong has the distrust of emotion and passion been that in the Western world it influenced the legal system itself. A premeditated act is considered more heinous than a crime of passion, in which reason is allegedly lost. But why is derangement considered more an illness than a premeditated act? One could argue just the opposite. It is as if the emotions were so feared that, if their suppression could not succeed, their use might be more readily excused.

It has been said that the issue of life and death is illumined by raising the hypothetical question "Suppose we were not allowed to die and had to live?" Similarly, one could pose the issue "Suppose we were not allowed to suppress our emotions but had to come to terms with them?" Neither their denial nor their expression gets at the core of the issue. The new sexual freedom has led some to give up sexual relations out of boredom, a renunciation that contrasts sharply with the historic monastic view in which one knew what it was one gave up, a deliberate limiting of one's human life and expression. Suppose one were not allowed to give up sex. Statistically, therapists have discovered that the abandonment of sex is one of the greatest problems in marriages in our century. The expression "Love and marriage go together like a horse and carriage" is oversimplified, but surely it suggests

that the issue of the senses is not their suppression or expression, but their context. Moreover, it suggests that the absence of love calls the marriage into question, that a dimension has disappeared and the relationship is narrowed. When passion wanes and boredom sets in, one has simply moved from an uncultivated expression of sexuality to its absence. In both instances, that full development of sexuality, that discipline of cultivation in which delight and meaning can increase is totally lost.

This problem of the emotions and the senses in relation to sexuality is part of the pattern one witnesses in the visual arts—an uncultivated, undisciplined view of the role of art. It is a pattern or attitude apparent in the following responses: "I don't know anything about art but I know what I like" or "I can do better than that." The visual arts as a whole have a special characteristic, not absent from other sensibilities but perhaps more fully expressed. They push to the particular and the universal simultaneously. No universal meaning is ever purveyed without the concreteness that an art object implies. Any art object survives as mere object, rather than as art, when it does not elicit shared perceptions in any generation or across generations and ages. A painting or sculpture that provides only a picture of the past is a historical object that may show artistic talent, but it does not function as visual art unless our humanity is involved in the yes and no, the pull of both, affirmation and negation, as we encounter it.

When we see an older painting, we usually recognize the subject matter, and, if we do not, we at least recognize the ingredients. We may not recognize the subject of Rodin's sculpture of the *Burghers of Calais,* but we surely recognize that we are confronting individuals from another time and place. When we see in the sculpture only individuals from the past, however, and not the *Burghers of Calais* in their total social matrix, art has lost its power as art. Then art is only recognition and not transformation.

Individuals are also easily bothered by the things they do not recognize. Picasso's or de Kooning's women do not seem like women at all, and in our rightful new feminist consciousness they bring new problems. When we are told that they are women and when we confront the obvious distortions, we still often cannot see the figures at all. The attendant shock is not intended to provide a distorted view of women or men; it is, rather, to bring us into a new way of seeing, where the ugliness can itself become part of a new way of seeing beauty.

Modern art confronts us in such a way that we cannot be indifferent; we are somehow different as a result. It deliberately tries to lead us into new territories. It has not always succeeded, for it has led many to believe that, since the recognizable patterns have disappeared, they could themselves do as well as the artists did. So many even today believe that children can do as well. But all one needs to do is to take a child's drawing or painting and

place it alongside one of the modern artists and, if one has eyes at all, one sees the difference. That a child can do as well as a trained modern artist is one of those unexamined ideas that disappears the moment one places the respective works side by side. In the past, similar theories were held about the work of Jackson Pollock. Any careful examination makes it clear that the apparent chaos is at once one that involves pattern and randomness, a control and an openness to accident. In a marvelous way, the randomness and accident do not overcome the structure, nor does the structure become so dominant and all-controlling that accident and openness are eliminated. How close this is to nature and life—a structured indeterminateness, an indeterminate structuredness!

Of course, some modern art is poor; in that regard it is not unlike other disciplines. But modern art has probably been more consistently ignored, decried, or found amusing than the other approaches to our world. It takes a discipline of seeing to find more than that in modern art. Indeed, calling for a new discipline of seeing may be one of its major contributions to our life. The statement "I don't know anything about art, but I know what I like" also testifies to a view of the visual that one would not accept in any other area of life. Where else would one use ignorance as a claim for validating one's opinion? There is a discipline in seeing, just as there is a discipline in everything else that we do well, whether it is reading or writing or making something or listening to significant music, or even loving someone. A discipline of seeing does not come by being told how to see, though that may be helpful, even necessary; it comes primarily by seeing and seeing and seeing over and over again.[3]

In the realm of music we assume that it takes discipline and repeated hearing to find one's way into the appreciation of a symphony. Such a discipline stands in marked contrast to the lure of a popular melody, which demands little of us. Frequently the same people appreciate both; yet in terms of the stretching of our sensibilities, a symphony rates above a popular tune. With respect to the visual arts, people are not generally willing to grant a similar distinction, that is, between naïve and high art. Perhaps that is because we have denigrated and denied the popular arts for

[3] One way to develop the strategy of seeing is as follows: Go to a museum once a week, concentrating on seeing four or five paintings that have some attractiveness or meaning for you. Spend enough time with each one, say, fifteen minutes. Then add a painting or sculpture on each visit. Trying to see everything is not helpful until one already has cultivated a discipline of seeing. Reading about the paintings is helpful, but only if such accounts help one see rather than tell one what the painting is about. Information adds to what the painting conveys, but information is not what a painting is about. What one is trying to develop is another way of sensing what the world is about, a sensing that is unlike any other avenue of knowing the world.

too long. To recover them as a medium in which we all participate will be
a cultural enrichment; however, to deny the enriching, stretching character
of high art is to ask that humanity all be at the same level, with the same
shared perceptions, never willing to be pulled out of where we are. Naïve
or folk art has an immediacy in that we recognize at once what it is, some-
times even with a faint smile, as if we might be equal or superior to it. Folk
art reflects with charm what and where we are; high art more often trans-
ports us to where we are not. At the same time, it is interesting that folk
or primitive art, when seen through the eyes of those who know high art,
frequently is seen as having transcending characteristics denied to those
who do not come with the trained eye. There is a difference in whether one
comes to folk art as folk, or comes to folk art from a perspective that also
knows the transcending facets of professional art.

The plea here is not that the visual or the world of sound be placed above
language and the verbal. The observation, rather, is that language, which
forms the essence of humanity and of civilization, has won such a total
victory. The development of literacy, given wings by the printing press, was
more than adding speech and writing together. It was a quantum leap,
setting the visual in the form of reading print into the orbit of speech. The
eyes had a harder time doing what only they can do, telling us about the
world by what we see. The lure of the great outdoors, from its more un-
spoiled settings to commercialized beaches and ski resorts, testifies to a
primordial, even a historical, memory of knowing something of the world
through the senses—seeing, and acting in the light of what one sees. Father
Nicholas Point, a Jesuit missionary in the nineteenth century to the Flat
Head Indians in the Northwest, resorted to painting as a communication
strategy, for what the Indians knew of life was conveyed more by a devel-
oped, cultivated sensitivity of seeing than by what they heard. Yet even
their hearing was attuned to what they knew from the memory of seeing,
as every outdoor person knows.

But for us this has changed. The civilizing power of speech, given visual
form in writing and print, is a phenomenal achievement. In this sense,
civilizing is the correct word, for it extends the human memory across the
ages and cultures. It makes the achievements of another time and place
contemporaneous with us, extending the civil or the domain of civility.
How ironic then that this civilizing power should suppress the senses of
touch, sight, and hearing, except as they reinforce its own approach. When
that moment occurred, the process of civilizing became oppressive as well
as liberating, a fact that we recognize much more today than did our
forefathers.

There is, however, a residual, almost magical power to the visual, which
has not lent itself to exorcism by a reading, verbal culture. Precisely when

modern iconoclasm

we are not looking, we find ourselves suddenly surprised by iconoclasm, by attacks on a visual reality that we had assumed had no power. Generally iconoclasm represents the rejection of the seductive, pervasive power of the visual as a threat to other perceptions considered more important and central, that is, more spiritual and ethical. There is a widespread assumption that spirit and bread, so elemental to life, are denied by all that the visual represents. However, let it be said that the visual arts, like music or literature, in some sense represent a necessity of the human spirit as elemental as spirit and hunger and something so central that not to know it deprives one of part of one's humanity.

Precisely because art has a seductive character, sensuous to the core, a discipline of seeing is essential in order for one to be illumined beyond the sensory embodiment. The discipline of seeing, learned by repeated seeing and essentially in no other way, forms the seductive into a discriminating sensuousness that is more than itself. Horizons are stretched, formed, and filtered, as creation's images are regained in their sensuousness, in their seductive aspects, precisely for their Creator.

Why should we leave seduction only to the devil? The devil has the monopoly on seduction because the demonic requires no discipline of seeing. God's seductive creation requires the appropriate discipline of seeing. The choice is not between innocent, uplifting objects, on the one hand, and sensuous, seductive art, on the other—as moralists like to describe it. The choice is in how one sees the sensuous, for art is sensuous by nature.

When the church arrests cultural vitality for fear that demons may be present, life and humanity are stifled, and the visual powers degenerate to the detriment of humanity. We live in a time of new opportunity. The gamut has been run from the domination of faith, to its material and secular denial, to new forms of perception, diverse and open to new-forming constellations. All art is not religious, and the museum is not its temple, but the artist today represents, to use the language of the late Paul Tillich, a manifestation of one form of the latent church. Such a recognition means that we do not expect the artist to utilize the subject matter in forms of the past, but, rather, to represent the new forms and perceptions that can become the source of transfiguration and transformation. This view of art places it in the realm of affirmation. Art may have a prophetic function, laying bare perceptions we would otherwise have missed—but prophetic in the sense that, like prophetic disclosures through other media, it arises out of a vision of reality that reflects its negation. The visual arts thus have a double character, disclosing a vision with which we may or may not agree but simultaneously purveying a shared vision through nuances unique to itself.

The Visual Arts and the Other Arts

The arts other than the visual made their way back into Protestantism in a way in which painting and sculpture did not. Perhaps they were considered safer than the visual, for dance, music, and literature by definition come and go. They are not continually present like painting or sculpture. A dance is gone, for example, except in memory, once the dance is over. Moreover, dance, music, literature, and liturgy itself are sometimes magnificent and more often tame and folksy. David may have danced on the altar before the Lord, but sometimes dances—for example, those of the Lord's Prayer—become poor art, merely illustrating the prayer. There seems to be something intimidating when the church is involved, so that artists of every stripe lose much of their passion in the church. Music, once also excluded from the Reformed tradition, has become the dominant Protestant art form. Again, music is not present unless it is being performed, except in the mind of a composer or one well trained in music. Moreover, when music is combined with words, as in a chorale, one has the best of both worlds with no special problems. The music overcomes the archaic nature of the language, while the language gives intelligibility to the music. Frequently, however, the words hide the depth of the music, what the music alone may bring. Beyond the ordinary level in which music seems to please us, the structure of music may also affect, address, stretch, confirm, trouble the depths of our being in ways no other discipline does, not because it is better but because it represents a unique sensibility, analogous to but not identical with other sensibilities.

Because literature is verbal, it has had an easier time in the church than have the other arts. But in a time when the verbal is not known for its own distinctive style, through which indeed what it says could not be said in another way in order to express a specific perception or reality, it is too easily assumed that the substance of a specific literature can be translated into other forms of speech. There is a tremendous difference between an essay, for example, and a literary creation of another order such as a poem or a novel. The latter conveys many features, a complex of nuances that no declarative prose could convey. That is why discussions of the meaning of a poem or a novel do not always enhance what one has witnessed but frequently reduce the meaning to levels of comprehension well beneath the level of the work itself. The delight of great literature is that talk may help us to understand it more, but talk never exhausts what one has read or seen. It does not permit a full conveyance of what is disclosed in another form. In theological work, the literary arts are incorporated in order to make vivid what has and is being said. Literature is used because it discloses

facets and nuances of theological meaning analogous to but different from what ordinary or philosophical discourse might provide.

There is nothing wrong with this use of literature, provided that illustration is not considered the only or uniquely special character of literary art. Poetry and drama are unique both because they are a special genre and because their style discloses what another style cannot. Poetry takes us into a world in which style conveys more than the subject that is present. David Daiches has put it well: "Great poetry carries beliefs into its language in such a way that it can achieve a communication transcending the bounds of those beliefs," and then he adds, "but we must learn to read it."[4] That is why talking about a poem should only be an act of honoring that does not transgress the boundaries. A literary art may be said to have facility and discipline when, in an imaginative suggestiveness, it creates resonances in our being that would be violated by overexplication.

In this sense the literary and the visual arts are identical. Indeed, the literary arts can be said to stand closer to the visual arts than to the disciplines that share the verbal in ordinary and philosophical discourse as we usually encounter it. As in the case of the literary arts, so in the visual, the verbal has its place, its way of talking about, of suggesting, of pointing to, but in such a way that the painting or sculpture speaks to us—if one may use the expression—in its own way. Thus, seeing conveys more and in ways different from saying. Respecting the boundaries, avoiding transgression, is important to both the literary and the visual arts.

This delineation of the literary and the visual implies that positive affirmations are as important to these arts as is the critical, allegedly prophetic nature of the arts. It may be true that the arts convey more quickly than other disciplines the seismographic shifts in a society, perhaps because sensitivity is so central to the nature of the discipline, though one wonders why it should be less true in others. Nevertheless, the value of the arts does not rest simply in either their pleasing or their prophetic functions, but also in their affirmations about life. Precisely this shift from the prophetic to the affirmative is to be found in the literary writing of Nathan A. Scott, Jr.[5]

Certainly the primary agenda of the abstract expressionists was to present the world anew to us, freed of forms that once had power but had become banal. From their different orientations, they strove to present the mystery of the grandeur of humanity. Mark Rothko evokes the mystical tradition; Robert Motherwell a humanistic stance in the grand classical sense; Jackson Pollock the visions of one who, though he descended into

[4] David Daiches, *God and the Poets* (New York: Oxford University Press, 1984) 219.

[5] Nathan A. Scott, Jr., *The Wild Prayer of Longing: Poetry and the Sacred* (New Haven, CT: Yale University Press, 1971). This volume discloses the major shift.

hell, saw new realities glimpsed from afar; Barnett Newman the grand sublime in rigorous, demanding form.

The arts, like other disciplines, can be trivial and, with respect to religious issues, banal. But they can also convey facets of life and truth in religious or nonreligious subject matter. Significant art, as classic, to use David Tracy's phrase, purveys more than what transpires in a given time; from a particular time, it carries us into perceptions suggestive and illuminating of humanity in other times.

Theology Today

It may be that definitional theology, originating in the late sixteenth century and continuing into our own time, will be a parenthesis in Western history. Theology before that time, as we have shown, was suggestive and imaginative rather than definitional, developing faith as a way of understanding. At the time of the Reformation, however, developments began that moved the theological enterprise in a definitional direction—largely, I think, under the influence of the Renaissance humanist tradition. How ironic it is that, although the rediscovery of classical documents and the other work of the humanist scholars made the Reformation possible, it also formed a mode of interpretation that was fatal for its future. The Renaissance created a milieu in which the previous excesses of imagination gave way to a literalism that expunged mystery and made a virtue out of clarity. Although Luther is chided for the vehemence of his rejection of the views of Erasmus and Zwingli, he was never more right than in seeing that the humanist literalism of both expressed a view of life and faith totally antithetical to his own. Erasmus expressed a Roman Catholic clarity and Zwingli a Reformation one, but neither saw that the clarity he defended destroyed too much of the mystery of both life and faith. Erasmus believed that the dark caverns of scripture needed illumination. Luther believed that there was enough light in scripture by which to live, enough that one should not try to clarify everything. Some dark caverns might not be susceptible to clarification and should simply be left to be. Likewise, Luther's rejection of Zwingli as of another spirit means that he rejected total clarification on the one hand and retreat to mystery that did not illumine on the other. Regrettably, the scholastic humanist theology of the seventeenth century, as has been previously suggested, tried to define the mystery. One needs to be clear about what is legitimate mystery and what is not, but defining or explaining the mystery itself is a limiting literalism.

The devastating humanistic emphasis on the clear and the literal meant that language no longer served a pointing and recognizing function; it had

become a defining function in its own right. Then the use of language, particularly its literal form, was no longer a vehicle but the reality itself. The shift from the literal to literalism was then born. As long as the faith of an age transcends what it literally portrays, it is not literalistic in its outlook. It does not then center in the literal. The literal is a natural purveyor of that which is more than literal. When attention shifts to the literal itself, however, the world is never again seen in the same way. The literal which conveys what is beyond it while not calling attention to itself then becomes the focus of attention in order to safeguard that to which it originally pointed.

Except for the repristination of fundamentalism and conservative theologies, theologians today are interested in symbols and literary forms, as well as in psychology and the social sciences. Theology is thus moving toward a view of language and reality that is closer to the arts than has been the case at any time thus far in the twentieth century.[6] Inversely, the arts, though not fully accepted in their own right, may also have made an impact on theology. Predominantly theology was closer to the social and psychological sciences, originally modeled on the philosophy of science, in the first half of the century than it has been since. In that earlier phase, theology was like the scholastic disciplines in which analysis, classification, prediction, and clarification played a major role. Today the analogy is closer to the more contemporary views of science and to the literary and the visual arts. We do, therefore, live in a time of new opportunity, one that must be seized. Theologians by and large do not yet know the extent to which their own disciplines may be enriched, if not transformed, by a deeper exposure to the arts, including the visual arts.

We live in a pluralistic world, a world with many convictions and many sensibilities. For some, that may be incapacitating. For others, an understanding of this diversity may also be a new opportunity, a way of understanding cultural diversity as also an expression of a split within humanity. Because our sensibilities are diverse, each offering something the other does not even when it centers on the same reality, we have the choice of taking one at the expense of the others or of counting on all of them, even when we know that we will not be able to cultivate all in equal ways. There is

[6] At the Emory Consultation on the Arts and Theological Education in December 1985, Walter Lowe and David S. Pacini, both of Emory's Candler School of Theology, suggested that I had been too much under the influence of a view of language that was no longer held and that I had reacted to the older views with a strain of romanticism. I would admit to a critical romanticism. When Lowe and Pacini, however, suggested that language, properly understood, could encompass the nature and meaning of the arts, I was not convinced and felt that they ignored the uniqueness of the visual arts—that is, the integrity of the art object, as John Cook calls it—which gives us what no other modality can.

a division in our very nature, an affinity with a difference among our sensibilities—sight, touch, taste, hearing, speaking. These modalities, understood from the standpoint of creation, define our full humanity in relation to God. Understood from the standpoint of our actual state—from the perspective of the fall, if you will—the unity does not come naturally. Understood from the standpoint of redemption, we need the discipline of each sensibility in order to express a full humanity eschatologically oriented to its fulfillment.

What does the pluralism in our culture and the pluralism in ourselves mean for the theological task? First, it validates a plurality of tasks. Second, it should make it possible for us to take on the tasks we think we can do well, without having to claim that the sensibilities with which we deal are most important or decisive. Theology can take different approaches. Third, it should make us aware that the disciplined cultivation of wider sensibilities is important for a full humanity and that it has implications even for selective areas in which we can and have decided to work. It makes collective scholarship important; it highlights the need to learn from one another, for each of us cannot be altogether competent in all things.

There are those, of course, who think that theology has fallen on evil days since the vast systems have disappeared. But the various and more limited approaches, if they do not claim to be the whole, can also enrich us and set the stage for untried and new forms for theological work. We have the possibility of a series of "as if" theologies, of approaches from differing angles of vision—all for the explication of the variegated texture of what humanity may be in the presence of God.

10

THEOLOGICAL EDUCATION
AND THE REAPPROPRIATION
OF THE VISUAL

FROM THE PRECEDING analyses it is obvious that the visual arts dropped out of the lives of the Protestant churches and have played a less significant role in recent Roman Catholicism than was formerly the case. More recently, however, among artists and the artistic community generally, religious perceptions, concerns, and subjects are receiving increasing attention. Moreover, among the public generally a new interest in the visual arts is apparent, indicated in the attendance at museums and at "block buster" exhibits as well as at community art events. All of this interest outside the church certainly is creating a climate in which the church can again take up its historic association with the visual arts, albeit in analogous rather than repristinating ways.

As in all popularly based movements, we face both a danger and an opportunity. There is the danger that this cause will burn itself out without a thorough theoretical and practical grounding that shapes the new interest. There is nothing wrong with a movement that mainly reflects curiosity and pleasure; in fact, one hopes more movements in history would have that character than they in fact do. But we also know that genuine delight and pleasure have to do with experiences that belong to the necessities of the human spirit. With respect to the visual arts, we need to find ways of recovering a fundamental grounding and orientation of interest in the visual arts.

Historically it is clear that the Protestant rejection of the visual had to do with the visual's association either with opulence or with cultic practices that had become too central and distorted, so that even many Roman Catholics found them unacceptable. One need only recall the emphasis on relics and their reliquaries, the number of Masses for the dead, or the

overprominent place of saints associated with particular places and events. The Counter-Reformation corrected many of the abuses, but the new Protestantism rejected the very practices with which the artistic tradition, in sharp contrast to the earlier history of the church, had become identified. Although Roman Catholic developments, particularly in the light of Vatican II, abandoned many of the Counter-Reformation thrusts, Roman Catholic art mainly followed a decaying baroque tradition. Roman Catholics never abandoned the visual arts, but in Roman Catholicism too their formative power was considerably reduced through a repetitiveness of style and content. The visual arts were a memory rather than a source of enoblement or power. Thus, in different but allied ways, Protestants and Roman Catholics lost the power of the visual. Its abuses had led either to its absence from Protestantism, or to its diversion in Roman Catholicism.

The price paid for that historic reaction has been a heavy one, namely, the depleting of one part of our humanity—the role that the visual, as one of many sensibilities, alone can play. Of course, we have not entirely lost the visual. The interest in museum exhibitions is only one of the more recent illustrations of its continued importance. For a long time travel has centered on nature and historic monuments. Seeing nature in its many manifestations, from the beauty of an English garden or the gardens of Versailles to the grandeur of sea and mountain, whether the Alps or the Grand Tetons, is deep in the human psyche. Seeing historic monuments is one of the ways in which we know we belong to history. In many ways we see so much in a kaleidoscopic vein, not knowing that seeing itself demands reflection, including the suppression of much that meets the human eye. But precisely here lies the problem. Seeing dare not in the first instance be made the subject of thought. Seeing has its own discipline, born of continuous seeing. Such seeing organizes the world in its own manner. Seeing as such, like talk as such, requires a habituated effort. Only a concern with seeing will restore sight to its rightful place.

It is one of the ironies of Western history that the emphasis on religion and Christianity as a matter of the spirit—a phraseology that itself inverts the notion that spirit is expressed through matter—has a tinge of otherworldiness that leaves the world aesthetically untouched. It is surprising, however, that such a religion of the spirit frequently leads to social and political involvements. Aesthetic dimensions, when present at all, are accidental, like frosting on the cake. That is what happens when seeing is relegated to what bombards us, when seeing is not a cultivated sorting-out of impressions or a forming of reality through sight. So many individuals like or dislike particular buildings or paintings without a disciplined basis of seeing on which preferences might be formed.

An Agenda for Theological Education

Since the public is now open to the possibility of seeing and in the churches a vacuum has replaced historic antipathy to the arts, an opportunity exists in theological education for a concerted program of reeducation. As has been the case with educational programs generally that have made a difference, the avenues of approach will need to come from many directions.

From the standpoint of curriculum one obviously faces an already overcrowded menu, required and elective. It is not unusual in theological schools that the addition of a single course, except in a nonthreatening slot, requires a curriculum revision. Leaving aside for the moment the question of whether or not additions can be made, what theoretical case can be made for education in the visual arts in theological education? Historically, the curriculum in theological schools was largely a unity of parts, as Edward Farley has shown.[1] Not only did it have a unity; all new discoveries could be added to one of the parts. Usually the additions were to philosophy, which in its earlier and classic sense included the political and aesthetic arenas. In short, all new knowledge became a part of philosophy. But as an ever-widening field of knowledge developed within philosophy and as philosophy simultaneously restricted itself more and more to the question of how we know, the newly-forming fields became independent of philosophy. As educational philosophy opened itself to this wider world through electives, courses developed in the areas of new knowledge and discovery. Knowledge of social processes led to social ethics courses in theological schools. New knowledge of the dynamics of the human personality, whether grounded in subterranean depths or the nature of personal/social interaction, frequently led to a variety of courses in psychology. The interest of clergy in quoting literary sources as apt metaphors of theological points led to the inclusion of literature and theology courses with mixed results, for the literary point and its illustrative use were not always congruent. However, at its best, preaching informed by literature was electrifying. Drama and dance also found their way into some theological schools, though much more at the periphery than ethics, psychology, or literature. On occasion, too, reference was made to the visual arts in preaching and in theological schools, but the reference primarily had an illustrative function, usually in the nature of a prophetic social commentary.

The study by Wilson Yates of the visual arts in theological education discloses that more is going on in theological education in the arts than one might think, as, for example, in the masters program (M. Div.) at the Yale

[1] Edward Farley, *Theologia: The Fragmentation and Unity of Theological Education* (Philadelphia: Fortress, 1983).

Divinity School, and in the masters (M. Div.) and doctoral programs at Graduate Theological Union.[2] But a more fundamental reordering is needed than the addition of programs and courses; these are needed, but they do not necessarily affect the whole. Without the addition of individuals trained in the arts with full faculty status, nothing much will happen. But the problem is even broader than that. The central question is, How can seeing, as a part of our humanity and therefore also of religious perception, be reclaimed? The problem is obviously compounded by the medium of television, for television reinforces a mode of seeing that requires no effort, that makes seeing trite. At best television is illustrative of thought and meaning; that is, it becomes the visual in the service of the verbal. Since discourse is central to our humanity, discourse is not the opposite of the visual. The discipline of seeing, in which seeing gives us the same reality in a modality that also makes it different and therefore instructive in a way only the visual can do, will make it necessary to talk differently about the visual than when we use it only in illustrative ways.

We must approach the issue of the visual in theological education from many angles. We need to call on systematic theologians to take the discipline of seeing seriously, as potentially providing insights and experiences that discourse alone will not provide. If that is done, those who feel they cannot give attention to the visual will at least be able to admit that their theology is a limited enterprise, leaving out dimensions that also belong to faith. That attitude of admitting limits would be good for theology. Some systematic theologians may also be enlivened by discourse that is serious about the modality of seeing and by what artists have and are providing. Seriousness at this level is not possible, however, unless theologians themselves engage in more than a casual acquaintance with the visual arts, unless they give the same time and attention to painting and sculpture that they do, for example, to ethical theory and practice.

Church history and historical theology are seldom prosecuted without reference to the interweaving of political and intellectual threads with strands of the life and thought of the church, but the same cannot be said of the arts, whether auditory, literary, or visual. Yet we know that for most of history the visual arts, for better or for worse, were of the very fabric of the life and thought of the church. This shortcoming calls for nothing less than the training and retraining of church historians.

The new interest in spirituality and the renewed interest in liturgy disclose a longing of the human spirit for experiences that are more than exercises in thought. It is surprising that these interests have had little

[2] Wilson Yates, "A Report on the State of the Arts in Theological Education." This is an extensive report of manuscript length, and it will be published in 1987.

association with the visual arts except for what has become the ever-present banner, an art form that seldom reaches the level of quality. In an area where the range of concern runs from meditation to the most structured liturgy, the arts seem conspicuously and inexplicably absent. The simplest form of Roman Catholic and Protestant worship involves prayers, hymns, meditation. Surely meditation can be facilitated by objects as well as by verbal or nonverbal directives. Full-fledged liturgical services, with their processionals, accompanied by the carrying of liturgical objects throughout the church, seldom stop to focus at some point, except for the dedication of a window or a font. But an art object or a stained-glass window, whether in a simple service or a liturgical extravaganza, can become a point of attention in which meditation, instruction, or edification may occur. Given the unfamiliarity with such use of the visual, and the lack of art of quality in seminaries and churches, the use of the visual arts initially will probably be for special events rather for regular services. But borrowing from local museums for special occasions, in spite of security and insurance problems, is more possible than is usually assumed. In a few places, such as in Christian Theological Seminary in Indianapolis, major works of art do exist which could be used for liturgical purposes as well as for providing a general ambience.

Perhaps the absence of the visual arts in theological education has more to do with the status and nature of biblical studies than with other factors. Churches that consistently stress that scripture is not only the vehicle for the elicitation and structuring of faith but also the blueprint for modeling the life of the church mainly ignore those passages of scripture that suggest a role for the visual. A fuller delineation of biblical materials in their context provides a modified view, one in which the "for" and "against" provide a basis for promise and for seeing potential dangers in the arts. One need add only that the biblical documents also point out dangers in emphasizing the spirit, such as false spirits and proud spirits. Scripture is double-edged, pointing to promise and danger on every level. History has made us very conscious of particular negative biblical texts on the visual, which, only with time, will find their way back into a new or original context. Biblical interpreters do not sufficiently realize the extent to which contemporary concerns color what they see in scripture. But the history of biblical interpretation shows that how we read scripture is conditioned by history as well as by faith. To know the variety of conditioned approaches does not detract from the question of truth but rather enriches it by the many angles of vision.

It is interesting that exploration of the human personality has not unearthed more of a role for the visual, since it is not unusual for psychologists and analysts to use the visual arts as part of their therapy. There is another

side to this discovery of the visual in therapy, which Archie Smith of the Pacific School of Religion has begun to explore. Nor does the visual play a role in ethics; indeed, the ethical concern for the poor frequently leads to a criticism of support of the visual arts as an inappropriate expenditure of funds. Right as their viewpoint may be about the poor, it nevertheless represents a truncated theology. In Jonathan Edwards's expanded vision, the whole plan of God's work is an expression of the beauty of being in which we participate and put everything in its context.[3] Theodore A. Gill has made the case that unless a full-ranging aesthetic concern embraces ethics, ethics will be short-circuited, filling a need that is not full-orbed in its human concerns.[4]

Perhaps the field of education in theological shcools touches the area of the visual more than the other educational enterprises do. But an examination of Sunday school materials is discouraging in the poor quality of its art and the illustrative use to which the materials are put. At more advanced levels only two magazines, now both defunct, had distinction in the arts, namely, *Motive* magazine and *Liturgical Arts*. *The Christian Century*, pleading financial constraints for neglect of the arts, seems blissfully unaware that modest means need not translate into tastelessness.

From kindergarten children to grandparents, painting, ceramics, and sculpture have become part of an avocational, recreational, and educational enterprise. At many levels such developments are encouraging signs. A Rockefeller Foundation report of a decade ago clearly showed that in situations where education in the arts existed in the early grades, the verbal skills were higher than where such education did not exist. But there is also a popular belief that simply "doing" the arts will enable us to understand them or teach us what seeing is about. Knowing by doing may enrich us but doing can also blind us if that is all that happens. Just as one need not be a musician in order to appreciate a world of music, so one need not be painter in order to be moved and instructed by the seeing of paintings. In both music and the visual arts, performance is preliminary, even desensitizing, unless one's sensibilities in those areas are stretched by a habituation that leads to the educated ear or eye, which then makes hearing and seeing second nature.

The stretching of our sensibilities is necessary if we are to understand and come to terms with our pluralistic world. Encounter with non-Christian religions, particularly the religions of the East, is both sought by many and

[3] See John Dillenberger, *The Visual Arts and Christianity in America* (Chico, CA: Scholars Press, 1984) 39–40, 174.

[4] Address delivered before the Society for Arts, Religion, and Contemporary Culture, New York City, 1 February 1986.

is necessary if we are to live on this planet. To have the kind of understanding called for in genuine dialogue, we need to know and see how the visual arts belong to those traditions. To bracket those out would be even more distorting to Eastern religions than to the Western scene. The demand for an educated eye will become even more important in the light of the emergence of the importance of the East.

A similar situation obtains if we are to be in conversation with the tradition of the arts in our own society. Many perceptions, congenial and noncongenial, in our society are being formed by artists, not because they want that task—indeed, some of them say that asking them to be prophetic voices is asking too much—but because their humanity as artists cries out for expressions lost or subsumed in our culture. Surely common humanity is the basis for a mutual enriching, a joint discovery, of our humanity.

Inasmuch as nothing less than a conscious effort is necessary on the part of all of us in order to reclaim a habit of seeing as a part of our humanity, the adding of courses to the theological curriculum, helpful as this has been and necessary as it is, will not solve the problem. Through courses we may create new faculty members in the field and send students into parishes with new interests. But if we are to affect theological education as a whole, we will need a total reeducation. It may be more feasible to inject concerns within existing disciplines rather than to argue for a new curriculum, whose chances of adoption would not be high. Curators in museums and art historians in universities can enter established courses and frequently would love to join in team-taught course, as the experience of some seminaries indicates. The world of art is more cognizant of the role of religion in the arts than the world of religion is of art. There are more untapped resources available in the arts than in most other areas of the curriculum.

Two additional strategies suggest themselves, each of which would require financial support from sources beyond those already available. First, a series of summer institutes and/or facilitative visits at various sites could generate interest and encourage the discovery of resources. Second, sabbatical programs geared to the visual arts would give momentum to the inclusion of the visual arts in all aspects of the curriculum. A year's exposure to the visual arts, including working in both museums and their libraries and having contact with significant working artists, would provide a basis for a recasting of one's own work. The time is right for such a program of institutes and sabbaticals. They could become the vehicle for the reintroduction of the arts into theological education and the churches.

PHOTOGRAPHIC CREDITS

THE AUTHOR AND THE PUBLISHER wish to thank the custodians of the works of art for supplying photographs and granting permission to use them. Unless otherwise indicated, photographs are by the author.

1. The Pontifical Commission of Sacred Archaeology, Vatican City.
2. The Pontifical Commission of Sacred Archaeology, Vatican City.
3. The Cleveland Museum of Art, John F. Severance Fund.
4. Vatican Museums and Pontifical Galleries, Vatican City.
5. The Pontifical Commission of Sacred Archaeology, Vatican City.
6. Vatican Museums and Pontifical Galleries, Vatican City.
7. The Pontifical Commission of Sacred Archaeology, Vatican City.
8. Yale University Art Gallery, New Haven.
9. Vatican Museums and Pontifical Galleries, Vatican City.
10. The Metropolitan Museum of Art, Gift of Ernest and Beata Brummer in memory of Joseph Brummer.
11. Vatican Museums and Pontifical Galleries, Vatican City.
12. Art Resource, New York.
13. Art Resource, New York.
16. The Metropolitan Museum of Art, The Cloisters Collection.
17. Art Resource, New York.
18. Fototeca Unione, The American Academy, Rome.
19. Art Resource, New York.
20. Art Resource, New York.
21. Art Resource, New York.
22. Art Resource, New York.
23. Art Resource, New York.
24. Art Resource, New York.
25. Art Resource, New York.
26. Art Resource, New York.
27. Art Resource, New York.
28. Art Resource, New York.
29. Cliché des Musées Nationaux—Paris.
30. Royal Academy of Arts, London.
31. National Gallery of Art, Washington; Andrew W. Mellon Collection.
32. Musée d'Unterlinden, Colmar, France. Photograph by O. Zimmerman.
33. Musée d'Unterlinden, Colmar, France. Photograph by O. Zimmerman.

34. The Metropolitan Museum of Art, Fletcher Fund, 1919.
35. The Metropolitan Museum of Art, Harris Brisbane Dick Fund, 1943.
37. Art Resource, New York.
38. Art Resource, New York.
39. Art Resource, New York.
40. Vatican Museums and Pontifical Galleries, Vatican City.
41. The Trustees of The National Gallery, London.
42. Art Resource, New York.
43. The Kunsthistorisches Museums, Vienna.
44. The Metropolitan Museum of Art, Bequest of Ogden Mills, 1929.
45. Art Resource, New York.
46. Alte Pinakotek, Munich.
48. Art Resource, New York.
50. The Metropolitan Museum of Art, Bequest of Mrs. H. O. Havemeyer, 1929; The H. O. Havemeyer Collection.
51. The Metropolitan Museum of Art, Bequest of Mrs. H. O. Havemeyer, 1929; The H. O. Havemeyer Collection.
52. The Metropolitan Museum of Art, Gift of Felix M. Warburg and his family, 1941.
53. Courtesy of The Pennsylvania Academy of the Fine Arts, Philadelphia
54. Museum of Fine Arts, Boston. Gift in Memory of Martin Brimmer.
55. The Metropolitan Museum of Art, Bequest of Mrs. H. O. Havemeyer, 1929. The H. O. Havemeyer Collection.
56. James Derring Collection, © The Art Institute of Chicago.
57. Art Resource, New York.
58. National Galleries of Scotland, Edinburgh.
59. The Albright-Knox Art Gallery, Buffalo. General Purchase Funds, 1946.
60. The Metropolitan Museum of Art, Bequest of Sam A. Lewisohn, 1951.
61. Museum of Fine Arts, Boston: Tompkins Collection.
62. © A.D.A.G.P., Paris/V.A.G.A., New York, 1985.
63. Philadelphia Museum of Art. Given by Mrs. Thomas Eakins and Miss Mary Adeline Williams.
64. National Museum of American Art, Smithsonian Institution, Gift of Mr. and Mrs. Norman B. Robbins.
65. National Museum of American Art, Smithsonian Institution, Gift of John Gellatly.
66. National Museum of American Art, Smithsonian Institution, Gift of William T. Evans.
67. Courtesy of the Trustees of the Boston Public Library.
68. The Tate Gallery, London.
69. Prints Sales Miscellaneous Collections, © The Art Institute of Chicago.
70. Solomon R. Guggenheim Museum, New York City. Photo by Robert T. Mates.
71. Collection, The Museum of Modern Art, New York City. Curt Valentin Bequest.
72. The St. Louis Art Museum.
73. Stiftung Seebüll, Ada und Emil Nolde, Neukirchen.
74. Stiftung Seebüll, Ada und Emil Nolde, Neukirchen.
75. Hirshhorn Museum and Sculpture Garden, Smithsonian Institution.
76. Delaware Art Museum.

77. Collection of Whitney Museum of American Art. Purchase.
78. Collection of Whitney Museum of American Art. Purchase.
79. Alfred Stieglitz Collection, © The Art Institute of Chicago.
80. © The Art Institute of Chicago.
81. Columbus Museum of Art, Ohio. Gift of Ferdinand Howald.
82. Albright-Knox Art Gallery, Buffalo, New York. Room of Contemporary Art Fund, 1953.
83. Courtesy of Amon Carter Museum, Fort Worth.
84. Collection of Whitney Museum of American Art. Purchase.
85. Courtesy of Roy R. Neuberger.
86. The Phillips Collection, Washington.
87. Collection of Catherine Heffernan.
88. Collection, The Museum of Modern Art, New York City. Purchase.
89. Permanent Collection University of Oregon, Museum of Art.
90. National Museum of American Art, Smithsonian Institution, Gift of the Harmon Foundation.
91. Collection, The Museum of Modern Art, New York City, Gift of Mr. and Mrs. William A. M. Burden.
92. Collection of Neuberger Museum, State University of New York at Purchase. Gift of Roy R. Neuberger.
93. Courtesy of Mrs. John de Menil.
94. Collection, The Museum of Modern Art, New York City. Purchase.
95. Courtesy of Annalee Newman.
96. Collection, The Museum of Modern Art, New York City.
 Purchase (by exchange).
97. Courtesy of Xavier Fourcade, Inc., New York City.
98. Collection, The Museum of Modern Art, New York City.
 Charles Mergentime Fund.
99. Photograph © Morley Baer.
100. Photograph by Bevan Davies.
101. Collection of Neuberger Museum, State University of New York at Purchase. Gift of Roy R. Neuberger.
102. Courtesy of the artist.
103. Philadelphia Museum of Art. Purchased: Edith H. Bell Fund.
104. Photograph by Karl H. Reik.
105. The St. Louis Art Museum.
106. Courtesy Monique Knowlton Gallery, Inc.
109. Permission of the artist.
110. Permission of the artist.
111. Courtesy of Marian Goodman Gallery. Permission of the artist.
112. Permission of the artist. Photograph by Alan Zindman.
113. Permission of the artist.
114. Collection of Rodney Sheldon.
118. By permission of the provost and council of The Coventry Cathedral.
119. Photograph by James K. Mellow.
120. The Abbey of St. John the Baptist.
121. Photograph by Ezra Stoller. © ESTO.
122. Courtesy of Candler School of Theology, Emory University.

LIST OF WORKS OF ART

THIS LIST OF WORKS OF ART indicates the location of all works of art discussed in this text. The arrangement of this listing corresponds to the order of discussion.

1. *Christ/Orpheus* (3rd century; Catacomb of Domitilla, Rome). Plate 1, *9*, 10
2. *The Good Shepherd* (3rd century; Cubiculum of the Velati, Catacomb of Priscilla, Rome). Plate 2, *9*, 10
3. *The Good Shepherd* (ca. 269-275; The Cleveland Museum of Art, Cleveland). Plate 3, *11*, 10
4. *Sarcophagus from Via Salaria* (3rd century; Museo Pio Cristiano, Vatican City). Plate 4, *11*, 10
5. *Sarcophagus* (mid-3rd century; Santa Maria Antiqua, Rome). Plate 5, *13*, 12
6. *Sarcophagus* (mid-3rd century; Museo Pio Cristiano, Vatican City). Plate 6, *13*, 12
7. *Christ and the Samaritan Woman* (early 3rd century; Catacomb of Praetextatus, Rome). Plate 7, *17*, 15
8. *The Healing of the Paralytic*, Tracing from the Christian Building at Dura-Europos (ca. 230; Yale University Art Gallery, New Haven). Plate 8, *17*, 16
9. *Sarcophagus including Entry into Jerusalem* (ca. 330; Museo Pio Cristiano, Vatican City). Plate 9, *21*, 20
10. *Roman Tomb Relief with Traditio Legis* (late 4th century; The Metropolitan Museum of Art, New York). Plate 10, *21*, 20
11. *Sarcophagus* (ca. 315-325; Museo Pio Cristiano, Vatican City). Plate 11, *22*, 20, 23
12. *Sarcophagus of Junius Bassus* (ca. 359; Treasury, St. Peter's Basilica, Vatican City). Plate 12, *22*, 23
13. *Infancy Scene of Life of Christ* (5th century; Santa Maria Maggiore, Rome). Plate 13, *24*, 23
14. *Wooden Door with Crucifixion* (ca. 432-440; Santa Sabina, Rome). Plate 14, *24*, 23
15. *Sarcophagus with Cross* (ca. 360; Grottoes, St. Peter's Basilica, Vatican City). Plate 15, *26*, 23
16. *The Chalice of Antioch* (ca. 550; The Cloisters Collection, The Metropolitan Museum of Art, New York). Plate 16, *26*, 25
17. *Statuette of Christ* (ca. 370-380; Museo Nazionale Romano, Rome). Plate 17, *26*, 25

46. Michelangelo Merisi da Caravaggio, *The Supper at Emmaus* (1606; Pinacoteca di Brera, Milan). Plate 42, *82*, 81

47. Rembrandt van Rijn, *The Supper at Emmaus* (1648; Louvre, Paris). Plate 48, *95*, 83, 94

48. Michelangelo Merisi da Caravaggio, *St. Matthew and the Angel* (1597-1598; Contarelli Chapel, San Luigi dei Francesi, Rome), 83

49. Michelangelo Merisi da Caravaggio, *The Calling of St. Matthew* (1599-1600; Contarelli Chapel, San Luigi dei Francesi, Rome), 83

50. Michelangelo Merisi da Caravaggio, *The Martyrdom of St. Matthew* (1599-1600; Contarelli Chapel, San Luigi dei Francesi, Rome), 83

51. Peter Paul Rubens, *The Miracles of St. Ignatius Loyola* (1617-1618; Kunsthistoriches Museum, Vienna). Plate 43, *85*, 84

52. Peter Paul Rubens, *The Miracles of St. Francis Xavier* (1617-1618; Kunsthistoriches Museum, Vienna), 84

53. Peter Paul Rubens, *The Triumph of the Eucharist* (1625-1628; Convent Descalzes Reales, Madrid), 84

54. Peter Paul Rubens, *The Glorification of the Eucharist* (1630; Carmelite Church, Antwerp), 84

55. Peter Paul Rubens, *The Triumph of Christ over Sin and Death* (ca. 1615-1620; The Metropolitan Museum of Art, New York). Plate 44, *87*, 84, 86

56. Gian Lorenzo Bernini, *Fountain of the Four Rivers* (1648; Piazza Navona, Rome), 88

57. Gian Lorenzo Bernini, *Elephant Carrying Obelisk* (1666-1667; Piazza Santa Maria Sopra Minerva, Rome), 88

58. Gian Lorenzo Bernini, *Colonnade* (1656-1667; Piazza San Pietro, Vatican City), 88

59. Gian Lorenzo Bernini, *Cathedra Pietri* (1657-1666; St. Peter's Basilica, Vatican City), 88

60. Gian Lorenzo Bernini, *Tomb of Alexander VII* (1672-1678; St. Peter's Basilica, Vatican City), 88

61. Gian Lorenzo Bernini, *Praying Angels* and *Ciborium* (1673-1674; Blessed Sacrament Chapel, St. Peter's Basilica, Vatican City), 88

62. Gian Lorenzo Bernini, *Baldacchino* (1624-1633; St. Peter's Basilica, Vatican City), 88

63. Gian Lorenzo Bernini, *Truth Revealed By Time* (1646-1652; Galleria Borghese, Rome), 88

64. Gian Lorenzo Bernini, *Transverberation of St. Teresa* (1647-1652; Cornaro Chapel, Santa Maria della Vittoria, Rome). Plate 45, *89*, 88, 90

65. Rembrandt van Rijn, *The Blinding of Samson* (1636; Staedel Institute, Frankfurt), 91

66. Rembrandt van Rijn, *Samson and Delilah* (1628; Staatliche Museen, Berlin–Dahlem), 91

67. Rembrandt van Rijn, *Sacrifice of Abraham* (1635; Hermitage, Leningrad), 91

68. Rembrandt van Rijn, *Death of the Virgin* (1639; Detroit Institute of the Arts, Detroit, MI), 91

69. Rembrandt van Rijn, *The Holy Family* (1631; Alte Pinakothek, Munich). Plate 46, *93*, 92

70. Rembrandt van Rijn, *The Holy Family with Angels* (1645; Hermitage, Leningrad). Plate 47, *93*, 92

INDEXES

Subjects

269

Names